Incredible
Light&Texture
in watercolor

James
Toogood

NORTH LIGHT BOOKS
CINCINNATI, OHIO
www.artistsnetwork.com

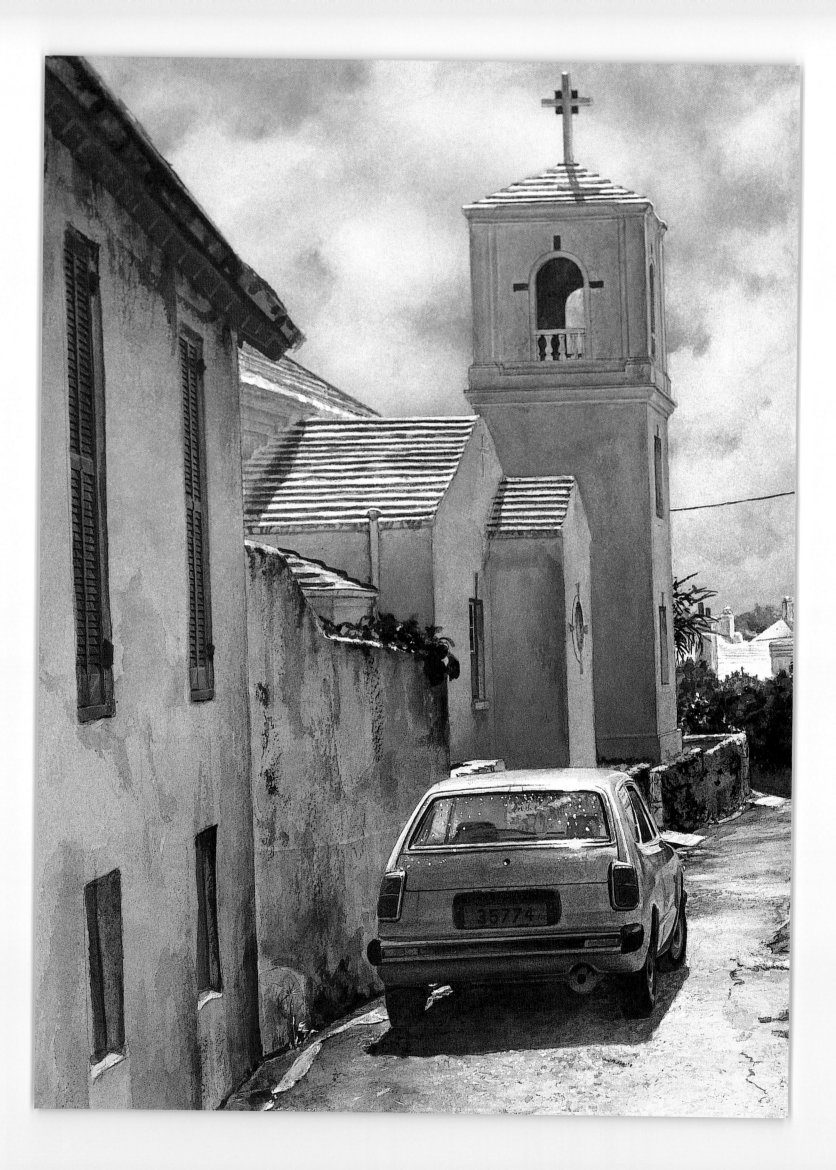

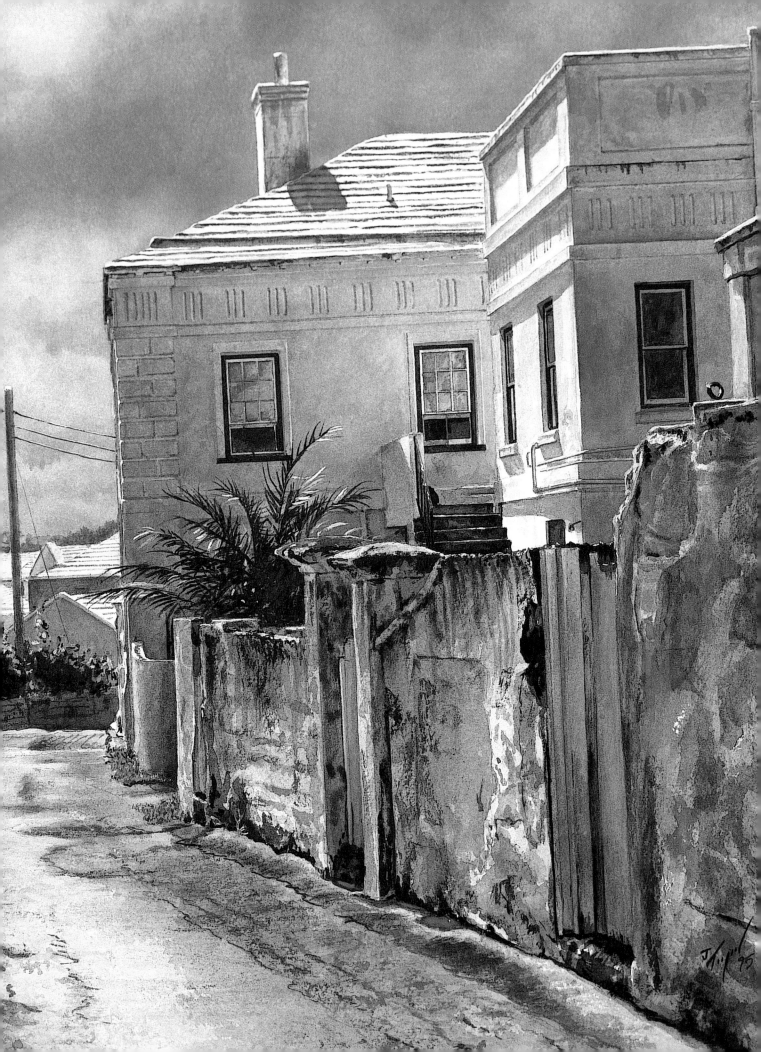

Photo by Dave Hoffman

James Toogood studied painting at the Pennsylvania Academy of Fine Arts in Philadelphia. His work has been exhibited in more than thirty-five solo exhibitions throughout the United States and abroad, including a retrospective of his work at the Woodmere Art Museum in Philadelphia. James has shown in countless group exhibitions, both juried and invitational, including those with the American Watercolor Society, the National Academy of Design, the Butler Institute of American Art and the Masterworks Foundation.

James has won numerous awards and is a signature member of many art organizations, including the American Watercolor Society, the Northeast Watercolor Society, the Pennsylvania Watercolor Society and the New Jersey Watercolor Society. His award-winning watercolors are represented in public and private collections around the globe and have been featured in numerous magazines, such as *The Artist's Magazine, American Artist, Watercolor* and *Bermuda Magazine*. His work has also been featured in a number of books including *Expressing the Visual Language of the Landscape; The Best of Watercolor, Painting Light and Shadow*; and *Splash 6, 7 and 8*.

James is represented by Rosenfeld Gallery in Philadelphia, Pennsylvania, and by the Windjammer Gallery in Hamilton, Bermuda. James lectures on watercolor technique and conducts watercolor workshops throughout the United States and abroad. He teaches at the Pennsylvania Academy of Fine Arts in Philadelphia, the Perkins Center for the Arts in Moorestown, New Jersey, and the Somerset Art Association in Bedminster, New Jersey. James maintains a studio in Cherry Hill, New Jersey.

Acknowledgments

I would like to thank Stephen Krouch who did all the large format photography of the paintings in this book.

I would like to thank the staff at North Light and my editors, Rachel Wolf, Jennifer Kardux, Jamie Markle and Layne Vanover. It has truly been a pleasure to work with each of you on this project.

I would like to thank my father, who was my first art teacher, and my mother, who was my first art history teacher. They really did make it seem as though anyone could grow up to be an artist.

And finally, I would like to thank my wife Eileen, without whom none of this would be possible.

Other fine North Light Books are available from your local bookstore, art supply store or direct from the publisher.

08 07 06 05 04 5 4 3 2 1

Library of Congress Cataloging in Publication Data
Toogood, James
Incredible light and texture in watercolor / James Toogood.
 p. cm
 Includes index.
 ISBN 1-58180-439-3 (hc. : alk. paper)
 1. Watercolor painting—Technique. 2. Light in art. 3. Texture (Art) I. Title.

ND2420 .T66 2004
751.42'2—dc22 2003066190

Content edited by Gina Rath and James A. Markle
Production edited by Layne Vanover and Gina Rath
Designed by Wendy Dunning
Production art by Joni DeLuca
Production coordinated by Mark Griffin

Art on pages 2-3
ST. GEORGE'S
14 "x 20" (36cm x 51cm) • *Private collection*

Metric Conversion Chart

To convert	to	multiply by
Inches	Centimeters	2.54
Centimeters	Inches	0.4
Feet	Centimeters	30.5
Centimeters	Feet	0.03
Yards	Meters	0.9
Meters	Yards	1.1
Sq. Inches	Sq. Centimeters	6.45
Sq. Centimeters	Sq. Inches	0.16
Sq. Feet	Sq. Meters	0.09
Sq. Meters	Sq. Feet	10.8
Sq. Yards	Sq. Meters	0.8
Sq. Meters	Sq. Yards	1.2
Pounds	Kilograms	0.45
Kilograms	Pounds	2.2
Ounces	Grams	28.3
Grams	Ounces	0.035

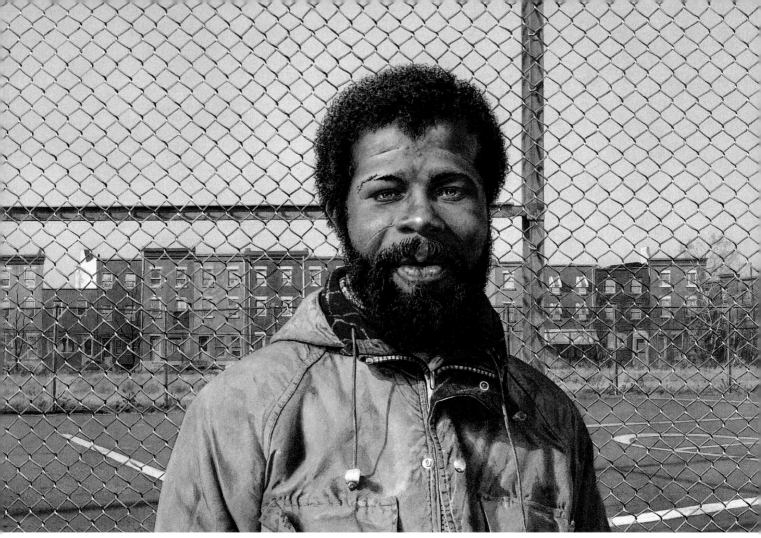

KINDRED SPIRIT

14" x 20" (36cm X 51cm) • Private Collection

For Eileen

Table of Contents

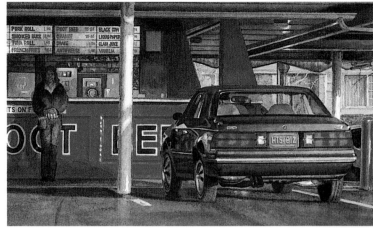

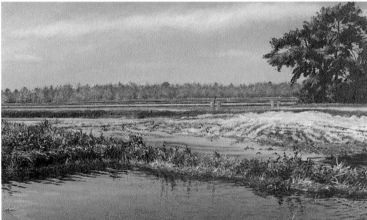

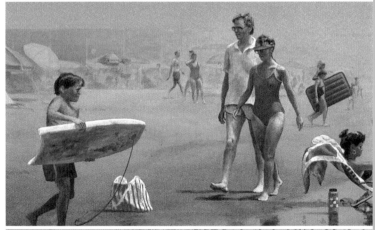

5 | Painting Natural Textures

6 | Painting Man-made Textures

7 | Painting Textures of People

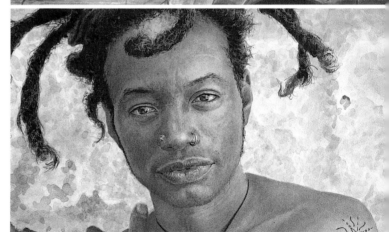

8 | Differences and Similarities

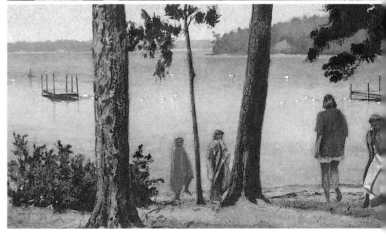

Introduction

Talent is overrated. Determination and persistence are more important. If you have a passion for painting, the skills can be acquired.

Painting, as I see it, is a powerful and unique language, one that can transcend the limitations of other languages to reach out across borders and communicate to virtually anyone, anywhere. In a painting, each brushstroke is like a syllable from the mind and hands of the artist that forms the foundation for this rich and expressive means of communication.

But paintings are even more than that, paintings are themselves physical objects, not merely images of something else. The artist uses tools, materials and acquired skills to actually make a painting. I see an intrinsic aesthetic commonality in all forms of painting, regardless of style or medium. This is true whether we are talking about a giant abstract expressionist canvas or an intimate little work on paper.

Watercolor is certainly one of the most elegant, versatile and popular painting mediums. Due to its popularity, much has been written about it. Still, myths and misconceptions remain. Among the most persistent is the notion that there is a proper or correct way to paint a watercolor. Over the years certain styles of watercolor painting become popular for a while, tempt-

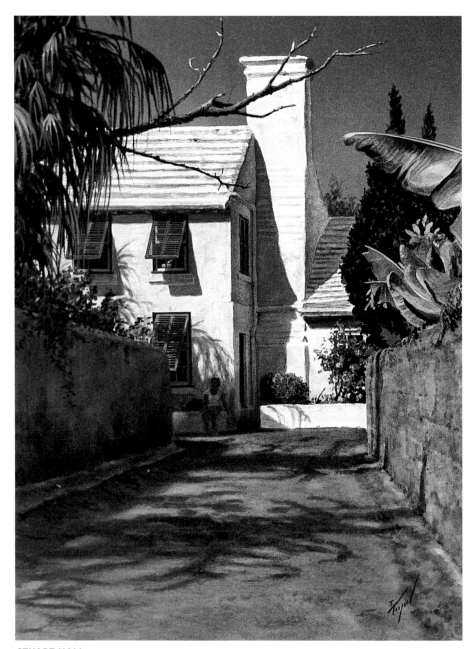

STUART HALL
13" x 10" (33cm x 25cm) • Private collection

ing some to suggest that the definitive style or even a proper way to paint watercolor has been discovered. I don't buy that. I believe there is no wrong way to make a painting, watercolor included.

History has shown us master watercolor painters of all styles who have developed a variety of new techniques. Today the medium has evolved to a point where one can find a myriad of different approaches that provide wonderful and exciting results. Even so, you might be very surprised to find out how similar many of the techniques that achieve those different-

looking results actually are. Regardless of the look you are interested in having for your finished painting, there are skills, techniques and concepts we all need to know that will improve our ability to make better watercolors. The more you know about the medium, the more freedom you have to explore your own interests and satisfy your own desires.

I personally seek a natural, matter-of-fact, realistic look to my watercolors. I strive to have brushwork that is both descriptive and elegant. I use a combination of many layers of color and usually a fair amount of detail. For my subjects I look to the people, places and things that make up our everyday lives. I feel virtually anything can make a suitable subject for a watercolor. The trick is to make the painting interesting. To that extent I focus on drawing, composition, color and, of course, light and texture.

Light is perhaps the single most influential aspect of a painting. Regardless of whether light is even depicted in a painting, we of course still need a source of light just to look at it. Light affects how we perceive all of the other elements in a painting. Even so, capturing the illusion of light in a watercolor can be a challenge. It is elusive and changeable, ranging from morning's first blush, to the bright

sometimes glaring light of afternoon, to the subtle half-light of dusk. It can be natural, artificial, simple and complex; it can be warm and it can be cold. But when you do capture light in a painting, it's magic.

Texture in a painting is more than the mere surface quality of a particular object, such as the roughness of a rock or the fluidity of water. Texture in a watercolor results from a combination of many things: surface, brush marks, paint quality and more. Texture in a painting elicits a sense of recognition from the viewer and gives greater insight into the nature of your subject. Together, light and texture set the mood and give a painting believability.

This book will show you a variety of different types of light and texture that you can use in your own watercolors and will discuss why these elements are important to your painting.

It will provide you with common-sense explanations about how light and texture relate to each other and to the other elements of picture making. Through step-by-step demonstrations, the book will demystify what at first might seem to be complex and difficult aspects of light and texture in watercolor painting. The elements are broken into bite-sized-pieces that will be easy for even the beginner to digest while still providing food for thought to the most experienced watercolorist. The book will provide you with key insights about light and texture that will enhance your ability to say precisely what you want with your own watercolors. And regardless of your own personal preference or style, this book will help you master techniques that will allow you to make watercolors that are filled with light and rich in texture.

1

Basics of Color, Paint and Other Materials

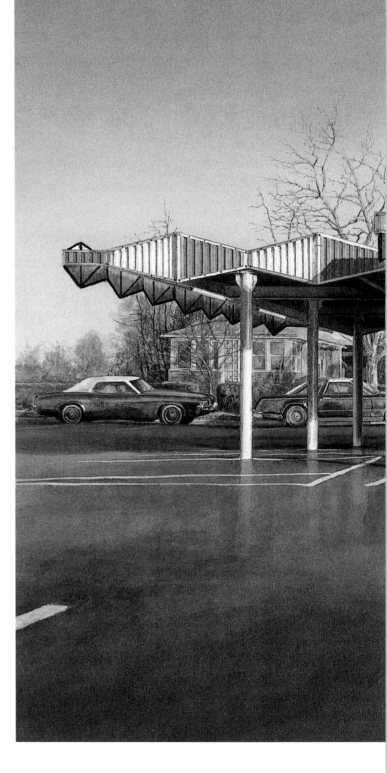

"The right tools make the job easy."

Being familiar with your materials and knowing how to use them properly is the first step in executing successful watercolors rich in texture and filled with light. There is an enormous amount of materials out there for the watercolorist to use. Therefore, many aspiring artists might feel a little overwhelmed and intimidated by the vast selection and not know where to begin.

Most experienced artists realize that it is not necessary to know everything about every single material available to make successful watercolors. But the more you do know about your materials the easier it is to get the results you desire. This chapter will discuss a number of the materials that you may find quite useful in your own watercolors.

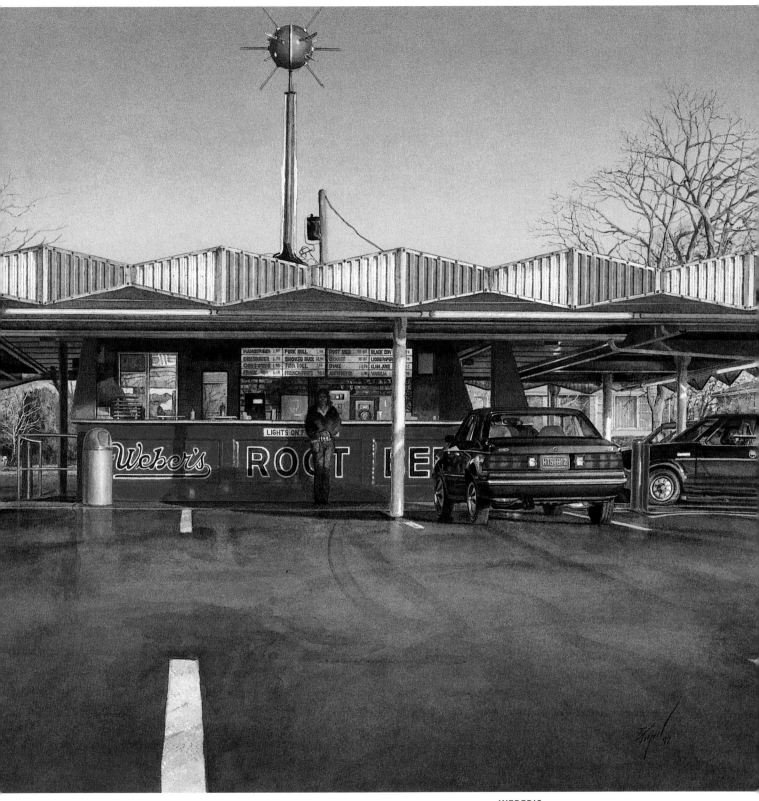

WEBER'S
14" x 21" (36cm x 53cm) • Private collection

Color, Paint and Pigment

From time to time one hears the terms *color, paint* and *pigment* being used interchangeably. Though they are related to one another, they are in actuality distinctly different. What we perceive as color is merely a sensation in the brain in response to stimulation of the eyes by certain wavelengths of radiant energy or light. More simply put, we see color because of light.

Pigment is a finely ground powder used as the coloring agent in paint.

Paint is a material typically made up of dry powdered pigment and some type of vehicle that is used to spread or carry the pigment over a surface.

I said typically, because paint can sometimes also be made from powdered dyes, also called dyestuffs. Dyes differ from pigments in that dyes are soluble (they dissolve into their vehicle) and pigments are insoluble (they remain separate and in sus-

pension within their vehicle). So in other words, pigment is the material in paint that is used by the artist to create the sensation of color in a painting.

There are several terms and concepts the artist should know concerning color, paint and pigment.

Color Terms

The three initial qualities of color to consider are *hue, brilliance* and *saturation*.

Hue refers to the color of an object—red, blue, green, etc.

Brilliance refers to whether a given color appears to be light or dark. This is also called tonal value.

Saturation refers to the difference between a given color and neutral gray.

Saturated colors are rich and intense. Less saturated colors are paler and dirtier.

Other Color-Related Terms
Chromatic Colors Any color except white, black or gray.

Local Color Sometimes a particular quality of light can alter the way we perceive a given color. Local color refers to the actual hue of an object, without the influence of light, such as a red shirt or blue pants, etc.

Prismatic Color Colors that resemble those that result when light passes through a prism.

Primary Colors Yellow, red and blue.

Secondary Colors Green, orange and violet. These colors are made by combining two of the three primaries.

Intermediate Colors These six colors are located in between the three primaries and the three secondaries on a color wheel. They are made by combining the two colors next to them, such as red and orange to make red-orange.

Complementary Colors On a color wheel these colors are found directly opposite one another. They are in complete contrast to one another. The complement for each of the primary colors is the secondary color that is made up of the remaining two pri-

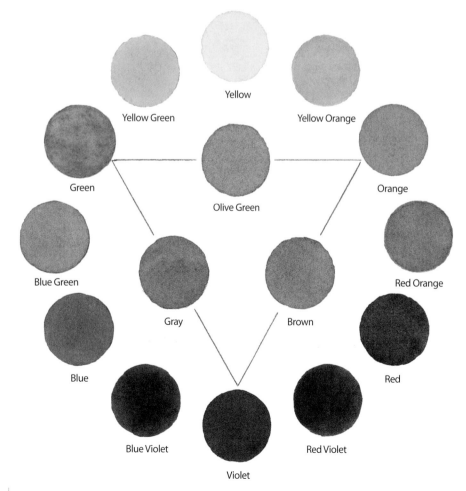

Yellow

Yellow Green Yellow Orange

Green Olive Green Orange

Blue Green Red Orange

Gray Brown

Blue Red

Blue Violet Red Violet

Violet

The Color Wheel
A color wheel is a clear and easy illustration of various color terms and concepts. Note that on this particular color wheel the color with the highest tonal value is yellow and is located at the top of the wheel. Violet has the lowest tonal value in this group of colors and it is located at the bottom of the wheel.

maries. For example, green is made up of yellow and blue, so its complement is red.

Tertiary Colors Gray, brown and olive green. These are made by combining two of the three secondary colors, such as green and orange. Tertiary colors are less vibrant and less saturated than the other color categories.

Color theory says that you should be able to make any color imaginable from the three primary colors. But paint and pigment have physical limitations, and too much mixing can cause colors to become muddy, eventually making black. Fortunately there is a wide range of paints available for artistic use. Besides a paint's color properties, it is important to know the other characteristics of the paint and pigment you use and the terms that are used to describe those characteristics. Understanding these terms will help you select the best paints for your individual works of art.

Paint and Pigment Terms

Grade There are two grades of paint commercially available: *artist grade* and *student grade*. While student grade paints are generally less expensive and some are reasonably useful, they are often inferior in quality. Though artist grade paints are more expensive to purchase, they are generally a better value because their pigments are usually more finely ground and the paint has less filler. Therefore they give you brighter, richer color and are used up less quickly.

Permanency Also referred to as *lightfastness*. This term refers to a paint's ability to resist light fade. For years some paint manufacturers have used one system or another to inform artists about the permanency of their paints. Others didn't even bother. Several years ago a standardized system

was established by the American Society of Testing and Materials (ASTM). Their lightfast rating system ranges from I—Excellent, to V—Extremely fugitive. Paints with an ASTM rating of I or II are considered permanent and appropriate for artistic use. Many otherwise desirable colors may not be sufficiently permanent for artistic use. That being said, there is a definite disagreement with some of the ASTM findings by several paint manufacturers.

If you are in doubt about a particular paint, you may wish to try this useful, if not entirely scientific, experiment. Paint a swatch of the color in question, then cover half of the swatch and put it in a south- or west-facing window. Keep it there and from time to time check the swatch to see if it has faded. I have used this method to test several paints, and if I see no detectable change after about a year or so of exposure, I then consider it safe for my own use.

Transparency and Opacity In art, *transparency* and *opacity* are the terms used to refer to a paint's ability to transmit light. A transparent paint transmits light easily, while an opaque paint will transmit little or no light, depending on how heavily it is applied.

When it comes to watercolor, there is sometimes a little confusion around the issue of transparency and opacity. Watercolor is often considered a transparent medium because typically the paint is mixed and thinned down with water, then applied in thin layers. Often what people don't realize is that the pigments used to make all paints, regardless of medium, are the same. Therefore all mediums have pigments that are transparent, semi-transparent, semi-opaque and opaque (even in "transparent" watercolor). For example, in all paint media, all Cadmiums are opaque, along with several other colors such as

Chromium Oxide Green and Cerulean Blue. Other colors like Hooker's Green and Prussian Blue are transparent.

Gouache Most artists know that gouache (pronounced goo-wash) is an opaque form of watercolor. Gouache is sometimes also referred to as designer color. These paints differ from watercolor because chalk or some other additional opacifier is added to make them opaque. Some artists frown upon the use of gouache, feeling it is somehow inferior to real watercolor. Others happily use it either in combination with watercolor or by itself. I personally do not use gouache, not because I find anything wrong with it, but with all the characteristics available in watercolor I find no need for it. I do use body color.

Body Color This term refers to opaque effects in watercolor. Body color is different from gouache. As discussed earlier many pigments are naturally opaque regardless of the medium. Opaque pigments can be thinned down to make them appear more translucent or be applied more thickly at full strength, which will make them more opaque. Additionally, Chinese or Titanium White can be added to any other color to make it appear more opaque. Some artists look down upon the use of white and even prefer to limit their palette only to those paints with pigments that are completely transparent. I personally prefer the richness of paint quality that comes from the interplay of various paints and pigments.

Toptone and Undertone Typically watercolors are sold in cakes or tubes. I prefer the tubes because it more easily enables me to take advantage of the paint's toptone and undertone. *Toptone*, also called masstone, is what a paint looks like right out of the tube or in heavy applications. A

paint's *undertone* is revealed when it is mixed with white or, in the case of watercolor, thinned down with water. Some paints, especially those made with opaque pigments, vary little in their appearance from their toptone to their undertone. Others, especially transparent paints with a deep tonal value, will change enormously from their toptone to their undertone.

When viewing a paint's toptone, light bounces off the surface of the paint. In watercolor, when viewing the paint's undertone, light passes through the layer of paint and hits the surface of the paper. This is one of the factors that gives watercolor its sparkle and many watercolorists rely solely on a color's undertone. I personally like the richness and complexity that come from using both a paint's toptone and its undertone.

Body This term simply refers to how thick or viscous a paint tends to be. Paints like Cadmium Red, Cerulean Blue and Yellow Ochre are examples of paints with a lot of body.

Physical Mixing and Optical Mixing
Paints can be mixed one of two ways. To mix paints *physically* you simply mix two colors on the palette. For instance, Cadmium Red and Aureolin Yellow will produce a kind of orange. When mixing *optically* you first apply one color to the paper. After it is dry, apply the next color. Because of the different properties of the two paints, the way they are mixed and the order in which you apply them will produce two or three slightly different oranges.

Staining and Non-staining Some paints are highly staining. They will not move and are difficult, if not impossible, to scrub or pick up after they dry. Non-staining paints not only can be easily scrubbed or picked up after application, but may also begin to move a little if one is not careful with subsequent paint applications. This can cause the paints to mix both optically and physically at the same time, causing the colors to become muddy. If you wish to limit the staining power of a particular paint you can mix it with a non-staining paint of limited tinting strength.

Sample Various Paints
When purchasing paint many artists stick to a somewhat limited palette of one brand or another. While this is not necessarily a bad idea, there are often differences between paints when looking from brand to brand—sometimes subtle, sometimes not. I believe it is time well spent to research and try out various paints from different manufacturers. Over time you will find the paints and brands that suit your particular needs and desires.

Tinting Strength This is a paint's ability to influence other colors. Prussian Blue has a very high tinting strength whereas Cerulean Blue has a much lower tinting strength. Cobalt Violet is an example of a paint with an extremely low tinting strength.

Granulation Some paints dry to a flat, smooth finish while others, such as Cerulean Blue, appear to separate out into a more uneven finish. These colors are called granulating colors. Some artists prize this effect and specifically seek out colors that granulate. For those times when this effect is not desirable, repeated applications of the paint will usually smooth the color out.

Earth Colors Paints made from clays and other materials found in the earth are called earth colors. They include: Siennas, Ochres, and other Iron Oxides, like Indian Red. Together these paints make up what is also referred to as the *dead color palette*, which differs from the brighter and more luminescent colors found in the prismatic palette. These colors may be substituted in a painting for the vivid colors in the prismatic palette, but in watercolor both palettes are typically used together.

Health Labeling The materials in most paints and pigments are safe if handled properly, but some are potentially dangerous and therefore proper care should be taken when handling them. Cadmium, chromium and other heavy metals are examples. Look for the health care labels on the tubes to determine if the particular color you are purchasing requires some care when handling it. All paint manufacturers should carry a health label on the tubes—unfortunately not all do.

Color Index Designations For years, the nomenclature for artists' paints has been a little out of control, and looking from brand to brand for comparable paints used to be quite confusing. I'll give you an example of what I mean. Winsor and Newton's Winsor Green (blue shade), Grumbacher's Thalo Green (blue shade) and M. Graham's Phthalocyanine Green are the exact same pigment—Phthalocyanine Green. On the other hand, paints with the exact same name on the label could be made of completely different pigments. How are you supposed to know that? These days you can look for the color index name and/or number on the tube. These designations are used to end the confusion about what is really in the tube of paint. The designation most commonly used and the easiest to understand is the alpha numeric color index name. The color index name for all three aforementioned paints is PG7. P stands for pigment; G stands for green; and 7 simply is the number assigned to the color. The color index name for Cadmium Red is PR108, while Ultramarine Blue is PB29 and Cadmium

Yellow is PY37. In some cases you may also find the color index number on the tube. The color index number for Phthalocyanine Green, PG7, is 74260. Check for one or both of these designations on the tube of paint, not just the name of the paint, to make sure you really get the paint you think you are getting.

Specific Pigment Qualities

Learning about paint and pigment is an ongoing process. Furthermore, from time to time companies may change formulas or come out with new products, so be sure to keep up to date.

Space does not permit a complete and comprehensive survey of all the popular paints currently available or even every single paint I myself might use. There are whole books devoted to the subject of paint and pigment, and since we all have different likes and dislikes there are also sometimes differences of opinion regarding the usefulness of any one particular paint.

Following is a list of paints that have a wide range of useful characteristics and are permanent for artistic use. There are also a few popular paints listed that I recommend you stay away from. This list is not meant to be comprehensive or to include every excellent and popular paint currently available. You might not even see a personal favorite, but every painting in this book can be done with this list of paints.

Color Charts: Yellows and Reds

Lemon Yellow This paint is typically made with either Nickel Titanate Yellow, PY53, ASTM I, semi-opaque or with Arylide Yellow, PY3, ASTM II, semi-transparent. In both forms they are clear, bright paints and very useful.

Cadmium Lemon PY35, ASTM I, opaque is a lovely strong paint and is a bit more saturated and intense than Lemon Yellow. Also sold as Cadmium Lemon Yellow.

Aureolin PY40, ASTM II is a transparent, staining, bright, clean color of medium tinting strength that mixes well or is lovely all by itself.

Gamboge Natural or genuine Gamboge NY24, ASTM V, staining, transparent, though popular, is not recommended because it is highly fugitive. Try substituting New Gamboge or Gamboge Hue or any other medium deep transparent yellow.

Cadmium Yellow The three Cadmium Yellows, light, medium and deep, are typically made with either Cadmium Yellow Light,

PY35 or Cadmium Yellow Medium, Deep, PY37. All of these colors are strong, opaque, semi-staining and very useful. Check the label carefully, though, because paints with this name are frequently mixed with other pigments and may not produce the expected results.

Cadmium Orange PO20, ASTM I, opaque, semi-staining has the same properties as other Cadmiums. I find it easier to simply mix Cadmium Yellow and Cadmium Red together to make it.

Cadmium Red Cadmium Red Light, Medium and Deep are known in the color index as PR108, ASTM I, semi-opaque, semi-staining. Many popular reds are not permanent. Rose Madder, Vermillion and even Alizarin Crimson cannot be relied upon to stand up to strong light. All the Cadmium Reds are permanent, but they are a yellowish opaque red that may not be the right hue in every circumstance. They are also all quite similar so I would suggest you only need one.

Alizarin Crimson Even though Alizarin Crimson PR83:1 is a transparent red that is quite popular, it is only moderately durable, especially in thin washes. I would recommend the following as possible alternatives.

Quinacridone Red There are three pigments with the name Quinacridone Red: Quinacridone Red PR192, Quinacridone Red Y (Yellow PR209) and PV19 Yellow Form. They are all ASTM II and are bright, clean, transparent and semi-staining. They are all bluish reds that are excellent substitutes for fugitive colors like Rose Madder, Carmine and Alizarin Crimson. They are sold under various names like Permanent Rose, Permanent Carmine or sometimes just Quinacridone Red.

Quinacridones

Quinacridones are part of a family of colors that are referred to as synthetic-organic pigments. (How's that for an oxymoron?) These and many other synthetic-organic pigments were first discovered as a result of coal-tar distillation. When the various chemicals that result from this distillation are re-combined they can create a variety of colors that represent most of the colors found on the color wheel. Early examples like Alizarin Crimson are not considered permanent, but virtually all of the more recent examples of the Quinacridones are completely permanent and safe for artistic use. Quinacridones are sold under a variety of trade names. For example, Permanent Alizarin Crimson (a replacement for traditional Alizarin Crimson) and Permanent Rose are both Quinacridones.

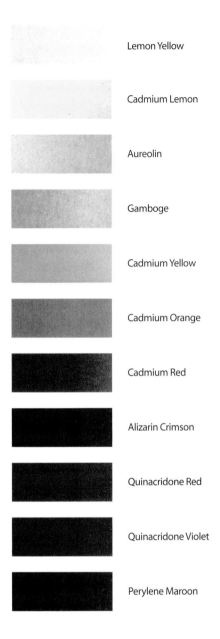

Lemon Yellow

Cadmium Lemon

Aureolin

Gamboge

Cadmium Yellow

Cadmium Orange

Cadmium Red

Alizarin Crimson

Quinacridone Red

Quinacridone Violet

Perylene Maroon

Quinacridone Violet There are two forms of color with the color index designation of PV19. Quinacridone Violet is PV19 blue form and Quinacridone Red is PV19 yellow form. They are both bright and transparent with an ASTM rating of II.

Perylene Maroon Perylene Maroon PR179, ASTM I, transparent has the look of Burnt Alizarin Crimson or Quinacridone Burnt Scarlet. It is semi-staining and brushes out beautifully. Many companies make a good example of this paint.

Color Charts: Blues and Purples

Cobalt Violet PV14, ASTM I, though permanent, has a very low tinting strength. Its toptone appears completely opaque but brushes out to be semi-opaque to semi-transparent. It is granulating and slightly pink. I use it sparingly, in little touches here and there, as an accent color. It is a little gummy, though, and therefore doesn't mix well.

Dioxazine Violet PV23, transparent, staining has a deep, dark toptone and a rather strong tinting strength. This is a rather controversial color. You may find it absolutely maligned by some authors. Winsor and Newton's version "Winsor Violet Dioxazine" is rated A or Permanent and suitable for artist's use by their chemists. And I must say that after leaving a swatch of it half covered in my studio window for nearly a year, I have found no detectable light fade. I also find it to be easy to work with and it mixes very well with other colors.

Ultramarine Violet If you are uneasy about using Dioxazine, PV15 may be a useful alternative. I find it to be a bit dirty and rather dull for my taste in many applications and it lacks the depth and glow of Dioxazine. However, there is no controversy about its permanency and it is rated ASTM I.

Ultramarine Blue PB29, ASTM I, non-staining is a very useful blue. Most manufacturers make an excellent Ultramarine Blue.

Cobalt Blue PB28, ASTM I is semi-transparent and slightly granulating. Many artists absolutely adore Cobalt Blue. In terms of hue it is somewhat similar to Ultramarine. It is softer than Ultramarine but is much less intense, with a lower tinting strength. If you wish, you could approximate the look of Cobalt Blue by simply thinning Ultramarine Blue down.

Cerulean Blue PB35, ASTM I is opaque, non-staining, of moderate tinting strength, and granulating in its initial washes, but will become quite smooth with repeated applications. It has lots of body. Many companies make excellent examples of Cerulean Blue, but check the label. Not all paints labeled as Cerulean Blue are actually PB35.

Manganese Blue Manganese Blue is referred to as PB33, ASTM I and is transparent and non-staining. This paint has a strong, bright greenish-blue hue that may seem very seductive. But every example I have tried is rather gummy and does not mix well with other colors. It can be used as a finishing touch on top of other colors or by itself as a single wash, but I would never put it down knowing that there were to be several other layers of color yet to come. As a substitute, I recommend a mixture of Phthalocyanine Blue PB15 and Phthalocyanine Green PG7.

Phthalocyanine Blue PB15, ASTM II, transparent, staining is a deep, rich, luminous color that brushes out to a lovely and light greenish blue tint. It is usually sold as Phthalo Blue. (Winsor and Newton uses the name Winsor Blue.) It is hard to find a bad example of this paint.

Prussian Blue PB27, ASTM I is staining and transparent. To my eye this paint tends to be slightly dirtier than Phthalocyanine Blue. It is the most intense of all the blues. Its toptone looks almost black, but when brushed out it too has a lovely light greenish-blue tint. Variations of Prussian Blue are Antwerp Blue and Paris Blue. Both are made from the same pigment but are less intense versions of Prussian Blue.

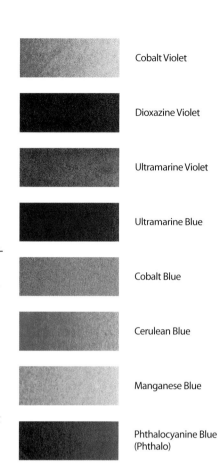

Cobalt Violet

Dioxazine Violet

Ultramarine Violet

Ultramarine Blue

Cobalt Blue

Cerulean Blue

Manganese Blue

Phthalocyanine Blue (Phthalo)

Prussian Blue

Ultramarine Blue

Ultramarine Blue is notable because it can be bleached by weak acids such as lemon juice. Bleaching the paint provides a look on the paper that is softer than masking and is a bit more controllable than scrubbing. English watercolorist John Sell Cotman (1782-1842) would use bleaching as a technique. For example, in a seascape with a ship in it, he would first paint a bold wash of Ultramarine over the sky. He would then bleach out the ship's mast and later apply Burnt Sienna to the mast. If you decide to try this as a technique yourself, beware. The chemical reaction between the paint and the lemon juice will temporarily produce a faint smell of sulfur or rotten eggs.

Color Charts: Greens and Browns

Phthalocyanine Green PG7, ASTM I, transparent, staining is a clear luminous color with a high tinting strength. It has a bluish, almost artificial, look and therefore often needs to be mixed with something to warm it up before attempting to paint something in nature, like foliage. It is commonly sold as Phthalo Green.

Viridian PG18, ASTM I is semi-transparent, non-staining and granulating. A good deal of people love Viridian, but I am not necessarily one of them. It is another bluish green, and because it is less intense and so granulating, I would rather use Phthalocyanine Green instead. If you do choose to use Viridian, choose carefully. There is a wide disparity in the quality of this paint from brand to brand.

Chromium Oxide Green PG17, ASTM I, opaque is a favorite of mine. It is a rich paint with a creamy body that is easy to work with and mixes well with other colors. Most companies make an excellent example of this paint. The literature from one company said that this color was staining, but I don't agree. In my experience this paint actually can be picked up quite easily. The look of Sap Green can be achieved by mixing Chromium Oxide Green with New Gamboge, which is staining.

Hooker's Green PG8, ASTM III is a semi-opaque paint. Traditional Hooker's Green is not really a very good color. However, most companies have reformulated it by mixing Phthalocyanine Green with one of a variety of yellows. These new colors are bright, transparent and look like greens found in nature. They mix well with other colors.

Yellow Ochre True Yellow Ochre PY43, ASTM I, opaque, non-staining is a wonderful and very useful color. It mixes well with other colors, but be careful, many paints labeled Yellow Ochre are really Mars Yellow, PY42. Mars Yellow is not an earth color at all, it is a synthetic color and is transparent. To me it lacks the softness and subtleties available when using true Yellow Ochre.

Raw Sienna PBr7, ASTM I is transparent and non-staining. In terms of hue, it is almost identical to Yellow Ochre. It has a moderate tinting strength.

English, Light and Venetian Red These three colors are basically the same thing, PR101—a synthetic iron oxide. Indian Red is usually sold as a slightly darker variant of PR101. All are ASTM I, opaque, non-staining and easy to mix. For the most part, if you have one, you have them all.

Burnt Sienna For some reason Raw Sienna, Raw Umber, Burnt Sienna and Burnt Umber have the same color index name and number – PBr7. All have an ASTM rating of I. Burnt Sienna is a roasted version of Raw Sienna and has a hue that is virtually identical to Venetian Red except that it is transparent.

Raw Umber PBr7, ASTM I is transparent and non-staining. This brown has the ability to take on some of the color properties of those colors placed around it—be it red, green or yellow. In fact, it is often used as yellow in shadow.

Burnt Umber PBr7, ASTM I, transparent, non-staining is the deepest permanent brown you can buy. Some people use VanDyke Brown instead of Burnt Umber, but beware; Real VanDyke Brown, NBr8, is made from organic matter and is fugitive. Most of the "VanDyke Browns" now available are really either just Burnt Umber or Burnt Umber mixed with some kind of black.

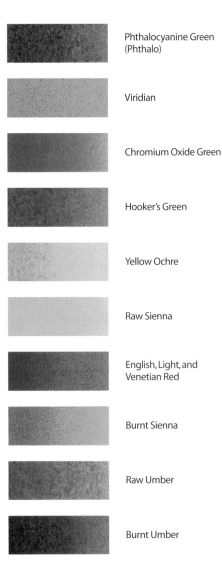

Phthalocyanine Green (Phthalo)

Viridian

Chromium Oxide Green

Hooker's Green

Yellow Ochre

Raw Sienna

English, Light, and Venetian Red

Burnt Sienna

Raw Umber

Burnt Umber

Earth Colors

Earth Colors, also called inorganic or mineral pigments, are among the oldest known pigments. They are usually types of naturally occurring reds, yellows and browns.

Color Charts: Blacks and Whites

Sepia Modern day Sepia is a compound color usually made by mixing either Burnt Umber or Burnt Sienna with some type of black. It is useful when you want a dirty, gritty dark brown like those you might see in a cityscape.

Lamp Black, Ivory Black Lamp Black PBk6, has a bluish cast, and Ivory Black PBk9, has a brownish cast. They are both ASTM I and opaque.

Zinc White PW4, ASTM I, is almost always sold as Chinese White. This color is a soft, smooth paint that mixes well with other colors and can be thinned for subtle mixtures.

Titanium White PW6, ASTM I. This is a stronger, brighter and more opaque white than Chinese or Zinc White, but I find that it makes for harsher, less subtle mixtures than Chinese White.

 Sepia

 Lamp Black

 Ivory Black

 Zinc White

 Titanium White

This complex and unusual painting of two mannequins in a storefront window would have been impossible to successfully paint without a clear understanding of paint and pigments.

NO
20" x 18" (51cm x 46 cm)
Private collection

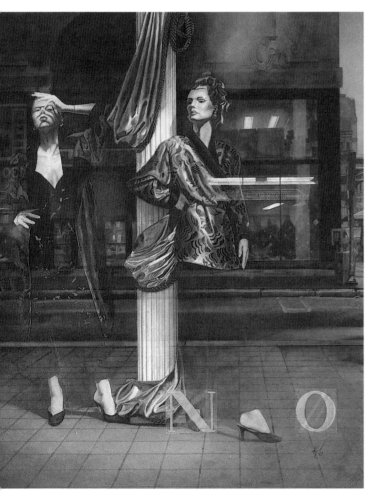

Blacks

I find store-bought blacks to be rather dull in appearance. You can create your own blacks either by mixing two complementary colors or several colors that will give your grays and blacks nuanced subtleties for any situation.

If you do find the need to buy a black the two most common are Lamp Black and Ivory Black. Most other "black" colors commercially available are made from these two.

Grays

All the commonly available grays, Neutral Tint, Payne's Gray and Davy's Grey, are mixes. Each company has its own formula to make grays. Davy's Grey usually has white mixed in. Not all of these mixtures are permanent, which to me seems a bit weird since you can choose just about any combination of colors you want to make mixtures that approximate these colors.

Whites

Typically watercolor is thought of as a medium that gets its special look and luminosity from light passing through layers of paint, hitting the paper and bouncing back out again. Since that is true, some artists therefore suggest that the use of any opaque pigments such as Chromium Oxide Green Cerulean Blue, as well as the use of white, should be avoided. I respect the rights of those artists who wish to incorporate such restrictions into their own work, frequently with beautiful results. But I must insist that to suggest that some colors are inappropriate or incorrect is silly. The interplay of different paint qualities allows the artist greater range and more freedom of expression. That being said, the ill-considered use of any paint may cause unsatisfactory results and the clumsy use of white may stick out like a sore thumb. So if you choose to use white, take proper care to use it subtly and appropriately. There are really only two types of white commercially available in watercolor.

Brushes

Besides paint, other indispensable materials you need are brushes, paper and some sort of drawing implement.

Let's begin with brushes. One of the keys to painting successful watercolors is water control, and this is where your brushes come in. Good watercolor brushes are precise instruments that act like an extension of the artist's arm and hand and give you freedom and control to express yourself in your painting.

These precise instruments can be a bit pricey, so before you part with your money it's worth your time and effort to learn something about their various characteristics and capabilities.

The two most common shapes for watercolor brushes are *round* and *flat*. Both can be made with either natural or synthetic hairs. I recommend that when purchasing brushes for critical, fine detail work, you go to the extra trouble to visit your local art supply store and test the brush before purchasing. Most good art supply stores are more than willing to assist you with this.

Round Brushes

Round brushes are made from several materials, including lesser grade red sable, pure squirrel hair, synthetic hair and a combination of natural and synthetic hairs.

Each type has its use and I encourage you to experiment with each of them to find the ones that best meet your needs.

Most watercolorists consider the finest brushes to be those that are made with kolinsky sable. A good round kolinsky sable has a beautiful point and is highly absorbent. It has exceptional spring and will readily release paint to paper. They are the best tool you can use for fine detail work. Kolinsky brushes are typically handmade and therefore quite expensive. Because they are handmade, in spite of the maker's best efforts, there can be some variation in performance from brush to brush.

Experiment with and try a variety of brushes, you too will soon have favorites.

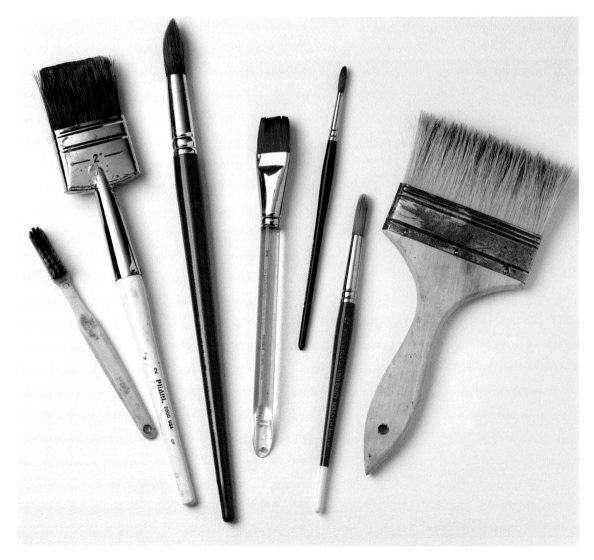

Synthetic brushes do not come to a point as well as natural hair brushes. They also absorb and release less liquid than natural brushes do. This is because natural hairs have lots of little quills on them that create more surface area and aid in the absorption of liquid. Synthetic hairs are smooth and monolithic but they have excellent spring and hold up very well.

Several manufacturers make excellent brushes. I personally use several different brands.

Each make has slightly different characteristics, and over time you will find the brands that you like best. Variations in characteristics do not necessarily translate into variations in quality. Some artists prefer a soft brush to a springy one. (I personally prefer a combination of good spring and good absorption for most of my brushes.) Good and less expensive alterna-

Testing New Brushes

To test a new brush, first jiggle it in some clean water for a few seconds to remove the sizing. Then take the brush and snap or flick it. If the hairs flop over to one side it means the brush does not have sufficient spring—move on to test another brush. If the second brush doesn't flop over, jiggle the brush in the water again but this time twirl or twist the handle between your thumb and forefinger along the back of your other hand to determine whether it has a good point and holds its shape. Then tap the brush on that same part of your hand to feel if it has good spring and bounce. If it does, you've found your brush.

tives to kolinsky sable with the qualities I prefer are natural synthetic blends. Several companies make these brushes as well. They typically have a golden look to their hairs.

Round brushes range in size from the ultra-small size 000 to as large as size 38, (which is so large you might even need two hands to pick it up). For general purposes I recommend using a no. 3 or larger. The smaller brushes do not hold enough liquid and you will either have to re-load your brush too often, or worse yet, you may run out of paint right in the middle of a brushstroke. (In this book, there is only one time when I use a brush smaller than a no. 3, it is a no. 2.)

To start off I would recommend a small, no. 2 or 3 kolinsky sable, a medium, no. 5, 6 or 7, preferably kolinsky sable, and a large, no. 15, 20 or larger, natural synthetic blend. (A kolinsky in this large size can be hundreds of dollars or more.) You can then add other brushes as you find the need. Do not forget to replace old brushes from time to time as they lose their point or wear out. But don't throw the old ones away, they can also have a use.

Flat Brushes

Generally, flat brushes come in sizes that range from about $^1/_4$ inch (6mm) to about 3 inches (75mm), sometimes more. They are made with a variety of materials, kolinsky sable, sable blends, synthetics, squirrel, even badger and ox hair. Flat brushes can be soft and fuzzy or have sharply cut

edges. Among other things, they are extremely useful for doing broad washes. Many watercolorists use them almost exclusively. I have several flats but there are three that I use most often. First is a 1-inch (25mm) golden nylon with a beveled handle. Next is a 2-inch (51mm) badger hair brush, and the third is a 4-inch (10cm) bristle brush that I picked up for a few bucks at the hardware store. In fact, when it comes to large, flat wash brushes, I've found that there are many inexpensive options for the watercolorist to use, one such example is a gesso brush.

Brush Strokes

There is a connection between the size and shape of your brush, the way it is best used and the resultant brush strokes. Small round brushes are often best manipulated by movements of the wrist, hand and fingers. These brushes are often used while the artist is sitting down and the resultant brushstrokes are best used for fine lines and detail. Larger rounds and most flats are often better manipulated by movements that come from the elbow and shoulder. They are often used when the artist is standing up and the resultant brushstrokes tend to be larger and bolder.

Other brushes that can be useful to create a variety of textures include oil painting bristle brushes of various shapes and sizes, which are good for scrubbing in color, and old toothbrushes, which are useful for spattering.

Paper

When light hits paper its texture is illuminated, adding an element of sparkle that contributes to the overall effect of your painting. Watercolor paper is typically available in three different textures: *hot-pressed* (smooth), *cold-pressed* (medium) and *rough*. It is also available in several different weights ranging from about 70 lb. (150gsm) to 140 lb. (300gsm) to 300 lb. (640 gsm) and more. The numbers refer to the weight of a ream (approximately 500 sheets) of 22" x 30" (56cm x 76cm) (Imperial size) paper. It is sold in blocks or in individual sheets, both of which are available in various sizes. It is also available in rolls that measure 44" x 10 yards (112cm x 9m). There are several excellent watercolor papers on the market with different characteristics that respond to different ways of painting. It is important that the paper you choose be acid-free.

Most artist quality papers are made of 100% cotton rag and are acid free, archival and of random texture. I have tried a number of them. Winsor and Newton, Lana and Saunders Waterford are all excellent papers that I can recommend, but my favorite is Arches. I like to use cold-pressed paper, usually 140 lb. (300gsm). I also keep some 300 lb. (640gsm) cold-pressed paper on hand for some of my larger paintings. Arches cold-pressed paper has just enough texture of its own to help me get the textural effects I am looking for without being so rough that it impedes the subtle effects that I also like. I like the way colors seem to have a little more sparkle to my eye on cold-pressed paper as compared to hot-pressed.

Dry watercolor paper taped and stapled to a board.

Paper Preparation

In preparation for painting, it is extremely important that you properly secure your paper. Many beginners skip this step thinking that it is too much bother—that is a big mistake. Properly securing your paper before the painting process prevents the paper from moving or buckling in some unpredictable way, which always seems to happen at a critical point in the painting process. This in turn could completely ruin your watercolor.

Over the years I have tried several different methods of preparing watercolor paper for the painting process. One popular method is to soak the paper in a tub and attach it to a board either with moisture activated packing tape or by stapling the wet paper to a board and then letting it dry. Having used both methods in the past I now find it simpler and less messy to tape and then staple dry paper to a board with a standard office stapler. To do this, first select a drawing board that ideally is square and several inches larger than your paper. I have maybe a dozen boards of different sizes. All are made of wood and are either solid or hollow-core luan drawing boards. A few are made from plywood, but sometimes plywood can be difficult to staple into.

Square your paper to the board using a T-square then attach it to the board with white artist's tape. Staple the paper through the tape at close intervals so that it remains completely flat during the painting process. I follow this procedure even if the paper I am using has come from a block. Remember, whether you use this method or another method to secure your paper, it is essential that you properly secure your paper before painting.

Drawing Implements and Other Materials

Drawing Implements

Artist's pencils usually are available in approximately 17 different grades of hardness, typically ranging from 6B—super soft, to 7H—extremely hard. I like an F-grade pencil, which is right in the middle, for sketching and a slightly harder, 2H, for more intricate drawing. If you like to draw over previously painted surfaces, you may find some of the harder H-grade pencils useful, as the extra hard leads in these pencils produce lighter, finer, more delicate lines on previously painted surfaces than the softer pencils.

Other Materials

Here are some of the other materials and supplies I use regularly for drawing and painting. Many of them will be discussed in more detail later in this book.

T-square This is handy when drawing true vertical and horizontal lines such as those found in architecture.

Triangle This can be used as a straight edge and for such tasks as finding vanishing points.

Compass-divider This is useful when laying out objects at regular distances like clapboards or bricks and for drawing true circles.

French curve I use french curves to draw irregular lines.

Palettes I have several palettes with wells of different sizes and shapes that I use for various purposes.

Masking solution and frisket paper
Masking is discussed thoroughly on pages 54 and 55.

Kneaded eraser Use this to make drawing corrections.

Pink Pearl eraser This can be used to erase non-staining colors. It is not advisable to use this to make drawing corrections because it may damage the paper.

Soft absorbent paper towels For wiping excess paint from your brush before application, blotting, etc.

Hair dryer I have heard some artists say that using a hair dryer will deaden the color on your painting. Personally, I have never known this to be the case and find a hair dryer to be an absolutely indispensable tool. In fact, a hair dryer was used frequently during the painting process for every watercolor and demonstration seen in this book.

Single-edged razor blades I use these to sharpen my pencils and to sometimes pick out highlights on a painting.

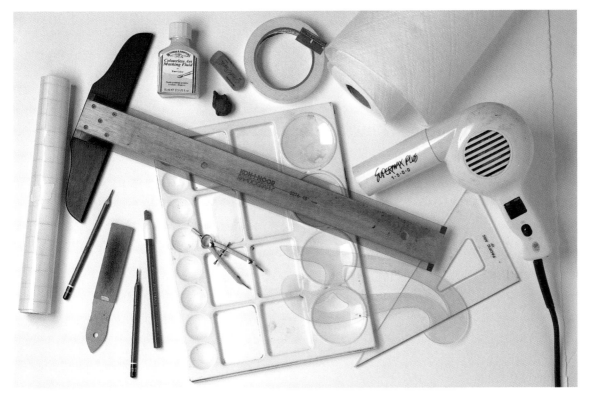

You may find you have many of these recommended materials already on hand.

2

The Basics of Drawing and Composition

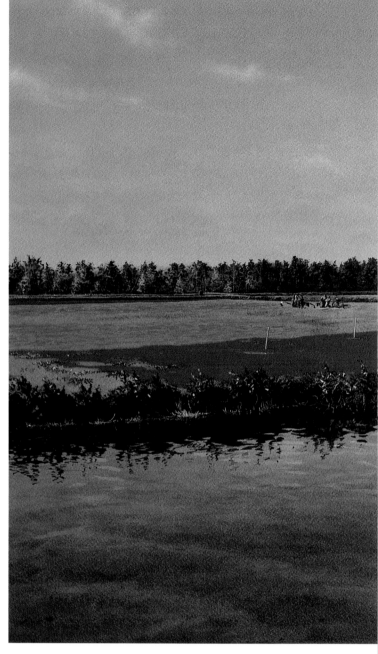

Two basic aspects of any painting are drawing and composition.

Drawing is simply how the artist describes an object's shape or form on a flat surface. Good drawing skills are extremely important when doing realistic watercolors. Yet most artists are not born with an innate ability to draw well. Fortunately there are techniques the artist can learn in order to develop good skills.

Composition is different from drawing. It is the organized arrangement of all the elements in your painting. The simplest shapes can be arranged in such a way as to create a satisfying composition. Conversely, an accurate drawing may not necessarily have a good composition. When combined, good composition and skillful drawing present the elements of your painting in a way that is pleasing to the eye and easy to understand.

This chapter will discuss specific drawing techniques and principles of composition that will help make your watercolors more powerful and easier to execute.

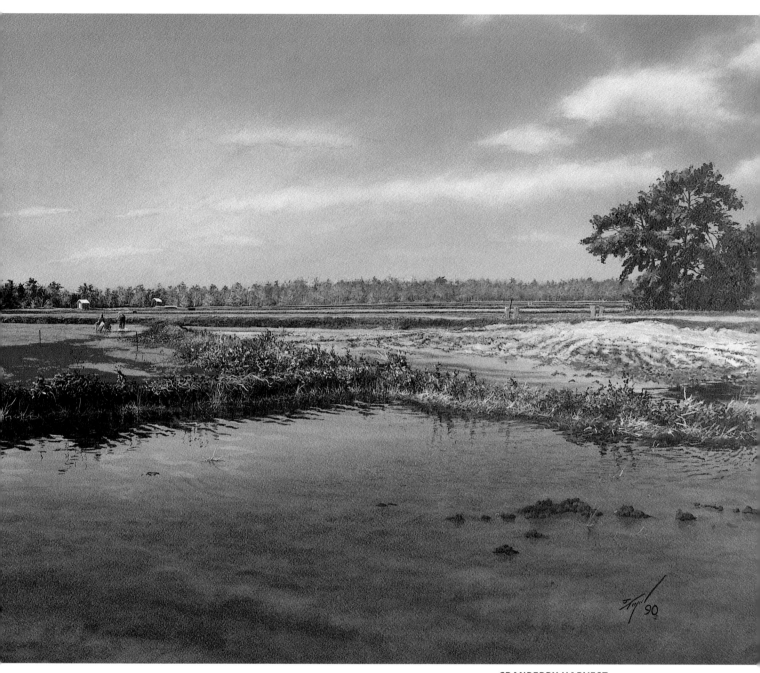

CRANBERRY HARVEST

15" x 29" (38cm x 74cm) • Collection of the artist

Value

Creating a three-dimensional illusion of space and distance is a basic fundamental of drawing. To accomplish this the artist needs to understand various aspects of two concepts, *value* and *perspective*. To draw or paint an object, you must describe it's shape and form using changes in value. Understanding value, combined with good drawing skills, can help to give your work dimension.

Value

Value refers to an object's degree of lightness or darkness and is measured on a gray scale that runs in increments from white to black. A gray scale can have as few as two increments, white and black, or could theoretically have an infinite number of increments. Some artists like to use only five; others may use 100 or more when creating more complex and nuanced paintings. I recommend that you start with nine: three light values, three mid values and three dark values. A value scale will help simplify and organize your thinking.

Relative Value

Every object has a relative value—it's value relative to it's surrounding. For instance, a white car in deep shadow may appear darker than it actually is. Instead of it being a 1 or a 2 on the value scale of 1 to 9, the shadow could make it appear as a 6, 7 or 8. Conversely, a black car in direct sunlight may appear lighter than it actually is. Instead of appearing to be a 9 on the value scale, the surrounding light may make it appear more like a 5 or 6.

Tonal Value

Colors themselves each have a value—a tonal value. For example, Lemon Yellow has a relatively light tonal value, while Cadmium Red has a surprisingly deep tonal value. When Prussian Blue is right out of the tube, its tonal value is so deep that it reads as black. See *The Color Wheel* on page 12 for more information.

When you look at a black and white photograph, you can clearly see how colors break down into their component values. In the case of a graphite drawing, the artist determines the tonal value and assigns a specific value to the subject. Refer to the color wheel on page 12 to see how that group of colors ranges in tonal value.

Nine Step Gray Scale

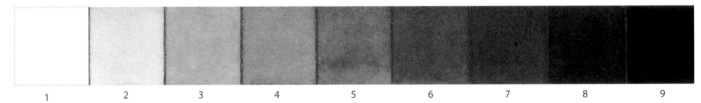

| 1 | 2 | 3 | 4 | 5 | 6 | 7 | 8 | 9 |

Squinting

If you have trouble determining the tonal value of your subject, try squinting your eyes. When you squint your eyes you slightly darken what you are looking at. You also increase visible contrast and eliminate superfluous detail. Squinting at your painting will also help you determine if the values already on your painting are correct or if they need adjustment.

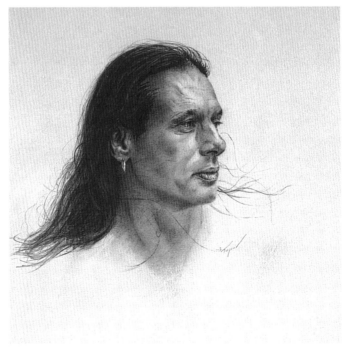

Values In a Drawing

This graphite drawing of my friend and fellow artist is a good example of how a value scale can help to determine and assign value to a subject.

BRUCE STUART
14" x 11" (36cm x 28cm)
Collection of the artist

Linear Perspective

Have you ever tried closing one eye, and with your arm out straight, covering up an object at a distance with your thumb? If so, you already have a sense of how linear perspective works. Even if that object is as big as a house, because of its distance from you, your thumb may actually appear larger than the object because your thumb is closer to you.

Linear perspective refers to a system of applied geometry designed to allow us to depict three-dimensional objects around us on a two-dimensional flat surface. Linear perspective makes objects appear larger when they are closer to you and smaller as they recede into the distance. Linear perspective is used in virtually all forms of realistic painting to create a sense of depth and scale. A few simple rules will enable you to draw in linear perspective accurately and easily.

The Vanishing Point

With linear perspective you can create the illusion of parallel lines in a three-dimensional space. The lines are actually not parallel at all, they are drawn on a flat surface at an angle. However, they are drawn so that they appear to be parallel in space as they recede into the distance converging at specific points called *vanishing points*.

Vanishing points almost always occur on the horizon line. When using linear perspective in a painting the artist must first determine the position of the horizon line and then draw it. Occasionally it is easy to actually see the horizon line. For example, when you are sitting on a beach looking out at the ocean, the line where the sky and the water meet is obviously the horizon line. But in many instances you cannot see it because

your view is blocked by obstacles such as trees or buildings. Eliminate this problem—regardless of your view or viewing position—by always drawing the horizon line at your own eye level.

The Picture Plane

A *picture plane* is an imaginary flat plane, kind of like an imaginary pane of glass through which the actual three-dimensional objects in life are viewed. If you were to look out a window and

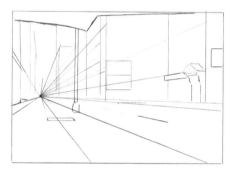

trace on the glass the objects you see just the way they appear, the result would be a drawing on the glass done in linear perspective. The window has become the picture plane.

You may also think of the picture plane as the surface of your paper up to and including the outer edges of your drawing. The artist draws on the paper, varying the size of the objects according to how near or far those objects are from view.

Simplifying Linear Perspective

This simple schematic clearly depicts one-point linear perspective as it applies to this painting.

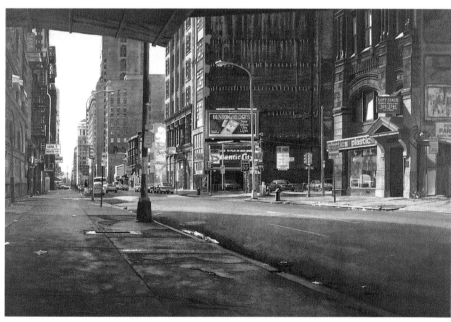

Paint Realistically Using Linear Perspective
Linear perspective is not only employed when drawing the geometric shapes found in a city, but is also used in depicting the illusion of distance, regardless of the subject.

ARCH STREET
14" x 20" (36cm x 51cm) • Collection of the Woodmere Art Museum

One-, Two- and Three-Point Perspective

Linear perspective is drawn in either one-point, two-point, or occasionally three-point perspective.

One-point Perspective

In *one-point perspective*, objects are oriented in such a way that one of the visible planes is parallel to the picture plane and is therefore literally parallel to the vertical and horizontal edges of your watercolor. The lines that occur on this plane don't recede to a vanishing point. The lines making up the other visible plane or planes do recede to a vanishing point or points along the horizon line.

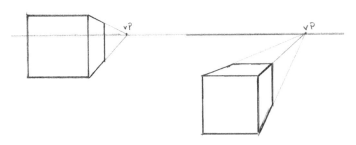

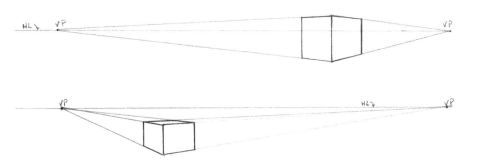

Two-point Perspective

In *two-point perspective* objects are oriented so that all the visible planes recede to separate vanishing points. Usually only the vertical lines are parallel to the picture plane in two-point perspective.

Using a Drawing Frame or Viewfinder

When we look at the world through both eyes we see the world with binocular vision and objects appear three-dimensional. When working from nature, to help you imagine the two-dimensional world of your drawing, close one eye and look through a rectangular hole cut in a piece of wood or matboard. This device is called a *drawing frame*. Using it will help you determine your picture plane. Furthermore, a grid of wires or threads can be attached to the drawing frame and a corresponding grid can be transferred to your paper to aid in your drawing. A drawing frame can also be made adjustable to change the ratio of height and width.

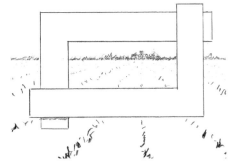

Three-point Perspective

In *three-point perspective* none of the planes or lines depicted are parallel to the picture plane. Objects are oriented such that the planes vanish to three separate points, two of which occur on the horizon line, but one of which does not occur on the horizon line. I personally find three-point perspective to be the least useful of the three types of linear perspective when painting realistic watercolors. It is often only used for stylistic reasons and was only used once in this book, on page 43, in the painting *Drive In*.

Legitimate Construction

Legitimate construction was first used during the Renaissance. With legitimate construction the artist attempts to create the illusion of space and distance while strictly adhering to the geometric principles of linear perspective.

Static Perspective

The principles of linear perspective can be applied to drawing virtually anything you can imagine and are an extremely valuable tool for the artist. However, it is sometimes felt that when the rules of linear perspective are too strictly adhered to that the result may appear to look a bit stilted. Even artists like myself who find linear perspective to be invaluable, may take liberties with its use. Static perspective is one such example.

In linear perspective theoretically all the visible planes vanish to a vanishing point. Normally these points are on the horizon line, but not always. For example, say that you want to draw the shingles on a gabled roof of a building. The two lines that make up the horizontal sides of the roof plane would vanish to a point on the horizon line the same as the walls of the building. It is therefore easy to determine the top and the bottom of the shingles, but the two lines that make up the vertical sides of the roof would, in legitimate construction, vanish to some undetermined point in the sky. This is where static perspective comes into use. In this case, the two vertical sides of the roof are drawn literally parallel to one another using a triangle and a piece of matboard that has been cut in half to line up the two sides. You then draw all the vertical lines of the shingles at the same angle. They will appear to have been drawn in perspective. This technique makes drawing a complicated pattern set at an angle much easier.

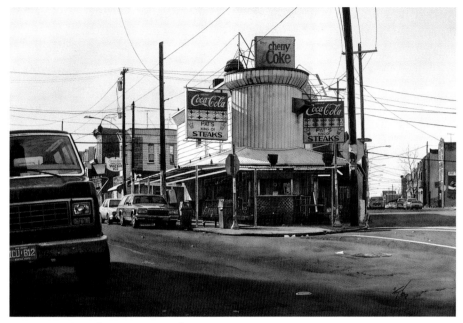

Incorporating Linear Perspective

Pat's is an interesting example of how a number of principles in linear perspective come into play. Some of the elements in the painting are drawn in one-point perspective. Others are drawn in two-point perspective. The building itself sits on a triangular lot. Linear perspective is essential in drawing its unusual shape. Finally, notice that the horizon line is below the street (visible on the right). This suggests that the streets in this painting are on a slight incline.

PAT'S
22" x 30" (56cm x 76cm) • Private collection

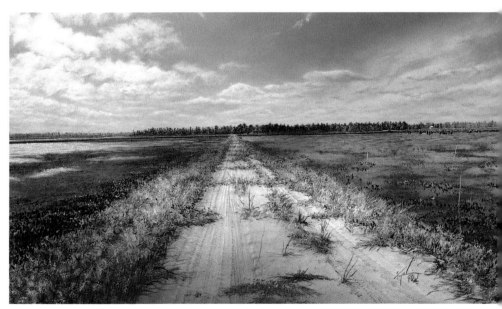

The Illusion of Distance

Linear perspective is not only employed when drawing the geometric shapes found in a city, but is also used to depict the illusion of distance.

CRANBERRY BOGS
18" x 30" (46cm x 76cm) • Private collection

Aerial Perspective

The term *aerial perspective,* (which is said to have been coined by Leonardo da Vinci), is also referred to by the more descriptive term *atmospheric perspective.* Aerial perspective refers to another way we perceive objects as they recede from view. When used in conjunction with linear perspective, aerial perspective enables the artist to create the illusion of distance.

Here are several principles that will help you to create a feeling of depth in your paintings:

Atmosphere affects the way we perceive value. As an object moves away (the distance increases) the visible contrast between light and dark decreases. For example, close-up, an object appears black and white, far away, it appears gray.

Atmosphere also has an effect on how we perceive color. The dynamic range of color is replaced by ever-cooler colors. Close-up, an object's color might be intense and brilliant, but far away, color becomes less intense—cooler.

Aerial perspective affects how we perceive detail and surface texture. As the illusion of distance increases, the need for detail and surface texture in a painting is diminished.

Generally, the effects of aerial perspective are less noticeable on bright clear days with low humidity and more noticeable when there is more moisture in the air.

However, to enhance the feeling of depth in your own paintings, I would recommend applying the principles of aerial perspective even when painting bright clear days.

Man in White Shirt and Black Pants Illustration

See this fellow in the white sweatshirt and black pants? As he walks away from you, not only does he appear smaller, but because contrast between light and dark decreases as distance increases, his shirt will appear grayer and his pants will appear lighter.

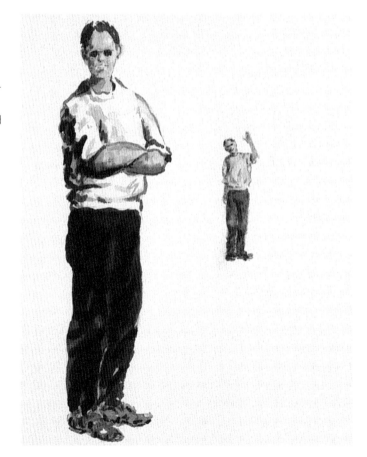

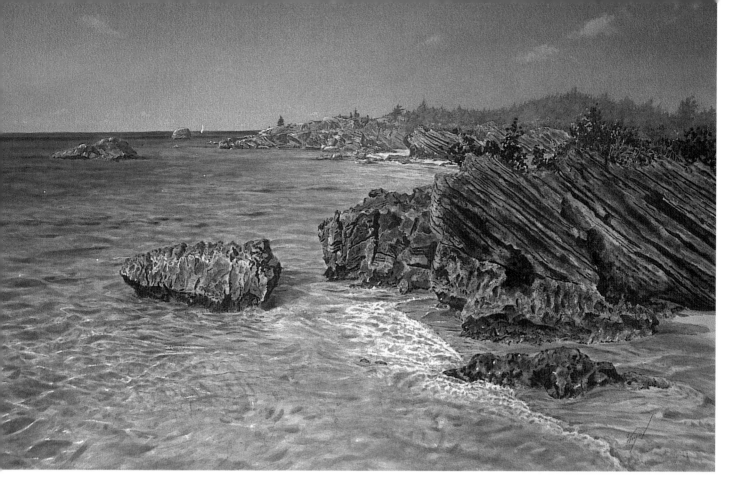

Using Aerial Perspective

The use of aerial perspective in this painting enables the viewer to clearly see three distinct zones of recession. In the foreground both the rocks and the water display a dynamic range of color and detail. As your eye moves to the middle ground, the rocks decrease in size, the contrast in the rocks is diminished and their color becomes bluer. As your eye moves to the background, contrast and size have further decreased. The relatively warm tones of the foreground rocks have been replaced almost entirely with a gray blue color.

CHAPLIN BAY

13" x 20" (33cm x 51cm) • Courtesy of Windjammer Gallery

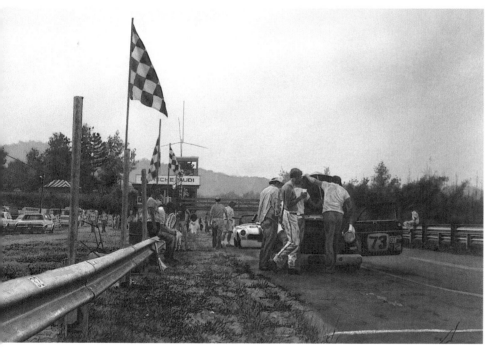

Combining Linear and Aerial Perspectives

Linear and aerial perspectives combine to produce a dramatic sense of space and depth in this painting. The sense of linear perspective begins with the arnco barrier, rushing from its position in the lower left of the watercolor towards its vanishing point. This line is repeated and complimented by all the other linear elements in the painting, the edge of the asphalt, the flags, even the people. Scale is diminished as distance increases. The feeling of depth is enhanced by the misty trees in the distance and even more so by the hill in the background which is represented by a single gray contour.

PIT LANE

13" x 20" (33cm x 51cm) • Collection of the artist

Composition

As stated earlier, *composition* is the organized arrangement of all the elements in your painting. Light and texture are only two of the factors to consider when designing your composition. Shape, color and line are also factors that come into play when composing a painting. A good composition provides a clear and logical structure that visually communicates to the viewer, in a way that is easy to understand and pleasing to the eye. When making a successful painting, good composition is more fundamental and in many ways, even more important than,

accurate drawing. (This can be seen in some forms of abstract painting where drawing isn't even involved.) Good composition however, is essential in all forms of painting, including beautifully drawn, representational watercolor.

When approaching a new subject, among the first things to consider are the size and shape of the painting. It is a good idea to begin by doing some *thumbnail sketches* (small, rough, preliminary sketches) to work out the basic dynamics of your painting.

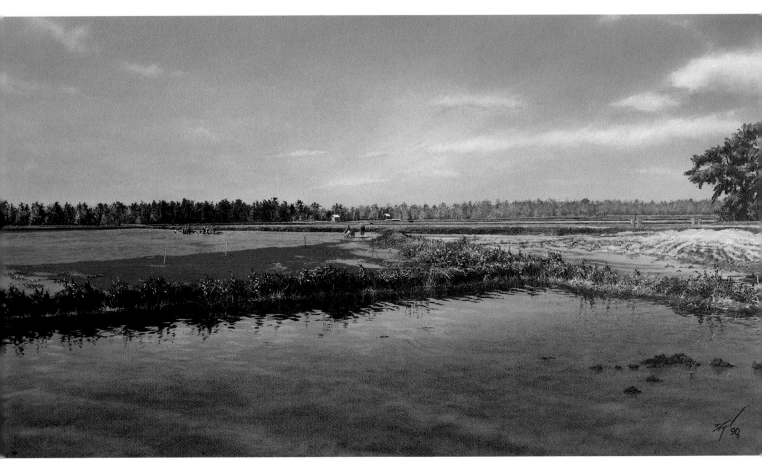

Using Composition

This painting depicts the autumn ritual of the wet harvest of cranberries. The feeling of expansiveness in this painting is reinforced because of the elongated horizontal proportion of the painting. The directional lines of the bogs carry the eye from the foreground deep into the distance and support the feeling of deep space. Even the clouds are arranged in such a way as to imply a sense of depth and eye movement.

CRANBERRY HARVEST

16" x 30" (41cm x 76cm) • Collection of the artist

Size and Shape

Size is certainly an important element in a painting. Have you ever seen a painting in person that you had previously only known from books, and been surprised by its size? Periodically the painting in question is larger than expected, but frequently the viewer is surprised at how small the painting is. Why does that happen? Anyone who has stood in front of a large imposing painting knows the overwhelming feeling one can get from the experience. But the actual size of a painting is not as significant as the illusion of size and scale that is contained within the painting.

Shape

The shape of your painting is determined by its proportion and its format. *Proportion* refers to the ratio of height to width in your painting. The ratio of a square is one to one. A square tends to be a less dynamic and interesting shape than a rectangle. That is why most paintings are rectangular in shape.

Format refers to whether the shape of the painting is horizontal or vertical. The mere shape of a painting enables the artist to subtly imply a lot about the nature of the subject. For example, the narrow feeling of an alley can be reinforced with a vertical format. You can increase the sense of expansiveness in a landscape with an exaggerated horizontal format.

In the past, certain subjects had specific formats and proportions that were considered the norm. Traditionally the format of a landscape is horizontal. In this format the implied view is from side to side. Today artists do not feel quite as constrained by the use of such strict conventions. A vertical format (which is a bit less conventional) can also be successfully employed for landscape painting. In a vertical format the implied view is frequently up and down. Because there is less of a peripheral view, a vertical format can also invite the viewer to look deeper into the painting.

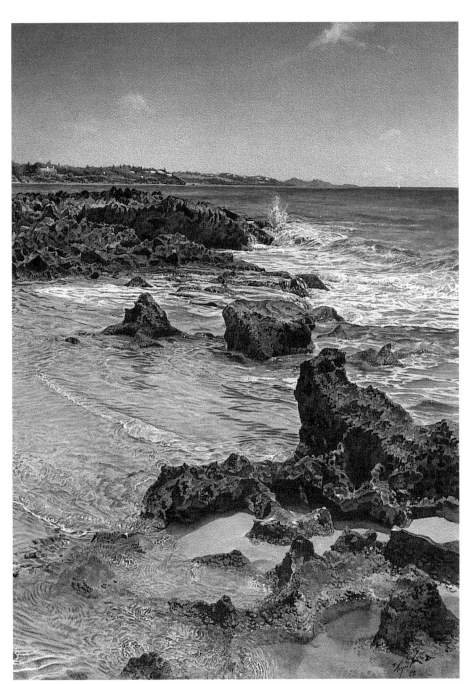

Using Format to Emphasis Your Composition

In this painting, the vertical format helps to carry the eye from the foreground to the action of the waves crashing in the middle ground and finally to the shoreline in the distance. Emphasizing this are the implied directional lines formed by the arrangement of the rocks as well as the movement of the water.

TIDAL POOL
20" x 15" (51cm x 38cm) • Private collection

Balanced Shapes

Even though artists may no longer feel quite as constrained by the conventional use of proportion and format, there are still certain intrinsic qualities about the shape of your painting that should be taken into account. A horizontal shape is considered more soothing to the eye than a vertical. Horizontal shapes are somewhat more passive and vertical shapes tend to be strong and dominant.

Balance

In art, visual balance is seldom symmetrical. Rather, it is a balance of relative weights, or *equilibrium*, of different points of interest positioned in such a way as to move the viewer's eye through the composition.

Division of the Rectangle

Compositional balance can be achieved several ways. One method, dividing the painting equally in half or into quarters, creates a static composition and impedes eye movement within the composition. Thus, it is advisable to not put important elements such as the horizon line or your model directly in the middle of the painting.

In order to allow eye movement and to impart better visual balance to a painting, you'll find it much more interesting to divide the composition into three or five equal parts, as shown below. You will find these two methods give you more compositional choices that invite eye movement.

Experiment with other ways of dividing your composition but keep your center of interest out of the absolute middle of your painting.

Equilibrium

Equilibrium is the state of balance between opposing forces. Equilibrium creates stability in a painting but it is not static. It is dynamic and encourages eye movement throughout the painting.

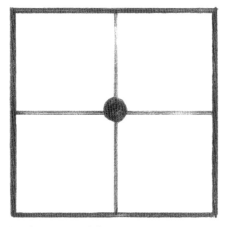

Static Composition
The equal division of a square painting is symmetrical and static. Putting the horizon line in the dead center can hurt the visual balance of your composition.

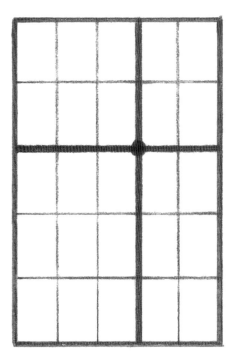

Five-Part Compositional Division
A 60/40, or five-part compositional division divides the composition into five equal parts both horizontally and vertically. Then the painting is divided into any combination of two and three parts as shown. Offsetting the visual center of your composition immediately invites eye movement.

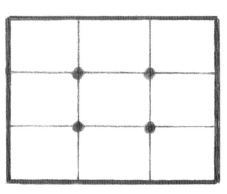

The Rule of Thirds
Dividing the composition into thirds is even simpler and easier than the 60/40, or five-part division. In this case you divide the composition into three equal parts, both horizontally and vertically. When using the five-part or three-part division, locating key objects at the points of intersection will tend to provide greater visual interest.

Conventions on Composition

There are many tricks and techniques you can use to lead the viewer's eye through the painting.

Movement

For a painting to hold our interest, it must have *movement*. In a painting there are two types of movement. The first type is the actual implied movement of objects, like birds flying, waves crashing or flags flying in the wind. But in art the term movement also refers to the way the eye is led through a composition. Virtually any aspect of a painting can be used to create eye movement, such as color, value, pattern or the arrangement of shapes. Even the shape of one particular object in a painting can direct the eye to a specific point and then release it to continue moving through the composition. By simply emphasizing or de-emphasizing a particular aspect of a painting, the artist can either move the eye to a particular point, or past it, as he wishes. Light and texture, can also be used to emphasize or de-emphasize certain areas of your painting. Once you've taken the viewer someplace in the composition, give them something interesting to look at.

Directional Lines

Directional lines also help to create movement. They are actual or implied lines that carry the eye through a composition to areas of interest. They can be anything from a road pointing in a certain direction, or a line of birds flying one way or another, or even the arrangement of cloud formations. Directional lines can be obvious or they can be so subtle that the viewer is visually transported from one place in the painting to another without ever knowing how they got there.

Points of Interest

When your eye moves through a well-composed painting, it will stop at various resting points or *points of interest* (such as the example on the previous page). A painting may have one or several points of interest. When there is more than one point of interest it is a good practice to prioritize them so that they do not compete for attention. When there is more than one equally important point of interest it impedes eye movement and creates an unbalanced composition. The dominant point of interest is also called the *center of interest* and all other points of interest in the painting should be subordinate to it.

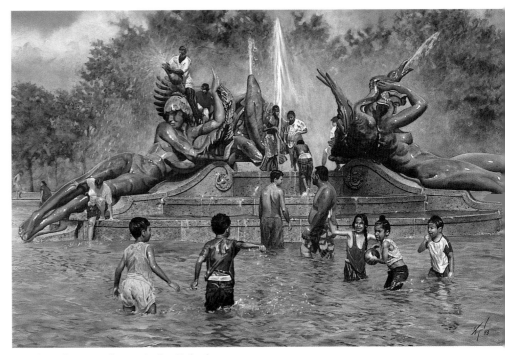

Moving the Eye Through the Painting

This painting is of people gathering at an unconventional spot to cool off on a hot summer day, and is an excellent example of how the eye can be lead through a composition.

The scene is the Swan Fountain in Philadelphia, otherwise known as the Calder Fountain. It was named after Alexander Sterling Calder (1870-1945), father of Alexander Calder (1898-1976), the inventor of the mobile. The painting is about the event, not one particular object. As a result, there is not just one but several centers of interest in this composition.

The primary center of interest is the children playing dodge ball in the foreground. First you see the boy in yellow then quickly move past the other children to the littlest boy to the right, who is perhaps a bit shy about participating in the game. Charming though he may be, his importance in the composition is to carry your eye to the right. Your eye then moves to the left and further back towards the people behind the children. Your eye continues to move up and to the left, up the fountain until you reach the fellow clasping his hands over the fountain spray. The figure of the fountain itself looks down at the person climbing off of the fountain bringing you back to the point where you began.

WATERSPORTS

20" x 29" (51cm x 74cm) • Private collection

Not all of your subjects will have a particular center of interest. However, most paintings do, and once determined, the various compositional tools discussed in this chapter can help you to emphasize your center of interest.

Contrast

There are a number of ways to either emphasize or de-emphasize elements in your composition. One excellent way is with *contrast*. By increasing or decreasing the contrast of an object you can make it more or less important in the composition. Done carefully, elements of a painting can be emphasized while still maintaining the illusion of aerial perspective.

Linear Tangents—Unrelated Lines and Shapes

Have you ever seen a painting (or maybe even painted one) where it looks like something other than hair is growing out of the top of some guy's head—maybe a flower pot, a fountain pen, who knows?

Artists can unintentionally create connections between unrelated objects that can confuse the viewer or break the feeling of balance and harmony in a painting. It is important to be aware of how the lines, angles and shapes in your composition connect and read to a viewer.

When composing a painting, avoid *linear tangents*. Linear tangents are objects in your composition that are just touching, or unrelated lines running into each other. When objects just touch they either act like magnets that repel one another or they draw unnecessary attention to unimportant parts of a composition. Rather than having objects just touching, try to arrange them so that their shapes overlap.

Using the Elements of Composition

This painting illustrates several of the compositional rules and techniques discussed thus far; however, it also bends one. That is, the focal point or the center of interest is the henge itself, but it has been put virtually at the center of the horizon line. The composition still works because the painting also correctly incorporates many of the compositional rules and techniques discussed here.

The composition is divided into five equal parts: two parts sky, three parts land. The same formula was also used to place the sheep at a point of vertical and horizontal intersection. The patterns of light and shadow on the ground add interest to the texture of the grass and rhythmically move your eye from the foreground back toward the henge. The clouds form a series of subtle triangular shapes that create a sense of the volume of the space and, like arrows, gently point directly at the henge. The vertical format helps to focus your eye directly on the henge; and placing the henge in the middle of the horizon line forces your attention to it. The contrast between light and dark also emphasizes the area.

STONEHENGE
15"x 11" (38cm x 28cm) • Private collection

Unrelated lines confuse the viewer because they connect things that should not be connected and disturb the flow of movement throughout the composition. Keep this in mind not only when making your composition, but also throughout the painting process.

Positive and Negative Space

Most people are familiar with the drawing of this well-known optical illusion. When you first look at it you see a young woman, and when you blink your eyes, you then see an old woman. This optical illusion illustrates how we sometimes look at only one part of a picture at a time. The artist's job is to consciously design all of the space within a painting.

In art the term space has several definitions and the way the artist treats the concept of space is important when composing a painting. Space in a painting is more than the illusion of depth or the illusion of distance between objects. Space is also both the area occupied by the objects themselves, the *positive space*, and the space around an object, is the *negative space*. Negative space has its own shape and, in a painting, is just as important as the arrangement of the objects themselves. Like the arrangement of notes and rests in a piece of music, both positive and negative space is necessary for the piece to be complete. Whether you think about it or not, your painting will include negative space. Failure to consider negative space in your composition may result in unintended consequences. This concept is easy to visualize and understand in watercolor painting, as the artist frequently reserves the white or light areas, painting the space around objects (the negative space).

Cropping

Occasionally. even after the most careful consideration, there might be something about your painting that seems wrong. Sometimes the solution is as simple as cropping the painting. For example, after I finished the painting *Vestibule*, I realized that my eye wasn't easily moving out through the door and into the rest of the composition; there was too much focus on the floor. The solution to the problem was actually quite easy. Cropping a little off the floor lessened the focus on it, releasing my eye to move throughout the composition. Compare the cropped and uncropped images.

VESTIBULE
21" x 15" (53cm x 38cm) • Private collection

3

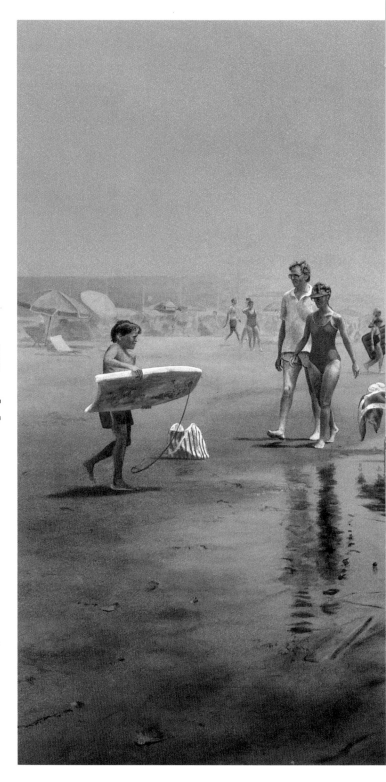

Keys to Creating Qualities of Light

There are many issues for the artist to consider when dealing with the effects that result from the ever-changing qualities of light. Each lighting situation is unique and will reveal different information the artist can use about the characteristics of form, color and texture in a painting.

This chapter will illustrate specific issues and challenges the artist faces when dealing with several different qualities of light. It will look at various circumstances that affect both light and texture and will give you key insights as to how you may successfully create these different qualities of light in your own work.

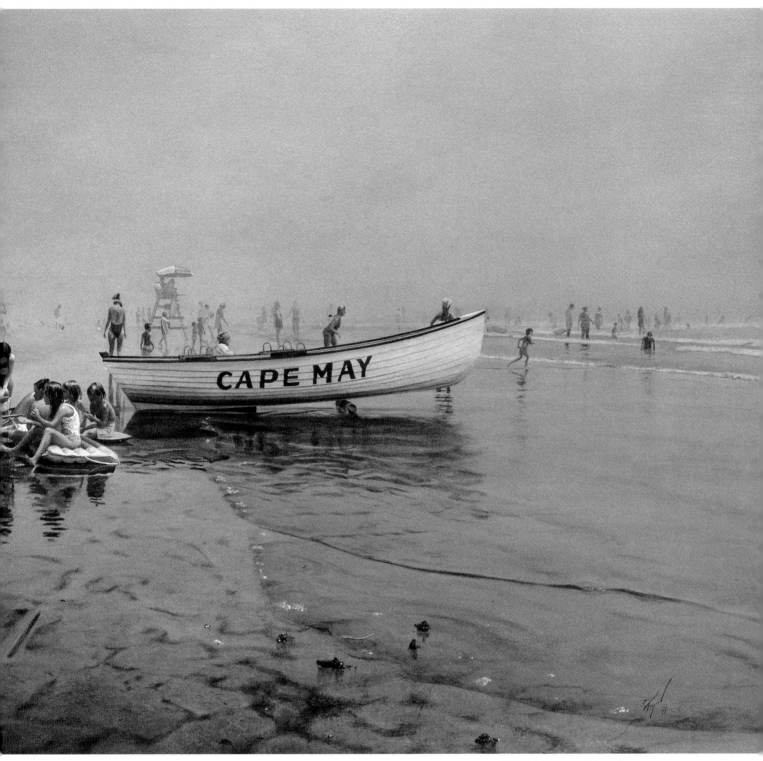

MISTY BEACH CAPE MAY
19" x 30" (48cm x 76cm) • Private collection

Bright Natural Light—Simple and Direct

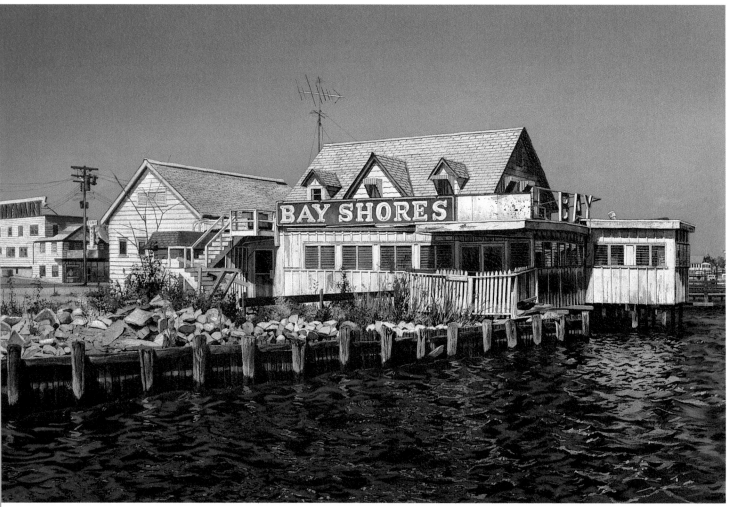

BAYSHORES
14" x 20" (36cm x 51cm) • Private collection

A change in plane is a change in value. That was one of the first lessons I ever learned about how an artist describes a three-dimensional object with a single source of light. In *Bayshores,* the changes in tonal value are clearly visible throughout the building, especially on the gabled roof. This simple direct lighting, typical of many landscapes, is useful to the artist and popular with those who are just learning how to capture a feeling of light because it clearly describes the change in value. Visual interest is enhanced by the cast shadows. The light clearly reveals the surface texture of the objects contained within the painting.

The key to successfully capturing this brilliant, strong light is to make the tonal value of the sky dark enough—somewhere in the middle of the gray scale—so that the building looks bright and sunlit in contrast to the sky. The cast shadows are significantly darker still. The contrast of these three values—the building, the sky and the cast shadows—creates the feeling of bright sunshine.

Chiaroscuro

Chiaroscuro, pronounced either ki-a-ro-skú-ro or skyur-o-skuro, comes from the Italian *chiaro-*clear, light and *oscuro-*obscure, dark. The term refers to the dramatic use of light and dark in a painting where the contrast between the two is extreme, such as in the work of Rembrandt and Caravaggio.

More Complex Natural Light

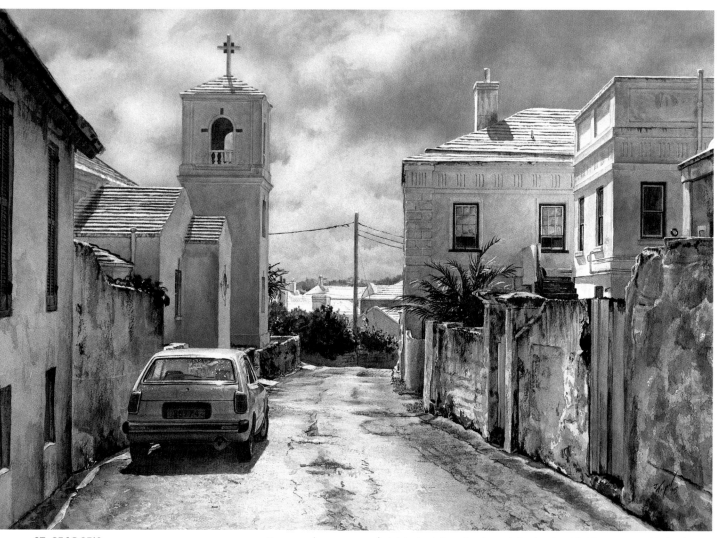

ST. GEORGE'S
14" x 20" (36cm x 51cm) • Private collection

Once you become comfortable depicting simple and direct natural light, you may wish for the greater challenge of depicting more complex natural light schemes. More complexity often adds greater visual interest to your paintings. Making compelling paintings is not merely a matter of observing and depicting what is in front of you, but rather it is taking the elements of your painting and manipulating them in such a way as to give the painting greater visual appeal. To accomplish this, various factors can come into play. The painting *St. George's* is a good example. The painting employs a more complex and dramatic natural light scheme than the simple, direct light in *Bayshores*. The scene is a narrow street in St. George's, Bermuda. It is midday, and the sun is bright after a momentary shower. The light in Bermuda is often brilliant, it seems to bounce in every direction from one surface to another and shadows sparkle with reflected light. There is often light and color even under the eves of buildings.

The sky (painted after masking off the buildings) was carefully designed to bring out the maximum feeling of light possible. The moving clouds in the background allow for a logical way to create the contrast. First, the building on the center right is receiving reflected light from the building to the right of it. The feeling of sunlight on both buildings is enhanced by the adjacent dark cloud. Conversely, the church on the left is darker than the surrounding clouds, almost in silhouette against the sky. The height of the church was slightly enlarged to give it more vertical presence. Finally, to complete this illusion of light, even the "white" clouds are darker in value than the surfaces seen in direct sunlight, which makes the surfaces in sunlight appear bright against the sky.

Artificial Light

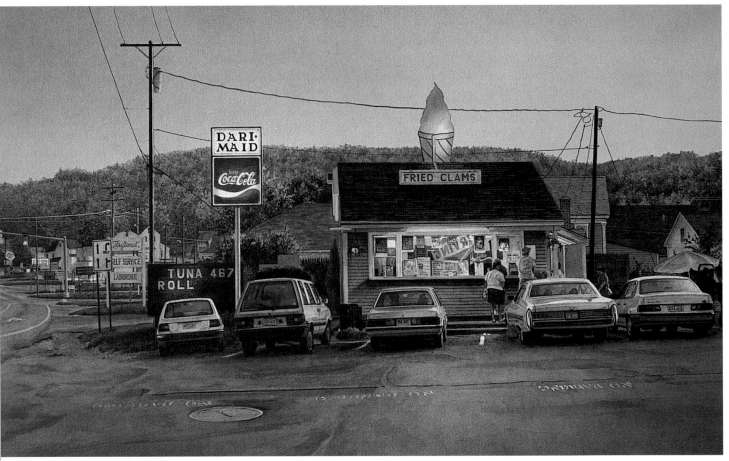

TWILIGHT OF THE WILDERNESS

14" x 21" (36cm x 53cm) • *Private collection*

Twilight of the Wilderness is a retelling of the classic Frederick Church painting *Twilight in the Wilderness*. While both paintings depict twilight, this time the heroic landscape in Church's piece ablaze with the dramatic light of the setting sun has been replaced with a somewhat less heroic scene. Yet this scene has something I dare say Church could have barely even imagined. No, it's not the soft ice cream or the fried clams. It's the artificial light.

Attempting to depict artificial light is often avoided by the watercolorist because it is believed to be difficult to capture. That need not be the case. Just as in doing daytime paintings with natural light, the key to success here is contrast. Notice in the painting how even though the setting sun has turned the sky a pale pinkish color, the Dari-Maid sign against the sky appears to be illuminated. This is because the sign is actually lighter than the sky, but even more so because there is a dark edge around the sign that increases the contrast between light and dark.

Look at the building itself. The trim on the building appears to be painted white but is in shadow from the setting sun. The central yellow light looks bright even against the white trim. This is because there is a concentration of even greater darks on both the clapboards and the roof shingles surrounding the trim. Even the fried clams sign, which is actually darker in value than the sky, appears white because it is surrounded by the dark roof shingles.

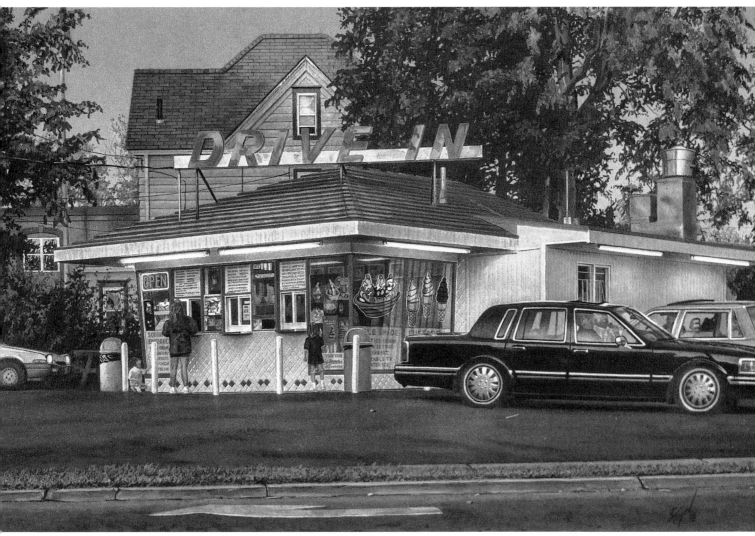

DRIVE IN

13" x 19" (33cm x 48cm) • Private collection

The Right Perspective

In spite of the fact that these two paintings have similar challenges in depicting light and texture, the drawing techniques are entirely different. *Twilight of the Wilderness* is drawn using simple, straightforward one-point perspective. On the other hand, the front of the building in *Drive In* has an unusual shape. The walls of the building taper inward. To accurately depict both the tile surface of the building and its overall shape and form, it had to be drawn in three-point perspective. This is the only example of three-point perspective in this book, but this building could not have been accurately drawn with out employing this technique.

It is said that beauty is in the eye of the beholder. Not everyone would consider pop icons of modern culture to be particularly beautiful. The aesthetic in this painting comes from the interplay of light, color and texture. The impact is heightened precisely because it comes from often over-looked sources of beauty.

In the painting *Drive In*, light from the setting sun and the artificial light combine with the over-all texture of the scene to produce a painting which is familiar, heartwarming and beautiful to the eye.

Notice that the walls of the building appear to be white even though the illumination from the artificial lights is clearly lighter in tonal value than the walls. The trick once again is to surround the "white" walls of the building with darker values. This makes the walls appear white by contrast to the darks and allows still lighter values to be in reserve for the artificial lights.

The contrast is not just of light and dark, but also the contrast of complementary colors. The building's red roof plays off the greenish lights of the custard stand. The orange glow from the setting sun visible on the tree, house and background building is in contrast to the royal blue of the sky, giving greater visual impact to both colors. The smooth, shiny surfaces of the building seem to come alive in this light. The overall textures in the painting appear far more interesting under these lighting conditions than they might during the day.

Time of Year

BUCKS COUNTY FARMHOUSE
21"x 30" (53cm x 76cm) • Private collection

Depending on your location, the changing seasons can bring both opportunities and challenges for the artist. One July morning a client contacted me to see if I would consider doing a portrait of his home. One challenge with this type of commission is to determine the most important features of your subject and showcase them in the watercolor. Upon arriving at the location I immediately saw two large sugar maple trees in front of the house. The foliage of the trees blocked much of the view of the house.

The solution to this problem was really very simple. I suggested that we wait until later in the season when the leaves had dropped. I proposed to paint an Indian summer view of the house on a warm autumn day. The light on the house would actually be better as well. In autumn the sun is lower in the sky and produces more dramatic cast shadows. The result is a much more interesting painting. In the foreground you look across the lawn, the sunlight broken by long shadows. You now look through the bare trees at the stone house, its own fascinating texture having been enhanced by the cast shadows from the trees. Finally, you now see the majestic conifers that act as the perfect backdrop for the house. Those trees were completely obscured earlier in the season by the maple trees.

Low and High Key Paintings

10TH STREET, WINTER
14" x 20" (36cm x 51cm) • Collection of the Woodmere Art Museum

Depicting the scarce light on a snowy winter morning is a challenge. Even though the local value of snow is white, the lack of natural ambient light makes everything in the painting, including the snow, look darker than it actually is. That is to say, the lack of ambient light alters our perception of the snow's relative value. The way to make a painting like this convincing is to paint it in a *low key*. Typically, paintings use a range of values from white to black with most of the values occurring in the middle of the gray scale. Key is the term used when a painting has a dominant range of tonal values at one end or the other of the gray scale. A painting is said to be *high key* if the dominant values in the painting are light. A painting is low key if the dominant values are dark, as in *10th Street, Winter*. This is not to say that all the values in a high key painting are only light or that all the values in a low key painting are only dark. To prevent a high key painting from looking weak, the use of a few carefully placed darks is necessary. This creates contrast and puts the values of the painting in context. Conversely, in a low key painting the strategic placement of a few brights puts the painting's generally darker values in context.

Because *10th Street, Winter* is a low key painting, the amount of information required to describe the surface texture in the scene is lessened. Furthermore, because of the falling snow, the effect of aerial (atmospheric) perspecitve is intensified as distance increases, the visible surface texture quickly diminishes and is eventually replaced altogether by the simple abstract contours of the buildings.

A Dominant Color Sets the Mood

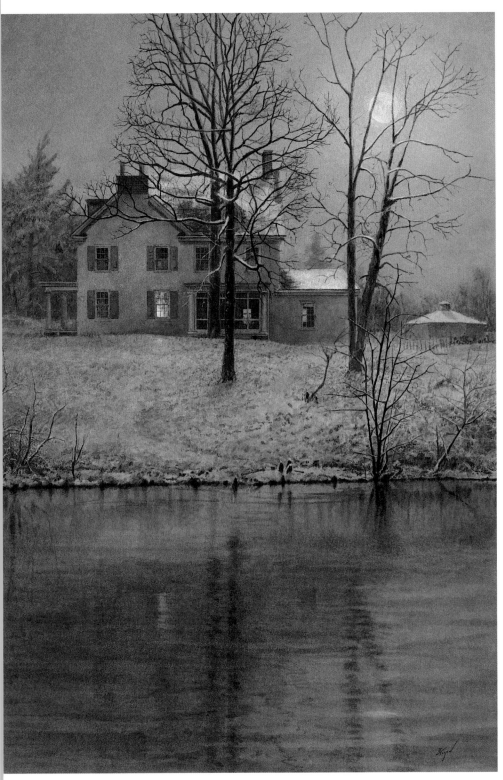

The delicate qualities of light found at dawn, dusk and evening have long been a challenge for even the most seasoned artist. These qualities of light were of particular interest to a group of American painters known as the Tonalists. Working from the early 1880s to about 1920, artists such as Birge, Harrison and George Inness sought to capture the sensual and mysterious forms found in nature when light is most subtle. They were of course influenced by the work of James Abbott McNeill Whistler, whose exquisite nocturnes were a distillation of natural elements dominated by a single unifying color or tone. Today many artists still consider the quality of light found at those times of day to be a source of inspiration. Decreasing the amount of contrast between light and dark together with the use of a dominant color or tone will help you depict those light effects.

The painting *Quiet Night* depicts a farmhouse sitting near a small body of water on a winter night. Like *10th Street, Winter* (see page 45), this painting is also in a low key. The primary illumination comes from the full moon. Even though the moon is full, it still provides less illumination than the sun would provide during the day, therefore there is less contrast. The dominant hue or tone, which is in large part Prussian Blue, not only unifies the composition but also sets a mood of peace, quiet and solitude. The mood is enhanced by a secondary illumination coming from the window suggesting a human presence. The colors, Cadmium Yellow Deep and Burnt Sienna, combine as a complement to the Prussian Blue.

QUIET NIGHT
14" x 11" (36cm x 28cm) • Municipal collection

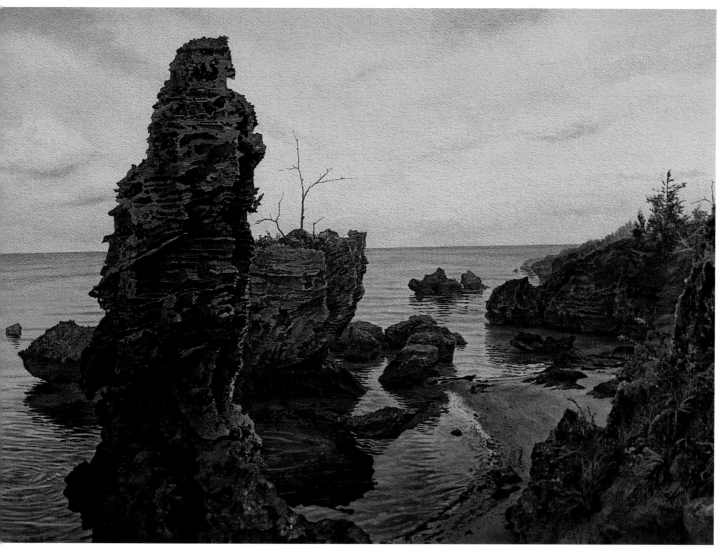

MORNING, SOUTH SHORE

14" x 20" (36cm x 51cm) • Courtesy of Windjammer Gallery

The mood in *Morning, South Shore* is a bit different from that of *Quiet Night* in that *Morning, South Shore* is brighter. Both paintings also employ the use of a dominant color and produce a feeling of serenity.

The scene is a tiny beach along Bermuda's south shore looking out at the ocean beyond. Despite the vastness of the ocean, the scene feels intimate. The beach is so small it might very well disappear altogether at high tide. The arrangement of the rocks reinforces the feeling of intimacy and even protection. The ocean is dead calm, non-threatening and serene. The dominant color in *Morning, South Shore* is essentially the opposite of *Quiet Night*. The sun is just coming up, and to depict that, a wash of New Gamboge was applied over the whole painting. The New Gamboge influenced the colors to come later, making all the colors in the painting slightly warmer than they otherwise would have been. The color of the rocks is a blue-gray. Because there is a greater degree of ambient light and more contrast between light and dark, the rocks' color is more complex and its texture is more visible than the objects depicted in the night painting.

Overcast and Misty Days

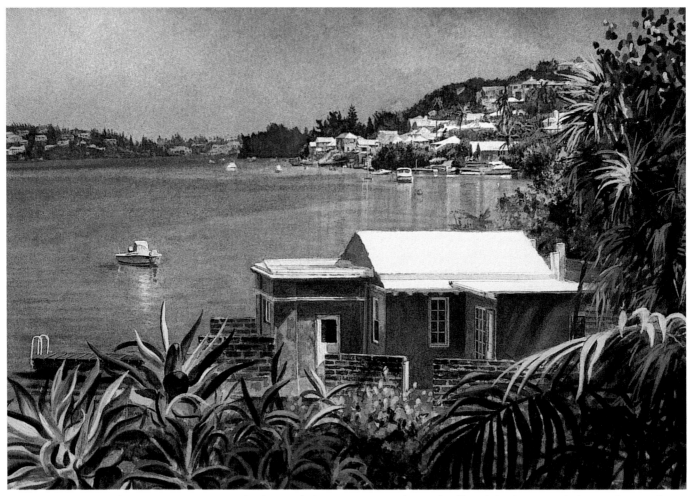

STORM OVER HARRINGTON SOUND
7" x 10" (18cm x 25cm) • *Private collection*

This dramatic little painting is a good example of how light changes with the introduction of cloud cover. The clouds from an approaching storm have caused an interruption in the visible sunlight. You can clearly see how the multicolored sunlit buildings with their bright white roofs lose their color and contrast as the storm approaches. The contrast of the two different lighting conditions heightens the impact of each.

Certain weather conditions produce a light that, at first glance, may seem dull and uninteresting to paint. Similar to what happens at dawn, dusk and evening, on an overcast day the decrease in ambient illumination causes one to perceive less contrast. But the reason for the decrease in illumination on an overcast day is different. At night, the changes in illumination occur because the sun is actually in a different position, moving away from us. On an overcast day, the sun is in the same position as it would be on a sunny day, but it is being blocked by clouds. Factors such as the thickness and position of the clouds have an effect on how the light, or lack thereof, is perceived. While this interruption of visible light could result in the objects appearing gray, flat and uninteresting, that need not be the case. These particular conditions can provide an opportunity for the artist to explore delicate yet rich qualities of light.

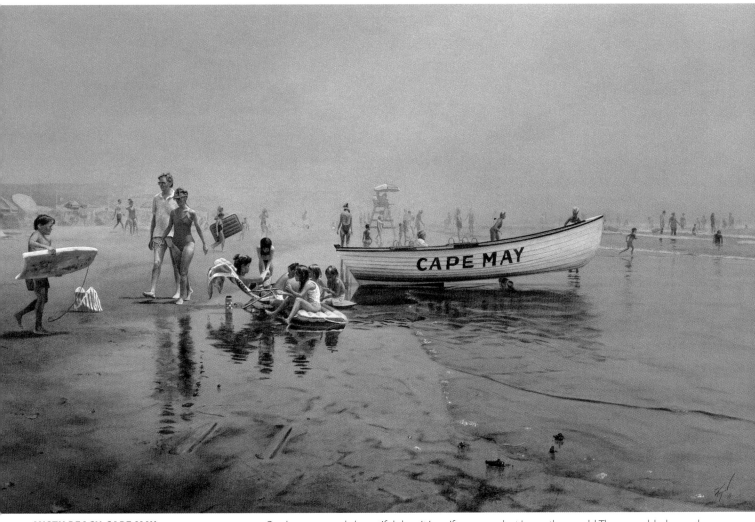

MISTY BEACH CAPE MAY
19" x 30" (48cm x 76cm) • Private collection

On these strangely beautiful days it is as if one were lost in another world. The assembled crowd, obscured by a shroud of vapor, basks in the peculiar light of some vague ethereal dreamscape. The figures, like apparitions, dissolve in the mist. Capturing this otherworldly light can be thrilling for both the artist and those who view the painting.

To create atmosphere, the figures in the foreground are first covered with masking solution. The masking solution remains in place throughout much of the painting. It is only removed when the background is virtually complete. The foreground figures are then painted and adjustments are made to integrate the foreground elements and the misty background.

Explore Light

In the Netherlands a group of artists known as The Hague School worked from about 1860 to 1900. Artists such as Anton Mauve and Hendrik Weissenbruch were noted for their sensitivity in painting the subtleties of light and atmosphere, especially on overcast days. As it did for these artists, exploring these delicate qualities of light can bring unexpected beauty to your own painting.

4

Basic Techniques

It's awfully simple when you know how and simply awful when you don't.

Once you are familiar with some of the challenges the artist faces depicting light and texture in watercolor, the next issue is learning the basic watercolor techniques that will enable you to meet those challenges. This chapter will explain how to do several basic techniques and it will show you how many of them can be used together to produce a watercolor.

Shinbone Alley is one of the many charming lanes and alleys in the historical town of St. George's, Bermuda. The town of St. George's, with its rustic buildings and abundance of natural sunlight, is a wonderful subject in which to explore many basic techniques every artist should know in order to make watercolors that are filled with light and rich in texture. The demonstration in this chapter is of another charming location in St. George's, Stockdale.

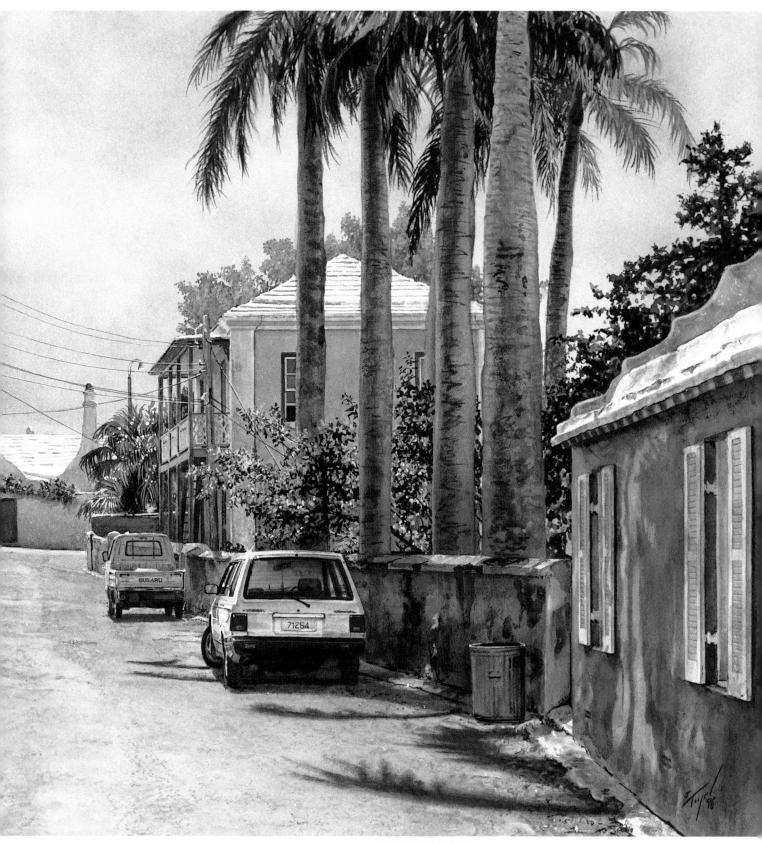

SHINBONE ALLEY

14" x 21" (36cm x 53cm) • Collection of The Masterworks Foundation, Bermuda

DEMONSTRATION
Flat Washes

The term wash is used frequently in water-color and actually refers to several slightly different techniques. The first and most basic is the flat wash. A flat wash is an even application of color on an area large enough to require several brushstrokes but done in such a way that the individual brushstrokes are not visible. Both round and flat brushes can be used to paint a flat wash. The trick to making a successful flat wash is water control. A flat wash can be applied either to dry or damp paper.

Before you begin to paint any wash, make sure to first mix enough paint to complete the entire wash. You will hardly ever have enough time to mix more paint while you are applying the wash.

It is important with any wash, if you see a flaw or slight imperfection, to not be tempted to go back into it while it is wet. If you have a flaw, dry the paper thoroughly and go over it again with clean water. If you are building up more than one wash of color, chances are that subsequent washes will fix the problem for you.

Know Your Materials

- "Puny palettes make for pitiful paintings"—anonymous.

- Palettes with puny wells are not really good for mixing a large wash. Palettes with large separate wells are excellent tools to use when premixing paint, especially for a graded wash. Paint wells are also sold separately and are available in plastic or porcelain.

- Synthetic brushes neither pick up nor release as much liquid as natural sable brushes do. Therefore, they are not recommended for use as a thirsty brush.

1 | **Begin the Wash**
Tilt your board and fully load the largest brush possible. Apply the paint evenly across the uppermost edge of the area to be painted. Gravity will cause the excess paint to run to the bottom of your brushstroke and form a puddle.

2 | **Add to the Wash**
Reload your brush and allow your next brushstroke to touch the puddle of paint from the previous brushstroke. The paint will run together and blend seamlessly. Repeat this process until the area to be painted is complete. You must maintain a wet edge throughout the process.

3 | **Remove Excess Paint**
Pick up any excess paint at the bottom of your wash with a "thirsty brush." To do this, dip a sable brush into some water and then wipe off the excess water on a paper towel. Now place the brush on the puddle of excess paint at the bottom of your wash. The thirsty brush will wick or drink up the excess paint. You can use a thirsty brush any time you need to pick up excess paint. Be sure not to forget this step. The excess paint at the bottom of a wash will dry more slowly than the rest of the area and the excess paint will run back into the wash and ruin it.

4 | **Final Wash**
If done correctly, the final wash will be clean and even.

Underpainting

An underpainting is the initial layer or layers (washes) of color on a painting's surface. This technique is especially useful in watercolor. Because watercolor is essentially a transparent medium, the underpainting in a watercolor is seen through the subsequent layers of paint and has an influence on the finished painting.

In the example shown here, the underpainting is used to initiate a feeling of light and is made up of a few flat washes.

This type of underpainting creates warm and cool versions of white in your painting and can be done regardless of the final color of the object, including those areas that are meant to appear as "white" in the finished painting.

A yellow underpainting will brighten and enliven subsequent layers of paint giving them a warm sunlit feeling, while the blue areas will cool and slightly dull those same subsequent colors to help impart a feeling of shadow. This technique is used in the paintings throughout this book.

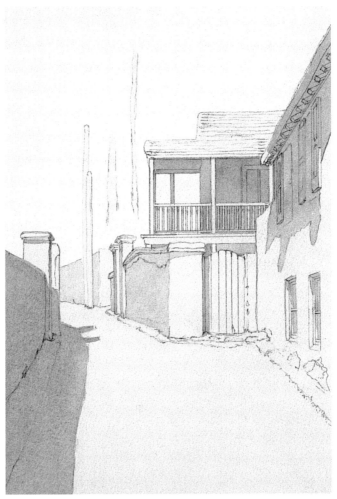

Use Flat Washes to Differentiate Planes
The first wash of Cadmium Lemon Yellow was applied over all the sunlit areas using a no. 5 round kolinsky sable. Cerulean Blue was applied to the areas in shadow. A second lighter wash of Cerulean Blue was then applied over the yellow to the sunlit areas that are in slightly less direct sunlight. This is done to differentiate all the primary visible planes.

Masking

Many watercolor artists like to reserve both the white of the paper as well as previously painted areas, by masking. There are several materials on the market that artists can use to mask a watercolor. The first is liquid masking solution, which is also called art masking fluid and liquid frisket. Masking solution is liquefied rubber latex. It is available clear or tinted. It is also sold in a permanent form, which is not removable after application. Masking solution is usually applied with a brush and removed with a rubber cement pick up.

Another useful masking material is frisket paper. This is a protective material sold in rolls and available in either a transparent or translucent form. It has a removable paper backing and can be cut and placed over the area to be protected. It is good for covering large areas and can be used in conjunction with other masking materials.

White artist's tape is yet another useful masking material. It can be used alone or with the other materials discussed here. Conspicuously absent thus far from this discussion is masking tape. Masking tape and drafting tape both can be used to mask a watercolor, but I prefer not to use them. Drafting tape has a low tack (it's not very sticky) and may come up right in the middle of a wash. Both masking and drafting tape are much less costly than white artist's tape, but neither one is archival and after removal they may leave a little unwanted residue that over time could possibly damage the paper. Admittedly this is a minor concern—masking tape has been a satisfactory material used by many artists for years.

Appling Masking Solution

Before applying masking solution, make sure your paper is completely dry. When you read the instructions on the bottle it will usually say "shake well before using." This is to mix the pigment that is in some masking solutions. The pigment is there to help you see the masking solution when it is time to remove it. I recommend that you do not shake the bottle because masking solution isn't that difficult to see when it's dry. Also, shaking causes little air bubbles to form, and when they pop they leave the paper unprotected. This may result in lots of little pin dots of color appearing on your paper after you remove the masking solution.

The most common implements used to apply masking solution are just some older brushes. Set aside a few older brushes of different sizes specifically for applying masking solution. You can use both natural and synthetic brushes for this purpose. Rubber latex is pretty sticky stuff, so to protect your brushes apply a small amount of soap to them before dipping your brushes into the masking solution. Try not to let the masking solution go past

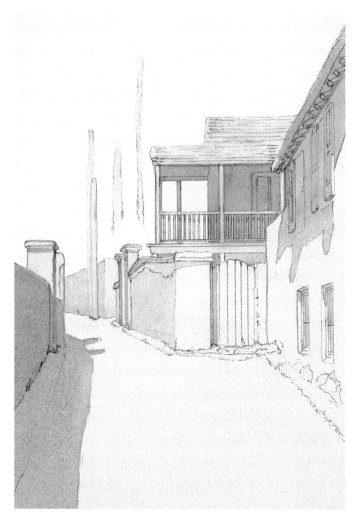

Uses for Masking Solution

Masking solution is useful to the artist to mask both large areas like the roof and main body of this building, as well as intricate details like the balusters on the porch railing.

the ferrule of your brush or it may be impossible to remove. As soon as you are finished applying the masking solution, clean your brush thoroughly with more soap and warm water.

Removing Masking Solution

Have you ever seen those funny little square rubber things on display near the checkout line at the art supply store? They are rubber cement pickups used to remove liquid masking solution. When you're ready to remove the masking solution, rub the corner of the rubber cement pickup over an edge of the masking solution. You should then be able to pull on the masking solution with your fingers and remove most of it. After removing, take the rubber cement pickup and go over the whole area again to remove any small remaining bits of dried masking solution.

After removing masking solution you may notice that the fibers of the paper are slightly lifted up, kind of like raising the grain on a piece of wood after its finish has been stripped off. This can become noticeable when applying subsequent colors. There are two easy things you can do to minimize this problem.

First, apply masking solution so that it stops at natural edges in your painting, like a roofline or some other change in plane. This way even if the masking solution has caused a small change in the paper's surface, it will not be noticeable. Doing this is less important when painting rough textures as shown in this example, but would be very important when painting a portrait.

Second, you may take a soft paper towel and ball it up so that the bottom is flat. Then gently rub the surface of your watercolor in a circular motion, pushing the fibers of your paper back down into place. Do not attempt to do this with a hard scratchy paper towel or you will damage the paper, causing more harm than good.

Frisket Paper

Frisket paper is an excellent material that can be used to mask off large areas in your watercolor, but similar to drafting tape, frisket paper has a low tack and therefore

should be secured with other materials. Before applying a wash I recommend the following method. First, cut the frisket paper and place it over most of the area to be protected—leave a little edge unprotected. Seal all of the edges of the frisket paper, first with white artist's tape and then with more masking solution, right up to the edge of the area to be protected. This may seem like a lot of work, but doing this will assure that the area is protected and you can apply watercolor much more quickly and without worry.

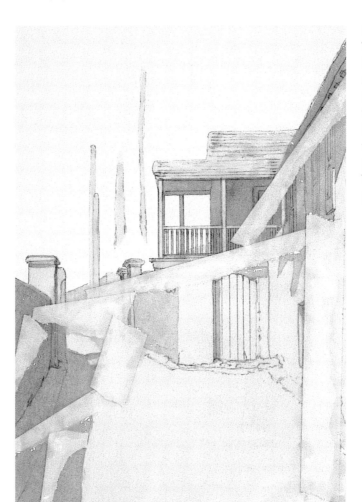

Using Masking Techniques to Protect the Paper
At this point I have used masking solution, frisket paper (which is clear) and white artist's tape as previously described. This is now ready for painting the sky.

Pre-moistened Paper

A number of watercolor techniques work well on damp and wet paper. Some techniques work better than others. Flat and graded washes both work well on pre-moistened paper.

Wet-on-damp

When painting either a graded wash or a flat wash on a damp piece of paper, there is already a certain amount of moisture on the paper, therefore you will need less water in your paint mixture than when applying a wash to dry paper. This is especially true with a graded wash since you are adding ever-increasing amounts of water to the paint mixture.

Dampening

To dampen the paper in preparation for either a wet-on-damp or a wet-into-wet technique, use either a large wash brush or a squirt bottle to apply the clean water.

Vary the Gradation

The sky not only typically appears lighter at the horizon but frequently also appears lighter either on the left or right depending on the direction of the sun. The side that the sun is on will appear lighter. If that is the case with your sky, you may apply a graded wash that is not only lighter at the bottom but also a little lighter on one side or the other. When the sun is directly behind you, you will likely not observe this.

To prepare the paper for working wet-on-damp, apply clear water to the entire area to be painted, then remove the excess water to the point where there is no sheen of water on the paper's surface. (Again, I like to use a clean soft paper towel to do this.) With pre-dampened paper you may find it helpful not to tilt the board as much as you do when applying a wash to dry paper. On damp paper there is less surface tension between the paint and the paper. So rather than puddle, the paint tends to simply run down the paper. If the board is tilted too much the paint may be difficult to control. With practice, however, you will be able to use this to your advantage. By turning and twisting the board one way or another, you allow the paint to run this way and that, creating wonderful soft effects. This way of allowing the paint to run can be very successfully employed with both a wet-into-wet or wet-on-damp technique.

Wet-into-wet

When working wet-into-wet, the paper's surface is moistened before applying paint. You may need to remove excess water (only remove water that is standing or puddling). Any excess water may be removed with a soft paper towel or brushed off with a large flat wash brush. When the paper is properly prepared for working wet-into-wet, it will be evenly wet and you should see a slight sheen of water on the paper.

When working wet-into-wet, the artist typically drops paint onto the paper, allowing the colors to spread or bleed across the paper. How this process turns out depends on the ratio of water to paint. Thicker applications of paint are easier to control than thinner ones, but both can produce pleasing results.

Paint can be dropped onto a surface that has been pre-moistened with clear water or into a previously painted area such as a flat or graded wash. In my opinion this technique works best when used sparingly. I do not use it too often and it is not used in the painting *Stockdale* on page 62. Two good examples of the wet-into-wet technique in this book are found in the sky in the painting *Horseshoe Bay* on page 74 and in the rusty metal in the painting *The End of Industry* on page 84.

If you drop clear water onto a wash, it causes what is referred to as a bloom. The weight of the dropped water pushes the surrounding paint out of the way. Frequently, as it dries, an undesirable splotch develops on the paper. This is one reason why it is not advisable to go back into a wash to fix a minor flaw. With practice and very careful water control you can avoid having this happen. Play around with this technique. Soon you will be creating lovely wet-into-wet effects.

Graded Wash

A graded wash is much like a flat wash, except the artist adds a little more water to each successive brushstroke when painting a graded wash. Like a flat wash, a graded wash may be applied with either a round or a flat brush. Once again it is best to use the largest brush you can, this will make the job quicker, easier and better-looking. A graded wash is a very important technique to learn. It is useful for painting any number of things and is particularly important when painting a sky. A graded wash, like a flat wash, may be applied to either dry or damp paper.

If you prefer, you can premix the paint in several separate vessels with ever-increasing amounts of water. (Keep a large vessel of clean water handy to add to the paint mixture as needed.)

To apply the wash, use the largest brush you can, slightly tilting the board. First dip the brush into the most concentrated mixture of paint and apply the paint evenly across the uppermost edge. Reload your brush with a more diluted mixture, allowing your brush to touch the puddle of paint from the previous brushstroke, and make another even stroke across the paper. Continue this process with increasingly diluted mixtures of paint until the wash is complete.

Pick up any excess paint at the bottom of your wash with a thirsty brush.

The color and value visible in a clear blue sky are seldom actually uniform. If you look carefully you will frequently see hints of other colors like yellow and pink, especially toward the horizon line.

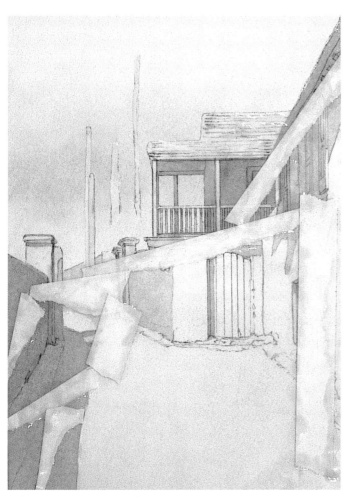

Using Graded Washes for the Sky
To paint this sky I turned the board upside down and applied a graded wash of Cadmium Lemon at the horizon line, quickly blending to clear water. After it dried, I applied a second graded wash of Permanent Rose just above the yellow (as shown) and blended once again to clear water.

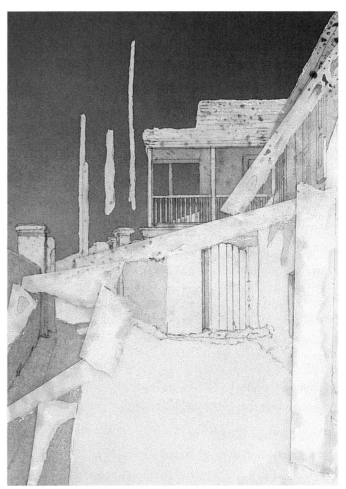

Building Layers of Color
I turned the board right side up and on pre-dampened paper applied a graded wash of Cerulean Blue. I began at the top gradating to clear water at the horizon. I repeated this several times. As I added layers of paint in the sky, I introduced other colors into the Cerulean Blue. Choose any other color you think appropriate to create the final sky color. Repeat this process until the sky has enough color. To keep colors clean be sure to dry each layer of paint with a hair dryer.

Layering Color for a Feeling of Light

Opinions vary on how many layers of watercolor are too many. Some artists suggest limiting layers to only a few, thinking that if too many layers of color are applied the color may become dull. This has not been my experience, however, and I will happily apply as many washes as I need to get the desired effect. I suggest that you apply as many or as few washes as you like when painting your sky. But be forewarned—many artists, even beginners, often do not make their skies dark enough to create a sufficient feeling of light.

Trying to create a feeling of light on a piece of watercolor paper seems to be a magical and elusive feat of alchemy. But, it's really just another example of the saying, "It's awfully simple when you know how and simply awful when you don't." It comes down to merely understanding and properly applying one single concept—contrast.

An Alternative Method

You don't have to have a deep blue sky in your painting to create a strong feeling of light. Take another look at the painting *Shinbone Alley* (page 50) and you'll notice that the light is a bit different. The sun is trying to burn through a haze of cloud cover, yet it still looks bright out. This is because even though the sky may appear rather pale, it is actually darker than both the white-roofed buildings and the street itself, thus making them appear bright by contrast. At the same time, the sky is not too dark. It is light enough to allow the building on the left and the palm trees on the right to look almost silhouetted against the sky. This contrast imparts a feeling of light to the painting yet still allows the objects to show an abundance of textural detail.

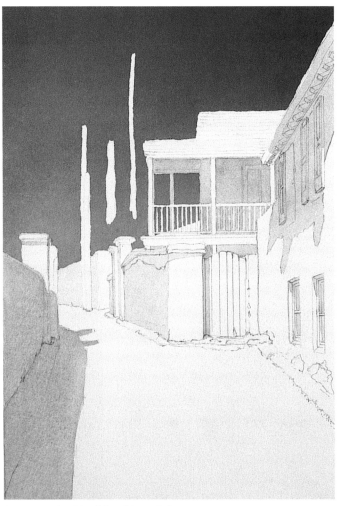

Remove the Masking Materials
Once the wash dried, I removed the frisket paper, removing the remaining masking solution with a rubber cement pickup. Notice how the sparkling feeling of light has been created.

Compared to the almost white paper the sky looks dark, perhaps even too dark. At this point in the past I might have been tempted to say "I wrecked it already." But I now know that it's supposed to look this way. Compared to the light underpainting, the sky does look rather dark but the sky's tonal value is actually only somewhere in the middle of the gray scale. To create the feeling of bright sparkling sunshine, the sky had to have sufficient tonal value (be dark enough) to contrast with both the objects in the finished painting that will appear bright and those that will appear dark. As more paint is applied to other parts of the painting, the sky will, by contrast, begin to appear lighter and lighter.

But it does not end with this step; in fact, this is just the beginning. As you look at the other basic techniques in this chapter, remain aware of how they all contribute to creating a feeling of light.

Mixing Color

Paint can be mixed both physically and optically. To mix paint physically simply take two colors, for example, Cadmium Red and Cadmium Yellow, mix them together on a palette and voilà—you have Cadmium Orange!

The other way an artist can mix paint is optically. Rather than literally mixing two colors together, the artist creates an illusion that the colors have mixed. Most people realize that if you look closely at most book or magazine reproductions, you see a dot pattern. Magnified, the pattern may consist of several different colors, but when viewed at a distance, they blend together to form one color. This way of optically mixing colors is similar to a technique known as pointillism, practiced most prominently by Georges Seurat, 1859-1891. In this case, the Cadmium Red and the Cadmium Yellow would be placed next to one another and when viewed from a distance they would appear to be Cadmium Orange.

A second way to optically mix paint is to place (or layer) one color over another. Watercolor is particularly well suited to this way of optically mixing paint. Even if the pigments themselves are opaque, as is the case with Cadmium Yellow and Cadmium Red, watercolor is essentially a medium which requires the pigments to be diluted with water before being applied; therefore, opaque paints like the Cadmiums can be treated as transparent or translucent and can be mixed optically in layers.

Dark Mixes

Depending on the amount of water used in the mix, the same colors can be used together to produce either very deep intense mixtures or very light ones. It is my opinion that in watercolor the most attractive darks come from either using an intense application of a single color or mixing two complementary colors together, not from using black out of the tube.

Especially good mixes are those vibrant colors with a high tinting strength. A classic combination is Pthalo Green and Permanent Alizarin Crimson. Another good combination that makes a vibrant dark is Ultramarine Blue mixed with either Burnt Sienna or Quinacridone Burnt Orange. One that works well, especially in a cityscape, is Prussian Blue and Sepia. This last combination can make just about the darkest black you can imagine, but the Lamp Black in the Sepia makes this combination a bit dirty. Therefore, it does not make a good dark everywhere, especially when doing a portrait.

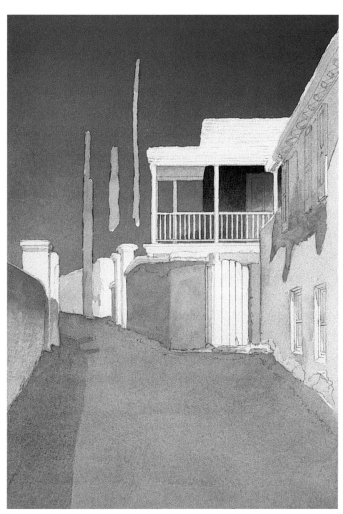

Recognizing Optical Mixing
In this example, optical mixing is evident in three locations. Physical mixing is seen in combination with one of them. In the first case, a flat wash of the local color, Quinacridone Burnt Orange is applied to the wall over the underpainting. Next, after applying two graded washes of Ultramarine Blue under the porch roof, another flat wash of Quinacridone Burnt Orange is applied there as well. Finally, a physical mixture of Burnt Umber with a little Cerulean Blue is applied to the road. That combination mixes optically with the blue cast shadow underpainting on the road and makes the wall begin to look as if it is "white", but also in shade.

Glazing and Scumbling

Traditionally, glazing and scumbling are terms reserved for describing oil painting techniques. They are both forms of what is referred to as overpainting. Overpainting simply refers to the application of those layers of paint on top of the preliminary layers or underpainting. Often multiple layers of color can create more complex and nuanced light and textural effects than could be achieved with a more simple and direct approach.

Glazing

In oil painting, a glaze or glazing refers to the careful application of a thin, transparent layer of paint over another color or underpainting. In watercolor, it also refers to a careful application of transparent color or over a previously painted surface. Glazing differs from a wash in that less water is used. Since the application is more controlled than a wash it does not disturb the previously painted surface even if that surface is painted with a non-staining paint that could possibly be disturbed by a wash. Therefore, glazing allows you to paint rich, complex color while keeping the colors clean.

Too Much Water

When a previously painted surface is disturbed by a subsequent layer of paint with too much water, the pigments mix both optically and physically at the same time. Be careful: This could quickly result in the colors going muddy.

Scumbling

In oil painting, a scumble or scumbling is a thin layer of opaque paint rubbed or scrubbed over a previously painted surface. Even though opaque, because the paint is applied thinly, it does not completely cover the surface below. The result is kind of a gauzy effect.

A scumbled passage is applied in a more random and casual way than the more careful and controlled application of a glaze. In watercolor this more random application of paint, regardless of whether the pigment used is or is not opaque, is also referred to as a scumble.

Glazing and scumbling are both highly useful techniques in watercolor, providing a painting with depth and complexity.

Applying Glazing and Scumbling Techniques

Hooker's Green was applied to the porch and right over the blue underpainting beneath the porch. A wash was applied to the gate with a more saturated mixture of Burnt Umber and Cerulean Blue than was used on the road. The under part of the porch roof was glazed with Dioxazine Violet and Quinacridone Gold. To intensify the color, I carefully glazed more Quinacridone Burnt Orange under the porch roof in and around the doorway and in between the balusters. The texture of the orange wall was developed with a series of glazes using Quinacridone Burnt Orange (you can use a few other colors if you like). Cadmium Yellow was scumbled to create the reflected light visible on the wall on the left. Burnt Umber, Cerulean Blue and Ultramarine Blue were scumbled on the wall of the building to the right to develop its texture. To show more reflected light, Quinacridone Gold and Permanent Rose were scumbled under the eave of the building on the right .

Creating Brilliant Color With Layers

American illustrator and landscape painter Maxfield Parrish, 1870-1966, has long been admired for the luminous color in his oil paintings. This is due in large part to his technique of using multiple layers of transparent glazes.

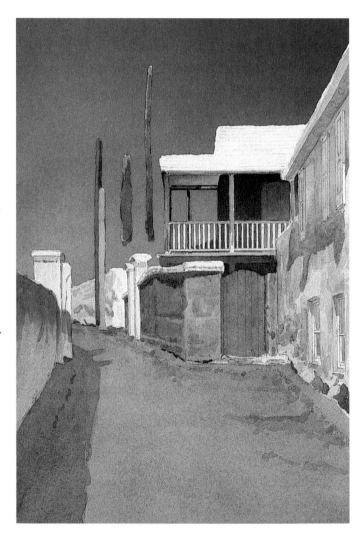

Drybrush

Drybrush is a pretty self-descriptive term and is an excellent way to bring texture to your paintings. Like glazing and scumbling, drybrush is a form of overpainting. In some ways, drybrush is similar to both techniques–especially scumbling–but with drybrush even less water is used in the paint mixture.

It is best done on paper that has a little surface texture of its own, such as cold-pressed or rough. Speaking of rough, this technique can be very rough on your brushes, so I would recommend that you do not use a nice new expensive kolinsky sable brush for this technique. Keep a few older brushes around for drybrush painting. Synthetic brushes work well and bristle brushes can also be successfully used. Typically drybrush is applied toward the end of the painting process or at least toward the completion of a certain passage in a painting.

To drybrush, first mix a small amount of water with your paint. The paint mixture on your palette should be neither too thick and heavy nor too thin. Wipe off excess paint from your brush on a paper towel before application.

There are several drybrush techniques. The first is to drag the side of the bristles across the paper. This is good for painting weathered wood, tree bark, stones, etc. Another is to splay apart the bristles and gently brush the splayed hairs in an up and down motion. This can often be useful when painting blades of grass. You can also drag a bristle brush or lightly tap it up and down to give the effect of blades of grass at a great distance.

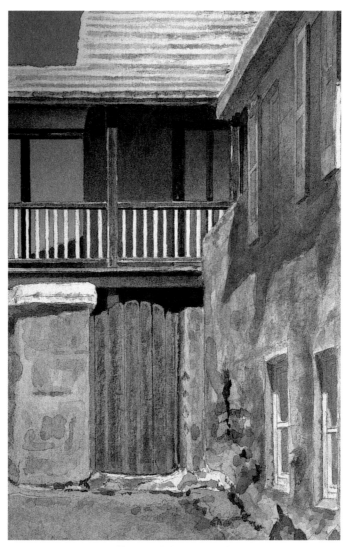

Creating Textural Effects With Drybrush

Different degrees of dryness are needed to produce different textural effects. For example, the roof of the building and the wooden gate. In both cases the flat side of the bristles were dragged along the surface of the paper, but with slightly more water in the paint mixture when painting the roof of the building than the weathered wooden gate. The other difference is that the brushstrokes on the roof are horizontal and on the gate they are vertical. Drybrush is also randomly applied to the wall of the building on the right to further enhance its rough texture.

Brush Marks

When painting a watercolor typically you first execute a line drawing in pencil and after that, begin to add layers of color until the painting is complete. At some point during the painting process you may wish to actually draw with the brush. In this case the intention of the brushstrokes differs from when painting a wash, in that these brushstrokes are intended to clearly leave visible brush marks.

Brush marks add their own particular texture to a painting that differs from the texture imparted by other techniques such as drybrush. Brush marks can be large or

small, decorative or descriptive. To be successful, brush marks should be direct and spontaneous, not random and sloppy, and never stiff or stilted. When done correctly brush marks add vitality to a watercolor.

Descriptive brush marks are used to create the illusion of certain specific textures such as the spiky texture of the palm fronds seen here. They are used throughout this book to paint everything—a sandy beach, water, foliage, even concrete.

Brush marks can also be used to create surface texture on the painting itself. This is where the actual texture of the paint plays a part in the overall final effect of the painting. Surface texture is easy to see in some oil paintings, especially like those done by Vincent Van Gogh. But it can also be seen in watercolor. The surface texture created by brush marks can add yet another subtle element of texture to your watercolor.

The direction of your brush marks goes a long way toward helping you describe the nature of your subject. The brush

marks on the palm fronds and other foliage describe their shape, volume and texture. The brush marks on the road and the building not only describe their texture but also the change in plane, from the relatively horizontal ground contour to the verticality of the building's wall.

Controlling Your Brush marks

Often to have sufficient control over the marks you make on the paper, it is necessary to make the paint mixture slightly firm to prevent it from running—as is the case with the palm fronds and the background foliage in this painting. The marks that give the road its texture are made from a more watery mixture of paint. When those wetter brush marks dry, a slightly dark ring forms around them that can also contribute to the texture of the road. Stockdale is another charming and historical location in the town of St. George's. It was the home of Joseph Stockdale, founder of Bermuda's first newspaper in 1784.

STOCKDALE
11" x 7" (28cm x 18cm) • Artist's collection

Applying Basic Techniques

Rarely will you need to use all the basic techniques discussed in this chapter in one single painting. *Stockdale* demonstrates several of the techniques every watercolorist should know. They are presented in approximately the same order you would expect to use them in your watercolor.

Close Up of *Stockdale*
Watercolor can create various types of texture depending on the technique used.

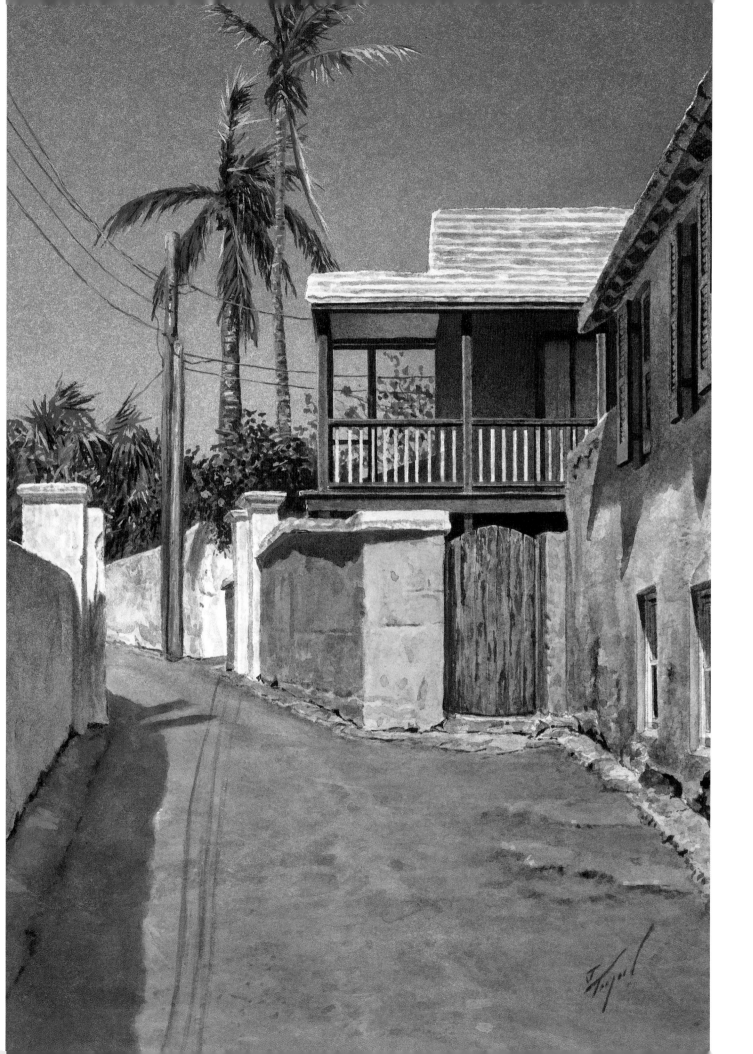

5

Painting Natural Textures

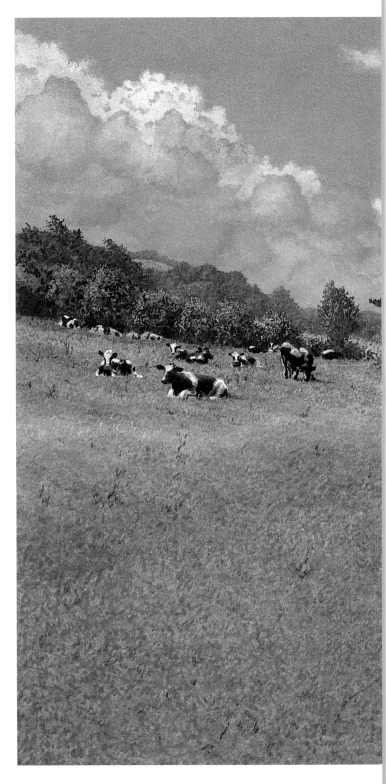

The challenge the artist faces when painting a watercolor with natural textures is to make the elements of the painting seem solid and believable without making them appear stiff or stilted.

This chapter will demonstrate techniques for depicting specific textures found in nature. In some cases, the demonstrations will be of the actual finished painting depicted on the page. In other cases, the demonstration will be a re-creation of the finished painting.

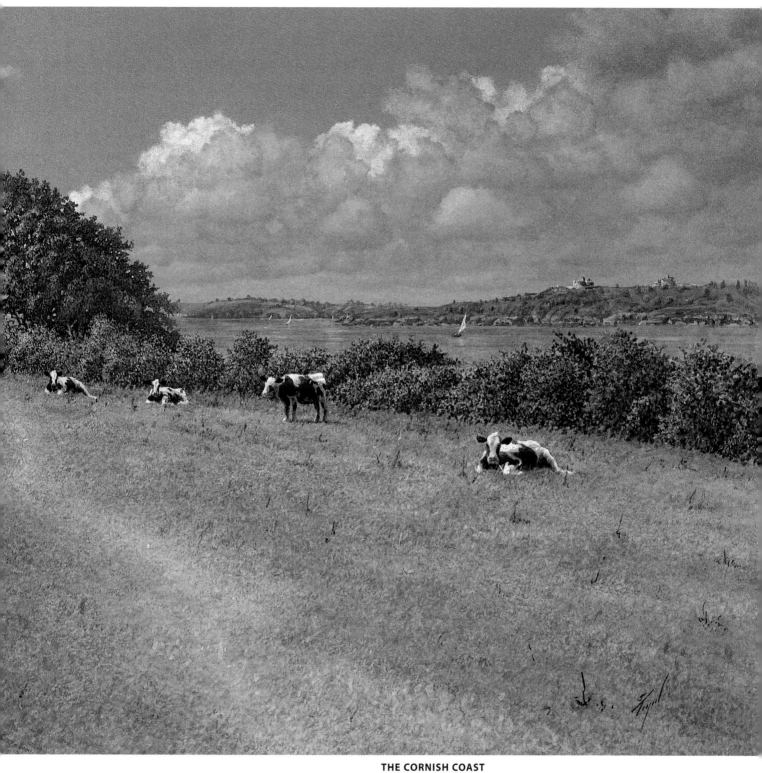

THE CORNISH COAST
13" x 20" (33cm x 51cm) • Collection of the artist

DEMONSTRATION
A Grassy Field

This scene is an area in the southwest of England known as Cornwall. It is recognized for its rugged and evocative coastline with fingers of land jutting seaward and lovely harbors where you find charming little fishing villages. The area is also known for its miles of hiking paths that meander along the edge of the English Channel. These paths wind through fields of sheep and cattle, up hills and down, providing with each step yet another exquisite view.

The light in Cornwall has been a source of inspiration to artists for hundreds of years. It is frequently a soft light dispersed by the moist air which softens the look of the surrounding texture.

For most landscapes you will be painting grass. The first instinct of some artists when confronted with a field of grass is to try and paint each and every blade. But whether you prefer detail or not, you should always begin your painting the same way—look for and paint the biggest, simplest shapes first. This demonstration will teach you how to do this successfully.

A Look Back

The English countryside has proven to be a source of inspiration for generations of watercolorists too numerous to mention. Here are but a few: John Robert Cozens (1752-1797), Thomas Girtin (1775-1802), John Sell Cotman (1782-1842), Henry George Hine (1811-1895) and Helen Allingham (1848-1926).

Materials List

COLORS
Burnt Umber • Chromium Oxide Green • Hooker's Green • Lemon Yellow (Nickel Titanate) • Raw Umber • Yellow Ochre • Chinese or Titanium White (optional)

BRUSHES
Nos. 3 and 5 round sables • No. 10 or larger round

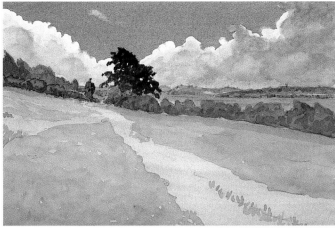

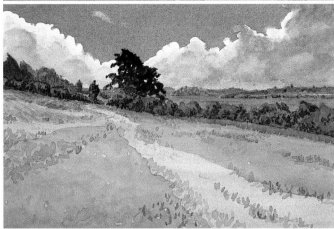

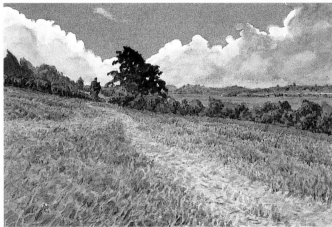

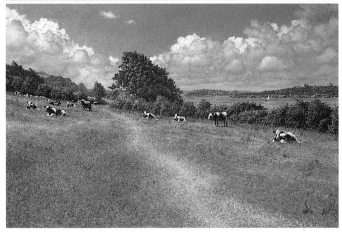

1 | Establish the Basics

Mix Chromium Oxide Green and Hooker's Green with Yellow Ochre and Lemon Yellow and using your no. 10 round, apply a wash of this mixture over the entire field area. Apply another wash of this mixture, but this time do not apply any paint to the path. Still using the no. 10 round, begin to establish some lights and intermediate darks. Introduce the Burnt Umber and make random brush marks to indicate the clumps of grass. Make the marks larger in the foreground and smaller in the background.

2 | Develop the Ground Contour

Using the same mixtures as in Step 1, but with a smaller brush, continue to develop the pattern of the grasses. Follow the contour of the ground, the ground is sloping down from left to right. The illusion of distance and the contour of the ground are both expressed by the size, placement and direction of your brush marks. The grass on the path has been trodden underfoot, your brush marks should express this, so make the marks shorter and less vertical. A path such as this would have naturally developed along a part of the field that is flat enough to walk on comfortably. So as you begin to develop the ground contour, indicate the flatness by making that part horizontal.

3 | Look For and Develop Patterns

Continue to use a random mixture of the same colors, introducing Burnt and Raw Umber here and there for greater color variety and visual interest. Look for and develop patterns in the grass. No matter how much detail you wish to put into your painting, do not attempt to paint each blade of grass. It is extremely time consuming and will just make the painting look stiff and stilted. Look for and paint the negative spaces by placing darks adjacent to one another to give the appearance of blades of grass in between them. But beware: Overusing this technique can produce stiff and unsatisfying results. At this point the painting should look pretty good, and many excellent artists would be correct to consider the field complete.

4 | Continue to Develop Detail

This step is a continuation and refinement of the previous step. Mix random combinations of all the colors previously used and continue to develop the grass until you are satisfied.

If you wish, you may add additional complexity to the field's texture. Add either Chinese or Titanium White to any of the previously used colors to create an opaque body color. Chromium Oxide Green, Yellow Ochre and Lemon Yellow are all well-suited to this technique because they themselves are opaque.

TIP • Sometimes it is easier to find and develop subtle and elusive patterns—such as in a field of grass—if you look at the painting in a mirror and see it in reverse.

DEMONSTRATION
Bare Branch in the Foreground

When looking at this finished watercolor, one gets a sense of quiet solitude and intimacy. This feeling comes in part from the calm water, but even more so from the overhanging branch, gnarled yet lace-like. The branch gives a moment of shade from the midday sun. You almost feel as if you want to duck your head under the branch to enter this tiny space overlooking the vast ocean.

To create this intimate feeling in a painting it is important not only that you draw and paint an interesting shape for the branch, but that the branch also appears to actually be in the foreground. This is done by reserving the deepest darks for the shadow on the bottom side of the branch.

For this demonstration we will be concentrating on painting the bare branch. Please see pages 76 and 77 for more information on painting the sky, and pages 74 and 75 for more information on painting water.

Materials List

COLORS
Burnt Sienna • Chromium Oxide Green • Hooker's Green • Prussian Blue • Sepia • Chinese White (optional)

BRUSHES
No. 3, 4 or 5 round sable • Old brush

OTHER MATERIALS
Eraser • Masking fluid • Rubber cement pickup • Single-edged razor blade

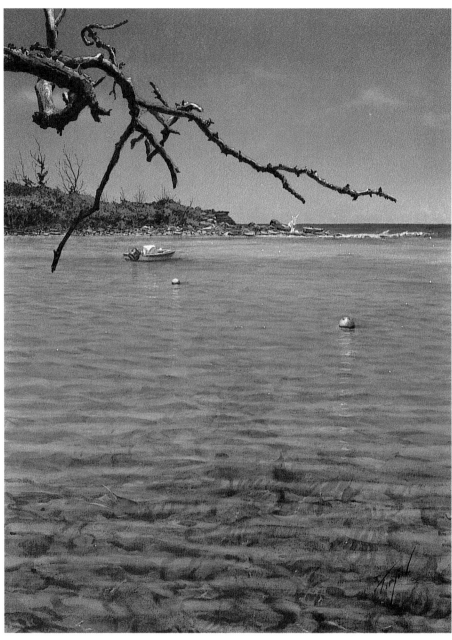

HUNGRY BAY
14" x 11" (36cm x 28cm) • Private collection

1 | **Draw and Mask the Branch**
After you have drawn an interesting shape for the branch, mask it with masking solution and block in (roughly paint) the land in the background using Hooker's Green, Chromium Oxide Green and Sepia. Paint a simple sky with a series of graded washes (see pages 76 and 77).

2 | **Underpaint the Branch**
With the rubber cement pickup, remove the masking from the branch. Paint the entire branch with a wash of Burnt Sienna. Block in the water (see pages 74 and 75).

3 | **Add Light and Shadow to the Branch**
With a combination of Sepia and Prussian Blue, begin to paint the shadow on the underside of the branch. Make sure the darks in the branch are darker than the darks in the background.

4 | **Add Texture**
Using the side of your brush, drybrush the branch in a random fashion to give it a natural texture. Continue to use the combination of Sepia and Prussian Blue. Randomly add a few touches of Hooker's Green to create more color variety within the branch. Begin to put in some of the deep checks and grooves in the bark with a rather thick mixture of Prussian Blue and a touch of the Sepia. This combination of colors makes an extremely dark and rich black.

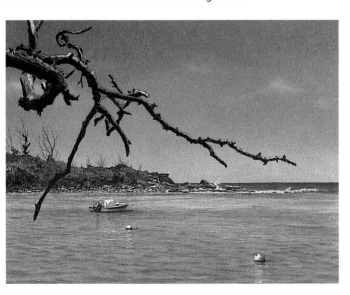

5 | **Add Highlights**
Add highlights to the branch with a little Chinese White. With a single-edged razor blade, scrape out some other highlights. The Chinese White may be omitted if you prefer, as using the single-edged razor blade by itself will produce quite satisfactory results. Finally, make sure your lightest lights and your darkest darks are reserved for the branch. If you find that is not the case, you can lighten the background by gently going over it with an eraser.

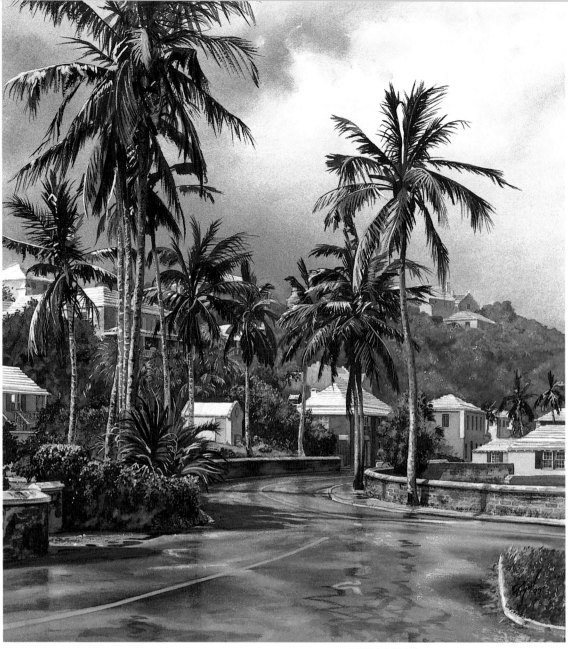

ROYAL PALMS
16" x 14" (41cm x 36cm) • Private collection

DEMONSTRATION
Palm Trees

The first and most distinctive aspect of a palm tree is its overall texture. For reference, there are several examples of palm trees throughout this book. Each species of palm tree has unique characteristics such as differing sizes and shapes of the palm fronds (leaves). In this Demonstration I will show you a few painting techniques to help you successfully depict the texture of palm trees.

Practice Palm Fronds

To successfully paint the palm fronds you may want to first practice the following brushstrokes on a scrap piece of paper until you are comfortable. With your no. 5 round, first draw the spine of the palm frond. The brushstrokes for the individual segments of the frond are made by pressing down on your paper with a fully loaded brush then pulling the brush across the paper while lifting up on the brush. The resultant brush mark will be fat at the base and pointy at the tip. Arrange the palm fronds in an interesting way and in accordance with the characteristics for each individual species.

Materials List

COLORS
Burnt Umber • Chromium Oxide Green • Hooker's Green • Quinacridone Burnt Scarlet • Raw Umber • Sepia • Yellow Ochre • Titanium White (optional)

BRUSHES
No. 3 white synthetic sable brush • No. 5 round sable

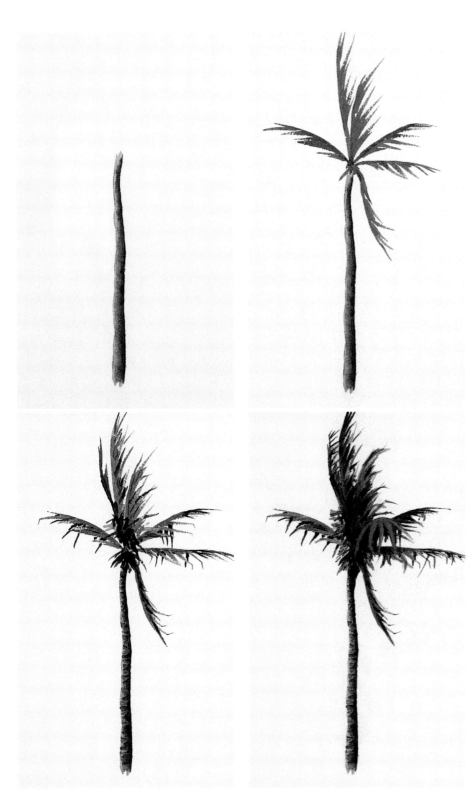

1 | Draw and Paint the Trunk

Draw and paint the trunk of the tree using Raw Umber mixed with a little Burnt Umber. While the paint is still wet, touch the edge of the trunk with some Sepia and let it bleed across the trunk. This will indicate the roundness of its shape and the shadow side of the tree.

2 | Master the Palm Frond Brush-stroke

As the palm tree grows, the older fronds at the bottom turn brown and drop off. To paint the bottom fronds using Burnt and Raw Umber, make them either brown, a little less colorful or both. For the newer palm fronds use a mixture of Chromium Oxide Green and Yellow Ochre with Hooker's Green.

3 | Paint the Intermediate Darks

Using random mixtures of Raw Umber, Burnt Umber, Sepia and Hooker's Green, add some intermediate darks to the palm fronds. Notice how the segments of the palm fronds drop in different directions. Carefully paint in between the previously painted sections to indicate this difference in direction.

Paint the semi-horizontal growth marks on the trunk of the tree with the previously mentioned colors. Add a little Quinacridone Burnt Scarlet where the fronds begin and also randomly elsewhere to add visual interest to the color of the palm fronds.

4 | Add Deeper Darks and Greater Complexity to the Tree

Add more concentrated mixtures of the colors to make deeper darks. To make additional palm fronds from the previously painted darks, scrub out some areas with a synthetic no. 3 round white sable. This will add greater complexity and more visual interest to the tree. Even though Hooker's Green is a staining paint, Chromium Oxide Green and Yellow Ochre, which were initially mixed with it, are non-staining and will allow much of the color to be lifted.

An Alternate Method

To depict additional palm fronds and to add highlights to the fronds, in the painting *Royal Palms*, instead of scrubbing out with a synthetic brush, Titanium White was mixed with other colors as a body color.

DEMONSTRATION
Jagged Coastal Rocks

The texture of an object can tell us a lot about its nature. Sometimes, though, the surface texture of an object is so complex and confusing that it leaves the artist wondering where to begin. Here is such a case.

The coral reefs that surround Bermuda form the basis for its indigenous stone, coral limestone. This stone is somewhat soft and extremely porous and is subject to erosion from the wind and surf. This in turn creates unusual and strangely beauti-ful jagged rock formations. It can be quite a challenge for the uninitiated to accurately depict both the form and surface texture of this rock. You must first visualize and simplify the overall shape and volume of the rock formations. Next, address the texture of the rocks. The bright midday sun clearly shows their overall form. Squinting your eyes helps to eliminate the superfluous surface texture and helps you to concentrate on the overall form.

Materials List

COLORS
Burnt Umber • Chromium Oxide Green • Dioxazine Violet • Hooker's Green • Phthalo Green • Prussian Blue • Quinacridone Burnt Orange • Quinacridone Gold • Sepia • Ultramarine Blue

BRUSHES
No. 5 round sable • An old no. 3 or 4 round sable (one that no longer points well)

1 | Block In Basic Local Color

Draw the rocks carefully. Focusing on their overall shapes, use your no. 5 round to block in the basic local color of all the objects. In this example the view is at low tide. Use a mixture of Ultramarine Blue, Dioxazine Violet and Burnt Umber to make a gray for the rocks above the high tide waterline and a mixture of Quinacridone Burnt Orange and Quinacridone Gold for below the high tide line. Use a mixture of Prussian Blue and Phthalo Green for the water. For the grasses use a mixture of Hooker's and Chromium Oxide Green. The rock in the distance is completely under water at high tide, so it receives only the Quinacridone mixture.

2 | Establish a Pattern of Light and Dark

Go over the rocks with the same mixture of Ultramarine Blue, Dioxazine Violet and Burnt Umber, leaving the lightest areas of the rocks alone. Make sure each layer of paint is dark enough to define the difference between it and the previous layer of paint. At the high tide line apply the gray mixture from Step 1. From then on use only the Quinacridones below the high tide line. Also apply them over the blue on the water to begin the reflection of the rocks in the water. Apply more Phthalo Green and Prussian Blue to the water. By making the water darker, the contrast will begin to make the rocks appear lighter.

To begin making the ripples on the water, apply the Phthalo Green and Prussian Blue both in a mix and individually. Also introduce a little Dioxazine Violet here and there in the water. To paint the ripples, use an older round that no longer has a good point. It actually works better to make these brush marks than does a new brush.

3 | Develop the Midvalues

Continue to paint the rocks. With a fully-loaded brush drop in wetter and more concentrated mixtures of the colors that were previously used. As this paint dries it forms a dark rough edge that helps convey the jagged feeling of the rocks. On the other hand, you want to avoid that dark edge when you paint the ripples of water; so as you apply more color to the water, take time to wipe some of the excess paint from your brush onto a paper towel.

4 | Develop the Darks

Continue to develop the ripples of water and to add darks to the rocks. Develop the darks in the grass. Be prepared to go over the dark areas on the rocks several times until they are sufficiently dark. At this time, replace the Burnt Umber with the darker Sepia. A heavy application of Prussian Blue is very useful to make occasional very deep darks in the rocks. Make any necessary adjustments to the rocks and make sure the water is darker than the lightest areas on the rocks so that the rocks appear bright and sunlit by contrast.

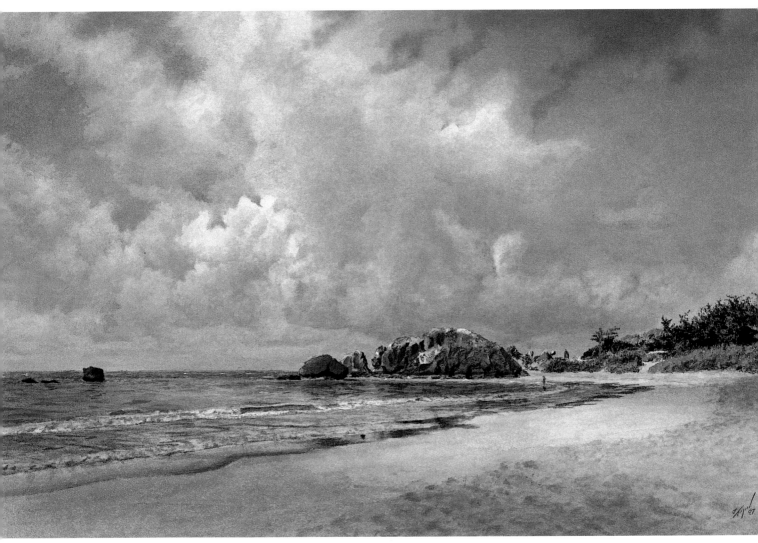

HORSESHOE BAY
9" x 15" (23cm x 38cm) • Private collection

DEMONSTRATION
A Sandy Beach

The texture of sand varies from place to place. Sometimes it is quite coarse and other times extremely fine. The color of sand also varies from bright white to almost black. At times it is tinged with one color or another. The sand in Bermuda is of a medium texture and has little pieces of coral that give it kind of a pinkish color. Regardless of where you are, there are some things that remain constant about a sandy beach. For example, as the tides move back and forth, the fluffy dry sand is smoothed out and flattened by the water, changing the appearance of its texture. Also, the sand by the water's edge is very wet and highly reflective.

In this demonstration I will forego the effect of the cloud formations and their shadows on the beach and concentrate on the texture of the beach itself. (For more on skies, see pages 76 through 78.)

Materials List

COLORS
Burnt Umber • Cerulean Blue • Hooker's Green • Permanent Rose • Phthalo Green • Prussian Blue • Raw Umber • Sepia • Ultramarine Blue • Yellow Ochre

BRUSHES
Nos. 3 and 5 round sables • No. 20 round

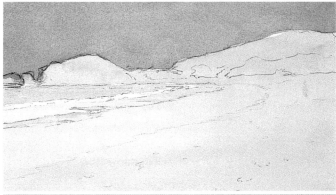

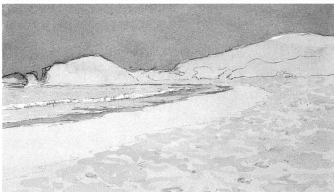

1 | Establish the Sky and Underpainting
First paint the sky (see Step 3 on page 77). Then, with your no. 20 round, apply a wash as an underpainting using a physical mixture of Yellow Ochre, Permanent Rose and a touch of Raw Umber. Cover the entire land area—rocks, trees, sand and all. With that same brush apply a mixture of Prussian Blue and Phthalo Green for the water.

2 | Develop the Sand's Texture
Apply a wash of Cerulean Blue with a touch of Ultramarine Blue to the edge of the surf. Add a few dots of a more concentrated mixture of those colors to the crashing waves. With your no. 5 round apply a mixture of Permanent Rose and Yellow Ochre to the dry sand above the high tide line in a random fashion. This will begin to develop the feeling of the undulations and depressions of the dry sand. Remember to make the marks for these depressions smaller in the background and larger in the foreground. Do this same step a second time.

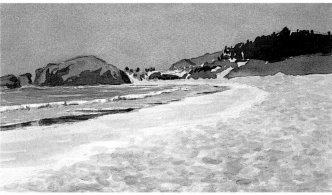

3 | Develop the Ground Contour
With your no. 5 round go over the rocks in the background using some Raw Umber and a touch of Burnt Umber. In the background, apply Hooker's Green with some Yellow Ochre to the foliage and some Hooker's Green mixed with Sepia to the darker foliage. Apply Burnt Umber mixed with Sepia to the lower and shadow portions of the rocks.

4 | Develop the Beach's Contour and Texture
To indicate more waves, apply more Prussian Blue and Phthalo Green to the water, leaving some areas unpainted. Apply a few intermediate darks to the base of the crashing waves. Apply a mixture of Sepia and Burnt Umber to the rock reflections in the wet sand by the water's edge.

At this point the intermediate darks in the background should make the beach appear quite light, so turn your attention back to the sand. Apply a mixture of Permanent Rose and Yellow Ochre to the sand below the high tide line in order to indicate the contour of the beach sloping toward the water. Replace the Raw Umber in the dry sand with a touch of Ultramarine Blue and further develop the depressions in the dry sand. Make the marks in the sand progressively lighter as you move from the foreground toward the middle ground. Do not apply any paint to the background of the beach. Repeat this step several times. As you continue to develop the painting's detail, use a no. 3 or similar sable brush.

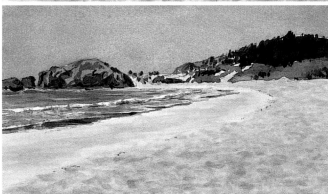

5 | Continue to Develop Detail
Apply a graded wash of Permanent Rose and Yellow Ochre beginning in the foreground and moving toward the middle ground. This will add additional color to the sand and soften its texture. Then repeat Step 4, continuing to develop the sand's texture until you are satisfied with it.

Apply the deepest darks to the background. Apply Raw Umber here and there to the shallowest parts of the water. The spaces not painted will give the appearance of foam on the water.

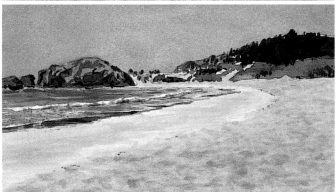

TIP · Overlapping random marks to depict the depressions in the sand causes happy accidents of patterns to develop when painting the sand. This results in patterns that look more natural and far less stilted than if you tried to painstakingly paint each individual depression.

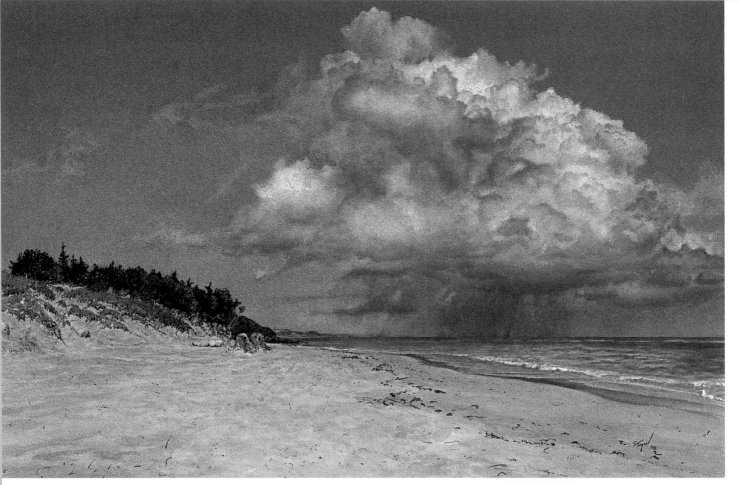

DEMONSTRATION
Dramatic Clouds

For some people clouds are inscrutable, amorphous objects. Getting them to look both solid and soft at the same time is a real challenge. The cloud in this demonstration is an example of the dramatic cloud formations that are frequently a part of the Bermuda landscape.

For this demo we are concentrating on painting dramatic clouds. For information on painting a sandy beach, see pages 74-75, for painting water, see pages 79-81.

Painting the Sky

When painting your graded washes, don't be overly concerned if streaks appear in the sky. Everything is masked off and you can blend everything with a large flat wash brush. An inexpensive brush will work just fine. At this point you could even use a squirt bottle to soak the paper and blend the sky until you are satisfied.

Materials List

COLORS
Burnt Umber • Cerulean Blue • Chinese White • Ultramarine Blue • Winsor Blue, Green Shade • Winsor Violet

BRUSHES
Nos. 3, 4 and 5 sable rounds • No. 4 synthetic round • 1-inch (25mm) flat wash brush • Large flat wash brush • Old brush

OTHER MATERIALS
Frisket paper • Liquid masking solution • Pink Pearl eraser • Rubber cement pickups • White artist's tape

76

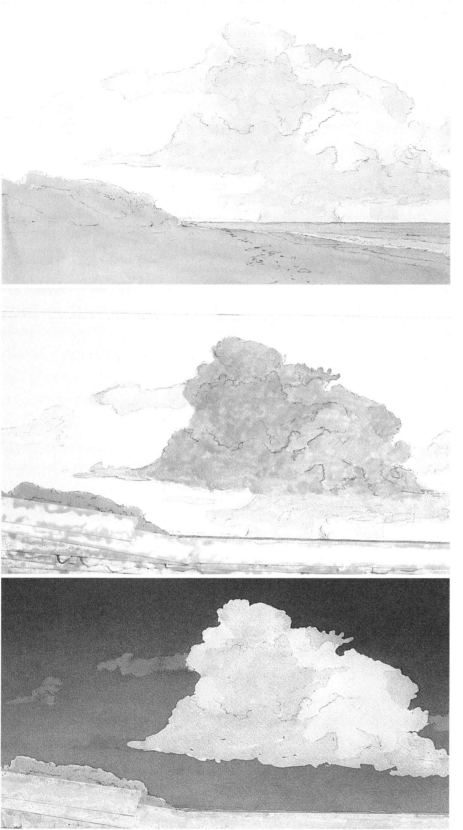

1 Paint the Underpainting

After you have done the basic drawing of the water, beach and cloud, apply a wash to the cloud with a mixture of Cerulean Blue, Ultramarine Blue, Burnt Umber and a touch of Winsor Violet. This underpainting on the white of the cloud will help it appear as if it is in the distance.

2 Apply Masking

Mask the foreground and the whitest part of the cloud.

3 Soften the Contour of the Cloud

Paint a flat wash of Cerulean Blue over the entire sky with a 1-inch (25mm) flat. Begin a series of graded washes for the sky using a combination of Cerulean, Ultramarine and Winsor Blues. Make the sky lighter at the horizon to give the sky depth. After you have applied a couple washes of the blue mixture, put a little more masking fluid on the slightly darker parts of the clouds and continue to apply the washes.

Remove all masking fluid from the cloud with a rubber cement pickup.

Observing the Sky

If you take time to observe a clear blue sky, you will notice that the sky is a lighter and sometimes different hue of blue toward the horizon. With careful observation you may also notice that higher in the sky, as the color deepens, that it appears lighter on one side or the other. This is because one side is closer to the position of the sun, and will thus appear lighter than the other side. This effect is more apparent in the morning and afternoon than it is at midday when the sun is at its highest position. Incorporating these two observations into your work will give even a clear blue cloudless sky greater depth and drama.

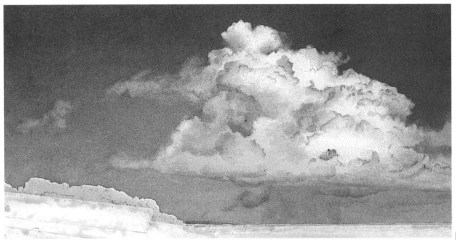

4 | Develop the Interior Portions and Create Patterns

Soften the contour of the cloud with a combination of three techniques. First, using a Pink Pearl eraser, go over the edges of the cloud (make sure the paper is completely dry when you do this). Then using a synthetic brush, scrub the edges of the cloud with clear water, being careful not to scrub too much at one time or you may damage the paper. Be prepared to dry the paper with your hair dryer and try this scrubbing technique again. Use your sable brush to dampen the edges of the clouds, then drop in more of the sky mixture, letting it blend into the edges of the cloud.

Begin to develop the rain falling from the bottom of the cloud with a physical mixture of Burnt Umber and Cerulean Blue. Turn your attention to developing the interior portions of the cloud. Use the color mixture for the sky plus Burnt Umber and a little Winsor Violet. Add this to the mixture used to paint the falling rain. Dampen areas of the cloud with clear water and drop some color on these areas. Also apply color to dry areas and take clear water to soften the edges of each facet of the cloud. Periodically dry everything with a hair dryer and then repeat this process. From time to time, after the sky has been thoroughly dried, use a squirt bottle to spray the whole sky and gently blend everything with your largest flat brush. Vary the combination of colors as you develop the cloud. Mix up the aforementioned techniques and look for interesting patterns as the cloud develops.

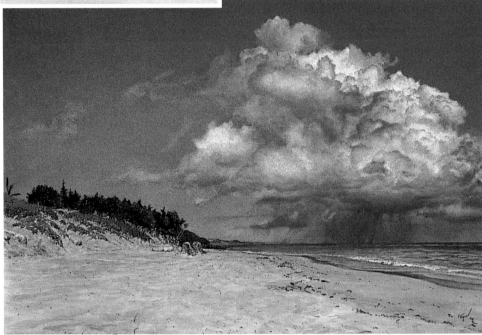

5 | Integrate the Cloud and Sky

Remove the mask from the rest of the painting and develop it so it integrates with the sky. Using Chinese White is an option. Use a few small touches of it in this painting near the horizon, on top of the previously painted falling rain. If you prefer not to use any white, those spots can be either picked out with a Pink Pearl eraser or scrubbed out with a synthetic brush. At this time, you may wish to go over some or all of the cloud with Chinese White to further soften it. I didn't do that for this demonstration, but you may wish to experiment with that technique and see if it is to your liking.

DEMONSTRATION
A Body of Water

What is the texture of water? Does it really even have a texture? For the purposes of painting, the answer is yes, it does have a texture. As to what the texture of water is, that depends. The texture of water is complex and varied, depending on a number of factors. Among those factors are its movement, visible sediment, the angle from which it is viewed and, of course, light. These factors and others produce the many textural characteristics found in water.

The principles discussed here apply to any relatively calm body of water. The first two things to consider are reflectivity and the volume of space from the foreground to the distant shore. To help you understand and visualize the reflectivity of water, think of a mirror or better yet, get one and lay it flat on a table. Then place some objects near the mirror and observe them from different angles.

Materials List

COLORS
Cerulean Blue · Dioxazine Violet · Phthalo Green · Prussian Blue · Yellow Ochre · Chinese White (optional)

BRUSHES
1-inch (25mm) flat · No. 3 or 5 round sable · No. 8 or 10 round · Old brush

OTHER MATERIALS
Liquid masking solution · Pink Pearl eraser · Rubber cement pickup

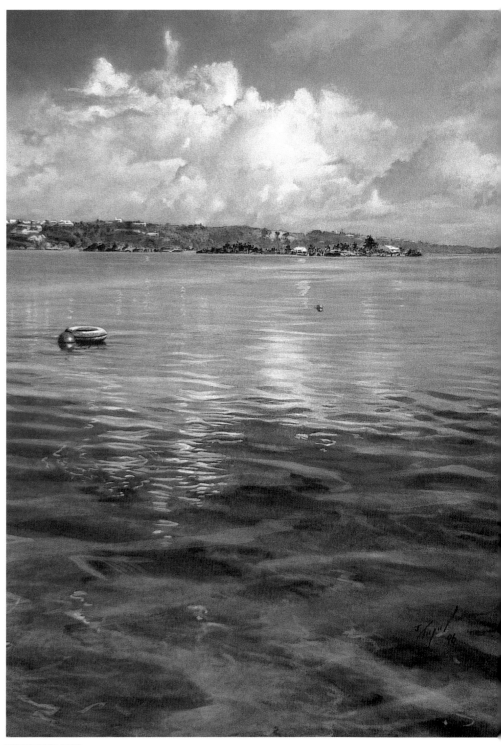

TRUNK ISLAND
14" x 11" (36cm x 28cm) · Private collection

1 | Paint the Object to be Reflected and Apply an Underpainting

To accurately paint a reflection, first paint the object that is to be reflected. In this demonstration, it is the clouds in the sky. You don't have to finish painting the object, but the more completely you understand the object being reflected, the more accurately you will be able to paint it. Refer to the demonstration on pages 76-78 to see how to paint clouds.

Typically there is less contrast in a reflection and the colors appear cooler, so apply a wash to the water using a mixture of Cerulean Blue, Phthalo Green and Prussian Blue. The lightest light in the water should be darker than the lightest light in the sky.

2 | Begin to Define the Water

Mix Cerulean Blue with Dioxazine Violet and use the no. 8 or 10 round to make a series of fluid, semi-horizontal brushstrokes. Work from the background toward the foreground with a fully-loaded brush, pulling back and forth across the paper and varying the pressure from light to heavy. Begin the stroke with slight pressure then apply a bit more pressure, then slight pressure again, almost lifting your hand at the end of the stroke. It may help to practice this brushstroke on a piece of scrap paper first. Remember, these brushstrokes represent the ripples of water as they move toward you, so make the brushstrokes larger as you move into the foreground. Do this step several times. Because watercolor is transparent, this technique will add complexity and visual interest to the water.

Create the Feeling of Light Dancing on Water

To create the feeling of light dancing on water, apply dots of masking fluid randomly on some of the highlights in the water. After building up several layers of paint to create the effect of the ripples on the water, remove the masking fluid with a rubber cement pickup. Pick out additional points of light in some areas using a single-edged razor blade. Apply dots of white paint to other areas. Each of these techniques will react to light differently. Therefore, when a viewer walks in front of the displayed painting, the light on the water appears to dance.

TIP • The surface of water often appears to be like a mirror, but the movement of water distorts the mirror effect, resulting in ripples. As ripples form on the surface of the water, the side of the ripple that faces the source of light is reflective, but the side of the ripple that is in shadow is no longer reflective. The shadow side now acts more like a window revealing what is below the surface.

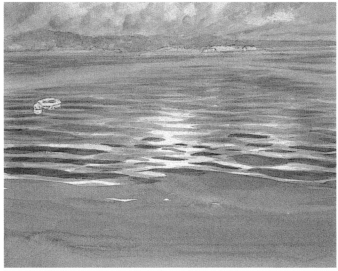

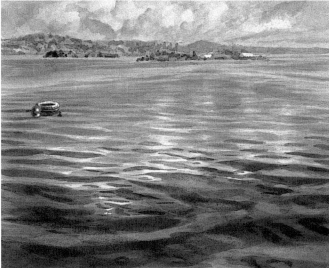

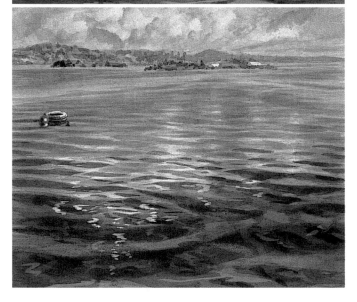

3 Develop Ripples

Continue to develop the ripples of water in the background and in the foreground. Look for patterns of light and dark that you can develop into ripples. To reinforce these developing patterns and to develop more contrast, further darken some of the emerging darks in the water. Apply a mixture of Prussian Blue and Yellow Ochre to the bottom of the painting then integrate that same mixture of paint into the ripples in the middle ground.

4 Develop the Darks

At this point finish the detail on the distant shore. Develop the darks of the ripples in the foreground and integrate them into the middle ground. Look for the light and dark areas in the sky and develop their corresponding reflections by adding color to the water in some places and erasing some color with a Pink Pearl eraser.

The inner tube and the red balls floating on the water's surface are boat moorings. They are painted after the water in the middled ground is painted.

5 Add Body Color

If you wish you may add some body color at this time. To further embellish the cross currents and the undercurrents in the water, add a touch of Chinese White to Yellow Ochre and apply it to the water in the foreground. Next, add some Chinese White to further extend the light areas in the water caused by the clouds. This same effect could be made by applying masking solution and then painting the water as was done in *Moon Over Harrington Sound* (see page 125).

TIP • As a breeze blows across water, it interrupts the water's movement and breaks up the reflection. In this demonstration that is indicated by the light green passage seen in the middle ground. This effect is also used as a directional line to lead your eye toward the island in the distance.

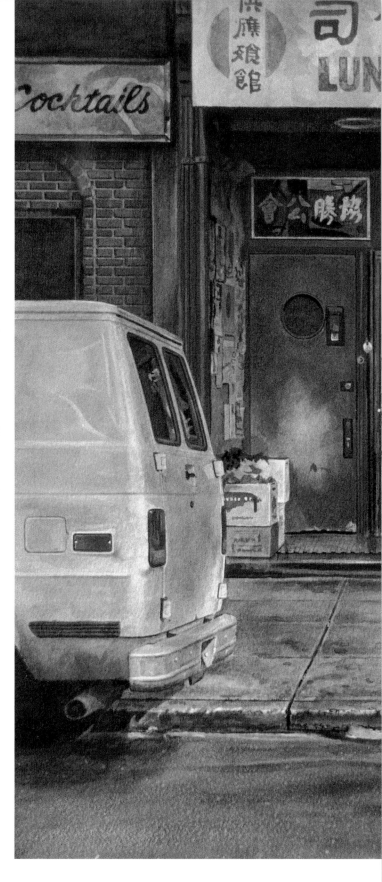

6

Painting Man-made Textures

We encounter man-made textures as a normal part of our everyday modern life. Too often artists shy away from painting common man-made elements and subjects, perhaps thinking these subjects are too mundane, banal or even ugly. Of course a painting doesn't necessarily have to be beautiful to be a successful work of art.

But when you really take time and observe, you may find there is real beauty to be found in these subjects. Using light and texture you can create compelling and even beautiful paintings of everyday subjects, transforming the mundane into the sublime and the banal into the profound.

This chapter focuses on several man-made textures in different lighting conditions. It also introduces you to techniques needed to make those textures look believable in your watercolor paintings.

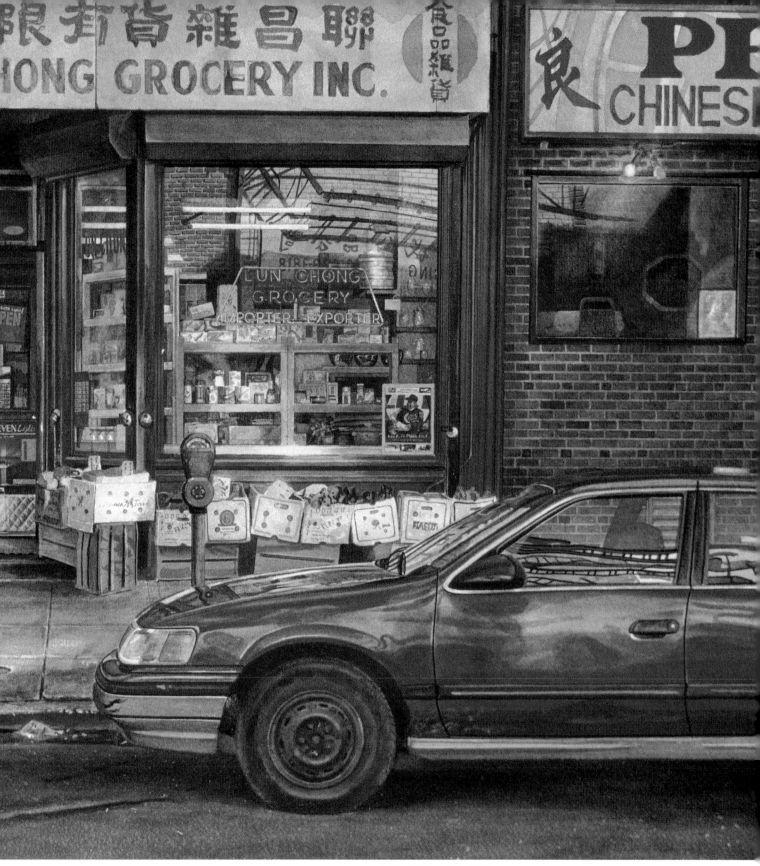

LUN CHONG GROCERY
14" x 19" (36cm x 48cm) • *Private collection*

DEMONSTRATION
Rusted Metal

This painting is about the unintended, or perhaps intended, consequences of man's technological development. The scene is bathed in a bright cold winter light that spills through the branches of this once lovely forest onto a repository for the discarded icons of industry. This amazing array of no longer precious metals produces but one final product—rust.

For this demonstration we are concentrating on a small section of the painting above, the rusted door of an old company van.

Materials List

COLORS
Burnt Umber • Cadmium Red • Cerulean Blue • Hooker's Green • Permanent Alizarin Crimson • Prussian Blue • Sepia • Venetian Red • Chinese White (Optional)

BRUSHES
Nos. 3 and 5 round sables

OTHER MATERIALS
Single-edged razor blade

Examples of Rust

Rust grows on unprotected metal surfaces and looks a bit different depending on the kind of coating the original surface had. For example, compare the difference between the rust on the red truck's door, the airplane wing it sits on and the chrome bumper on the white car next to it. As rust begins to form on a chrome bumper, its mirror-like finish begins to flake off and the bumper begins to look like a strange mosaic. You will find many examples of rust in this painting.

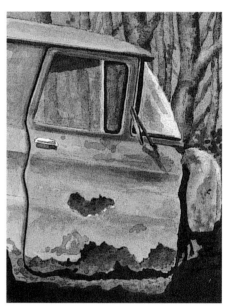

1 | Paint Local Color

After painting much of the background, use a no. 5 round sable to paint the body of the truck with a mixture of Permanent Alizarin Crimson and Venetian Red. Paint the inner front fender of the truck with Cerulean Blue and a touch of Permanent Alizarin Crimson. Then apply a mixture of Venetian Red and Burnt Umber to the rusted area on the bottom and in the middle of the door.

2 | Use Wet-Into-Wet to Develop the Rust's Texture

Using a random mixture of Cadmium Red and Permanent Alizarin Crimson, continue to paint the faded paint on the truck. Apply another mixture of Venetian Red and Burnt Umber to the rusted surfaces of the truck's body. While that paint is still wet, drop in a slightly thick application of Hooker's Green to the upper edge of the rusted spots. Dampen the inner fender at the front of the truck with clean water then drop in a little Venetian Red and let it spread. Apply dots of concentrated color to the rusted areas. Those dots will dry with hard edges and give more texture to the rusted surfaces.

3 | Add Darks and Finishing Touches

Repeat Step 2 as necessary. Add Sepia and Prussian Blue to the darkest areas on the rusted surfaces adding any necessary darks to continue developing the texture of the rust. For even more texture introduce a little drybrush to the rust. Combine all the previous techniques to develop the rust until you are satisfied. Add highlights to the bottom edges of the rust by scraping with a single-edged razor blade or using Chinese White, or both.

DEMONSTRATION
Peeling Paint

Rodio's is one of those unpretentious little places you see along old two-lane highways that offers hungry travelers good food, cheap prices and lots of hot coffee. There is a variety of interesting textures here to paint—dirt, metal, plastic and, as demonstrated, paint peeling from the building's wood siding.

Regardless of the surface, when paint begins to peel, similar things happen. So the techniques in this demonstration can be used to represent other peeling painted surfaces as well.

Materials List

COLORS
Burnt Umber • Cerulean Blue • Prussian Blue • Raw Umber • Sepia • Ultramarine Blue • Yellow Ochre

BRUSHES
No. 3, 4 or 5 round sable

TIP • The light in this painting is similar to the light in *The End of Industry* except this time the light is warmer. This affect is achieved by underpainting a graded wash of Lemon Yellow in the sky beginning at the horizon line and moving up to clear water. I then painted a series of graded washes first using Cerulean Blue and then mixing both Ultramarine Blue and Prussian Blue with the Cerulean Blue.

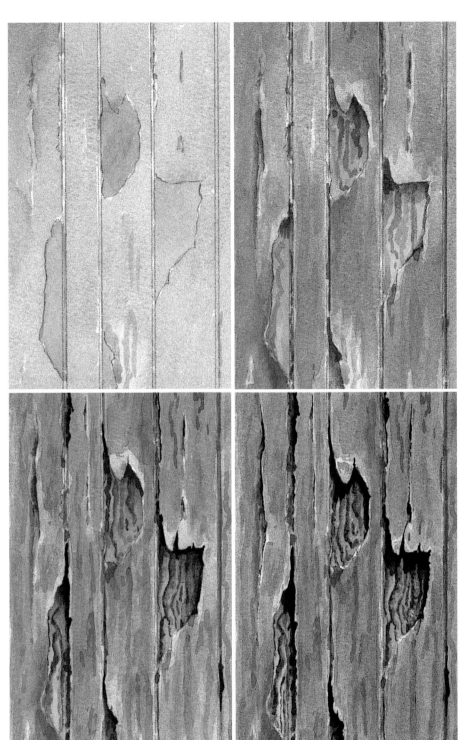

1 | Define the Large Areas Where Paint is Peeling

Draw the siding and then draw the areas where the paint is peeling. Using either a no. 3, 4 or 5 round sable (whichever you have available), paint the building with Cerulean Blue (with the exception of those areas where the paint has peeled away). In those areas, apply a mixture of Yellow Ochre and Raw Umber.

2 | Determine the Light's Direction

Determine the direction of your light source and with the same brush and Burnt Umber and Sepia, begin to put in some shadows and highlights. Also begin to indicate the grain of the wood, both on the exposed surfaces and what is visible through the weathered paint. Begin to paint the shadowed edge of the exposed wood by applying a mixture of Burnt Umber and Sepia to the edge and blending it out with clear water.

3 | Add More Texture

With the same brush, continue to develop the texture on both the painted and unpainted areas of the siding by adding ever deeper intermediate darks. Continue to develop the wood grain, especially on the unpainted surfaces, using Burnt Umber and Sepia. Create a sharp edge on one side of the grain and a softer edge on the other by dampening the edges with clear water and pulling the paint to the side. Use a little Ultramarine Blue mixed with Cerulean Blue to indicate shadows on the painted surfaces.

4 | Finishing Touches

Intensify the color on both the painted and unpainted surfaces. Finish development of the exposed wood and use a mixture of Prussian Blue and Sepia to paint the cast shadows created from the chips of peeling paint.

TIP · Fresh paint, especially glossy paint, tends to be shiny and reflective. However, as paint weathers, it begins to appear somewhat chalky. It also begins to crack and peel away from weak spots (like the edges of boards) where water tends to collect.

DEMONSTRATION
Stone Buildings

The Woodmere Art Museum is located in Philadelphia, Pennsylvania. The Museum boasts an extensive private collection, including European fine and decorative arts as well as important works by American landscape painters such as Jasper Cropsey and Frederick Church. The collection also includes an extensive collection of the works of important American painters from the immediate area, such as N.C. Wyeth and Thomas Anshutz.

The building seen here on a bright summer day with its many additions, is an amalgam of architectural styles. The original two and one-half story mansion was first built around 1860 in the style of an Italian villa. The building is characterized by the use of indigenous fieldstone that has a somewhat random pattern, similar to that found in *Bucks County Farmhouse* (page 44). Later additions, including the four and one-half story Victorian tower to the right and the other subsequent additions to the left, employed an ever-increasing use of a more formal looking cut stone.

Stone structures of one kind or another are found virtually everywhere and make very attractive subjects for watercolor paintings.

Materials List

COLORS
Burnt Sienna • Burnt Umber • Dioxazine Violet • Prussian Blue • Sepia • Ultramarine Blue • Yellow Ochre

BRUSHES
No. 3 or 4 round sable • No. 5 round sable

OTHER MATERIALS
Pink Pearl eraser • Single-edged razor blade

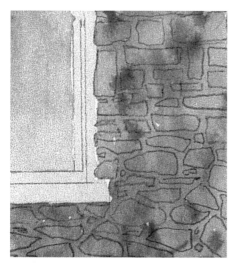

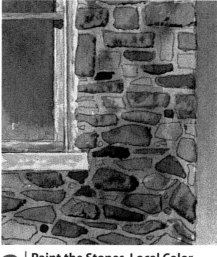

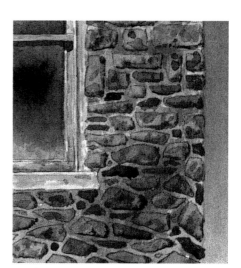

1 | Draw the Stones and Paint the Mortar

Carefully draw the stones, trying to make as many as possible overlap, this will make the building look more solid. Using a no. 5 round sable, paint the mortar by randomly applying Burnt Umber, Yellow Ochre and Sepia, some mixed, some single colors. While the paint is still wet, drop in heavier concentrations of these three colors and any other colors you would like. The randomized application of paint in this step will help contribute to the texture of the stones.

2 | Paint the Stones, Local Color

Depending on the type of stones in your building the colors in this step may vary. With a no. 3 or 4 round sable, apply a light to medium application of Ultramarine Blue to several of the stones. While still wet, apply Sepia to the lower and shadowed edge of the stones and allow the Sepia to bleed into it. Repeat this step on several of the other stones, substituting Burnt Umber mixed with a little Dioxazine Violet for the Ultramarine Blue. Repeat this step again, substituting Burnt Sienna, for the remaining stones. To create more variety, vary the intensity of these mixtures from stone to stone.

3 | Continue to Develop and Add More Variety

With a no. 3 or 4 round sable, use a random combination of Ultramarine Blue and Sepia to make a few marks here and there that indicate shadows on the irregular surface of the stones. Dampen several other stones with clean water to let more color bleed onto the stones as in Step 2. Make adjustments to the mortar as needed.

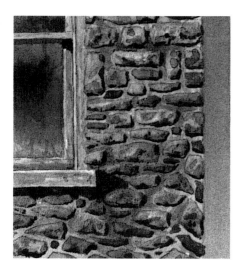

4 | Finish Developing the Texture

Paint the cast shadow under the window ledge using a mixture of Prussian Blue with a touch of Sepia. Continue to make adjustments to the mortar if necessary. Using the same mixture, add more darks to the shadow side of the stones. Pick up highlights on the stones with a Pink Pearl eraser or a single-edged razor blade if needed. Make whatever finishing touches you feel necessary until you are satisfied with the texture of the stone.

TIP · In this demo, the stones depicted on the bottom are a slightly more randomized type of fieldstone typical of a farmhouse, while the upper stones to the right of the window are a more formalized type of cut stone.

DEMONSTRATION
Brick

The city is a fascinating place to find a subject for a painting. With so much visual stimulation the city can be a real feast for the eyes. All this stimulation can be quite a challenge for the artist. With the cacophony of light and texture screaming for your attention, the job for you as an artist is to organize certain aspects of the painting and give them visual stability.

The uniform pattern of brickwork provides an excellent way to organize a textural component of your painting. It gives the painting complexity and creates a solid structure to which you can relate other aspects of your painting. Don't be intimidated by the prospect of painting all those bricks, it is actually quite easy as demonstrated in the following simple steps.

Materials List

COLORS
Burnt Umber · Cadmium Yellow · Indian Red · Prussian Blue · Raw Umber · Sepia · Ultramarine Blue · Yellow Ochre

BRUSHES
No. 3, 4 or 5 round sable · No. 8 or larger round sable or synthetic white sable

OTHER MATERIALS
Dividers · Pink Pearl Eraser (optional) · Single-edged razor blade (optional) · T-square · Triangle

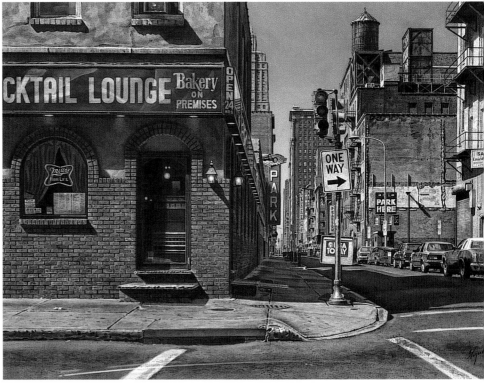

PEARSON
22" x 29" (56cm x 74cm) · Collection of the artist

Three Useful Tools

When painting a man-made structure like a building, it is important that it have a sense of solidity and stability. The more accurately you draw and paint the organized surface texture of your bricks, the more solid and stable your building will look. To achieve this accuracy, three simple tools can be used: a T-square, dividers and a triangle.

1 | Underpaint an Accurate Drawing

To successfully create the illusion of a brick building, your drawing must be accurate and the scale of the bricks needs to correspond to the scale of the building. This need not be difficult at all. With the use of a T-square and a pair of dividers one can determine the position and scale of the bricks easily and draw them accurately.

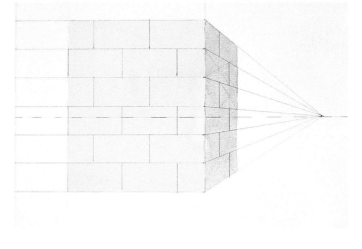

There are a variety of bond patterns for bricks. The simplest is the running bond shown here. To define the height of each course of brick, use the dividers and mark off equal increments along the vertical edge of the building you are drawing. The example shown is in one-point perspective, which means one side of the building vanishes to a single point on the horizon line and one side of the building is parallel to the picture plane (see page 28). Use your triangle to make the appropriate lines back to the vanishing point. When the drawing is complete, underpaint any areas in sunlight with Cadmium Yellow and the areas in shadow with Ultramarine Blue using a no. 8 round.

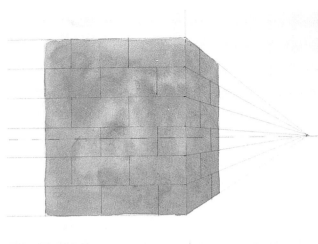

2 | Paint the Random Texture of the Mortar

With your no. 8 round, mix a puddle of Raw Umber and Burnt Umber large enough to cover the entire brick area and paint the area. While the area is still wet, drop in extra concentrations of both Umbers along with some Ultramarine Blue. This should not be applied too carefully. The randomness of this step will contribute to the texture of the mortar and because watercolor is transparent, this step will also contribute to the texture of the bricks.

3 | Paint the Bricks Themselves

Mark off the remaining edge of the mortar joint with a pencil on the sides and top of each brick. As you become more familiar with painting bricks, you may wish to skip this step and define the mortar joints by simply painting the bricks and leaving a space for the joint. With a random mixture of Indian Red, Burnt and Raw Umber and Yellow Ochre, begin to paint the bricks. Again, you can use either a no. 3, 4 or 5 round sable, but the larger brush will hold more paint and require you to reload less often. It looks more interesting to vary the color a little bit from brick to brick. While each brick is wet, drop in extra concentrations of the four brick colors along with a little Prussian Blue and Sepia. This will begin to create more texture in the bricks themselves. Remember to do this step a little bit differently on each brick.

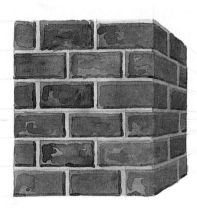

4 | Create Light and Shadow to Add Depth to the Bricks

When you have finished painting each brick, go over it again with a random mixture of the colors used to paint the bricks. Leave the upper edge of the brick and the edge facing the sun alone, as this will give each brick a stronger feeling of light and begin to create the illusion of depth. Paint the bottoms and the shadowed edges with a dark combination of the aforementioned colors. You may also wish to create even darker shadows by applying a mixture of Prussian Blue and Sepia on the shadowed edges.

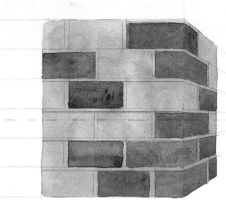

5 | Optional—Distressing the Bricks Adds Greater Visual Interest

There will probably be times when you want to create greater textural interest by distressing the bricks a little. Most of the colors used in this demo are non-staining and can be scrubbed with a synthetic white sable brush to lift some of the color from your painting. This step is useful in making the bricks look older. A mixture of Prussian Blue and Sepia makes a deep dark to depict missing or crumbling mortar. A Pink Pearl eraser and a single-edged razor blade can also be used to further distress the bricks. Drybrushing with the side of your brush is also useful in creating more texture. Combine these techniques as you wish until the desired effect is achieved.

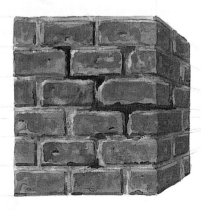

Using Brick Techniques in a Painting

When working on a complete painting, resist the urge to address too much foreground detail, like the bricks, until much of the background is developed. It is easier to relate foreground detail after you have already developed much of the background.

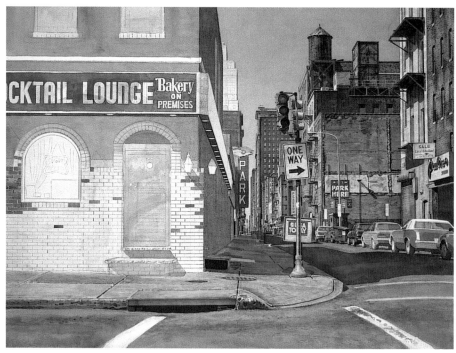

Planning Before Painting
When I was ready to add the bricks, I carefully drew the brick pattern, paying attention to unusual shapes like the arched window and the doorway seen here. As demonstrated in Step 2 (page 91), I varied the paint mixture to create more variety in the bricks.

Develop Other Areas While Painting the Bricks
I continued working on the bricks until complete. The areas that were underpainted with Prussian Blue now read as if in shadow. To make sure all elements of the painting relate to one another I continued to develop other areas of the painting as I painted the bricks.

Creating Texture, Shadow and Variety
I then turned my attention to the bricks on the side wall. As they recede from view, less and less detail was needed to paint them. I developed the texture of the bricks, adding more shadows and more variety to the mortar. I glazed more blue over the cast shadows where I needed to make them sufficiently dark.

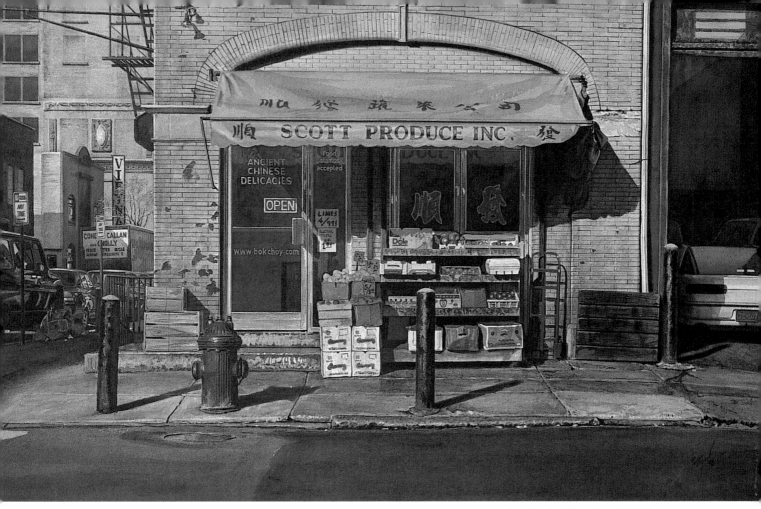

ANCIENT CHINESE DELICACIES
14" x 21" (36cm x 53cm) • Private collection

Weathered Concrete Sidewalk

The world is full of little details we often are not fully conscious of as well as some that we completely ignore as we race from one place to another. For the artist, though, focusing on little details can make a difference in the success of a painting.

To find a classic example of what I mean we need look no further than the ground beneath our feet. A city is covered with literally miles and miles of concrete. Yet how often have you taken the time to examine what concrete really looks like? Do you know its texture or how light affects it? Paying careful attention to little details like this will make your paintings believable and will give the viewer a sense of recognition and understanding.

Materials List

COLORS
Burnt Umber • Cerulean Blue • Dioxazine Violet • Hooker's Green • Prussian Blue • Raw Umber • Sepia • Ultramarine Blue • Yellow Ochre

BRUSHES
Nos. 3 and 5 round sables • No. 5 synthetic round • Toothbrush

OTHER MATERIALS
Pink Pearl eraser

TIPS · When painting sidewalks, pay careful attention to the vertical surfaces at the joint marks and the edges of each concrete section. Remember that a change of plane is a change in value, and depending on the direction of the sun, the vertical edge will be either lighter or darker than the flat surface of the concrete.

· Be sure to practice spattering (Step 2, page 94) before using this technique on a painting.

1 Pay Careful Attention to Your Drawing

People often think that sidewalks are flat, though they really aren't. Sidewalks lean this way and that, following the contour of the ground. Pay careful attention when drawing the sidewalk, the joint marks on the sides of each concrete section will both follow the contour of the ground and, if extended, would eventually meet at a vanishing point. In many older cities the curbs are made of a material other than concrete. In this demonstration, it's granite.

With your no. 3 round sable, use a combination of Burnt Umber mixed with Cerulean Blue to block in some of the concrete sections and Raw Umber mixed with Cerulean Blue for others. Use Ultramarine Blue to block in the curb. You may mix whatever other colors you wish at this point to block in the concrete. You needn't be too careful with your color mixtures. In fact, to paint a dirty city sidewalk, a little palette mud actually works just fine.

2 Use Spattering and Stippling to Develop Surface Character

Begin to develop the character of the sidewalk surface with a random mixture of colors. Place a number of little dots of color here and there with your no. 3 round sable. This technique is called stippling.

Mask off those areas you don't wish to spatter. You needn't use masking solution or frisket paper. Old scraps of paper or anything else you have handy will work fine. Take the toothbrush, dip it in some of your paint, rub your thumb across the brush and spatter small drops of color on the sidewalk. Wetter mixtures of paint will produce larger dots and denser mixtures will produce smaller dots. These dots will become the stone aggregate seen in the concrete. If the spattered marks look too strong, use your no. 5 round synthetic to blend them so that they don't look so obvious. Use the stippling technique on the granite curb only, and develop its texture.

3 Interweave Washes of Color

Interweave small washes of color here and there with the stippling and spattering techniques, using each of the remaining colors listed to add variety and dimension to the sidewalk. Vary the way the paint is applied. Blend a little extra color along the edges of each concrete section. Scrub off and blend some of the stippled and spattered areas with a synthetic brush to make them less noticeable. Combine techniques from Steps 2 and 3. The more complexity you have, the better your sidewalk will look. Continue to develop the texture on the granite curb.

4 Finishing Touches

Introduce more Cerulean Blue to the mix of colors to gray the sidewalk down. Use your synthetic brush to further blend the colors. After that, you may wish to try using a Pink Pearl eraser on some areas to remove any excess or unwanted color. The scrubbing action on the surface of the paper will also contribute to the concrete texture. Paint the cast shadows and remember that they too follow the contour of the sidewalk. Put in whatever remaining darks are necessary on both the concrete sidewalk and the granite curb.

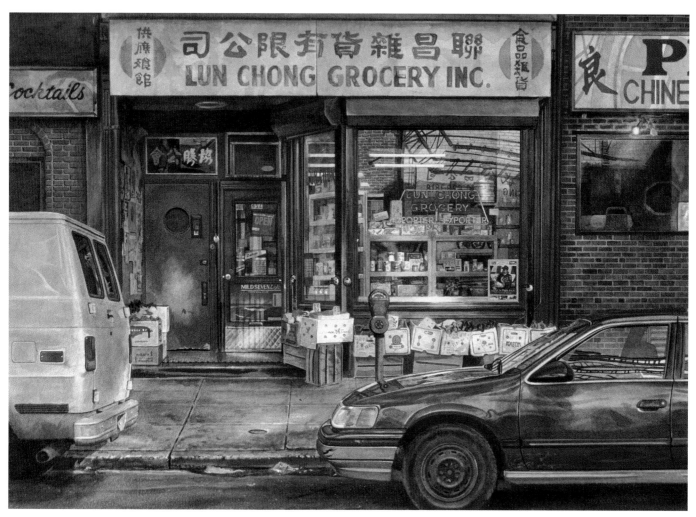

DEMONSTRATION
Metal Reflections

The city's almost endless array of color, light and texture has been a source of inspiration to artists for years. There are many wonderful and challenging textures to paint in the city. Certainly among the most fascinating and challenging are the many reflective surfaces one finds in the city. Reflections add strong visual interest to a watercolor. The twisted and distorted reflections on the surface of an automobile are particularly interesting to paint.

In the painting *Lun Chong Grocery,* the scene is made even more interesting because of the light. The scene is in shadow, but reflective light bounces from across the street on both the car and the

buildings behind it. Some artists might feel a little overwhelmed at the prospect of trying to paint these seemingly complicated patterns, but these patterns can be taken apart and put back together in a clear and understandable way.

There are several other reflective surfaces in this painting, but this demonstration will focus primarily on the car and refer to the background only as it relates to the reflection on the car. Remember that all reflections act like mirrors to one extent or another. When painted correctly, reflections, even twisted and distorted ones like those found on the car, will be plainly visible and make sense to the viewer.

Examine and Analyze Reflections
Before the reflections on the car can make sense to the viewer, they have to first make sense to you. So take time to carefully look at and analyze the distorted reflection and determine exactly what is being reflected where. Once you have determined exactly what you are looking at, it will make painting it a lot easier.

LUN CHONG GROCERY
14" x 19" (36cm x 48cm) • *Private collection*

Materials List

COLORS
Cadmium Red • Cadmium Yellow • Deep Cerulean Blue • Dioxazine Violet • Perylene Maroon • Prussian Blue • Quinacridone Burnt Scarlet • Quinacridone Gold • Sepia • Ultramarine Blue • Yellow Ochre

BRUSHES
Nos. 3 and 5 round sables

OPTIONAL
A couple of French curves

Relections Vary

Different materials vary in their amount of reflectivity. There are many examples of reflective objects in this painting. Note that the side of the car does not appear as reflective as the car's hood, windshield or side glass, which suggests that the paint on the side of the car has oxidized. If you look closely, you can still see the reflection of the building across the street in the dull paint, but the edges are not as crisp as those elsewhere on the car.

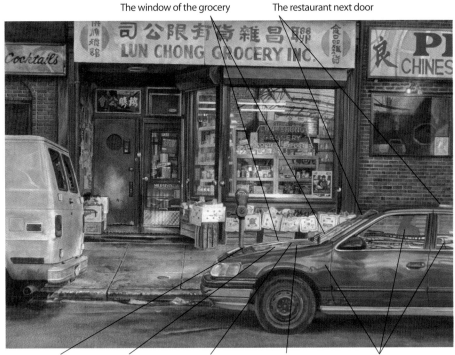

The window of the grocery The restaurant next door

The parking meter The yellow product display The bottom of the window The neon signage The building across the street and the blue sky

1 | Draw the Car and Apply the First Washes

Take time to carefully draw all the major aspects of the car, then carefully draw the reflection. Whether or not you choose to draw an accurate "portrait" of a particular car, as shown here, is up to you. What is more important is that you accurately draw the reflection so that it will make sense in the context of the painting.

Apply a wash of Quinacridone Gold to the body of the car with a no. 5 round sable. Over that, apply Perylene Maroon as indicated in the illustration. Apply Cerulean Blue to the side glass and Yellow Ochre to the reflection in the glass. Apply a mixture of Sepia, Ultramarine Blue and Prussian Blue to the tire and the wheel, and Cadmium Red mixed with Cadmium Yellow Deep to the side window. Use a no. 3 round sable to begin the finer detail of the reflection on the car's hood.

TIP • A set of French curves can be very helpful when drawing the car.

2 | Block in the Background

With the no. 5 round sable begin to block in the background, and as you do, apply a mixture of Perylene Maroon and Quinacridone Burnt Scarlet to the red areas of the car. Apply a mixture of Dioxazine Violet and Ultramarine Blue to the car's dark trim. Apply Ultramarine Blue and Sepia to the wheel and tire. Apply a second wash of Yellow Ochre to the reflection on the side glass. Notice which reflections should have hard crisp edges and which reflections are soft.

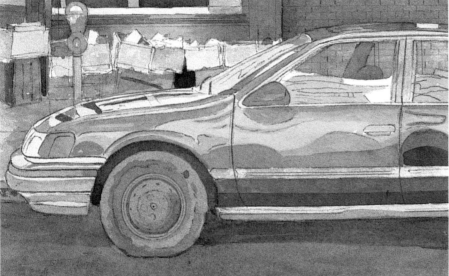

3 | Add Intermediate Darks

Continue to develop the background. Use the no. 3 round sable to add more color and detail to the reflection on the car's hood. Add more color to the bottom of the car. To make the car's side window look both reflective and transparent, draw the bricks that are visible through the car's glass (note the difference in color and value between the bricks seen through the window and those that are not). The bricks seen through the window are bluer and lighter because they are seen through the reflection of the sky above the building across the street.

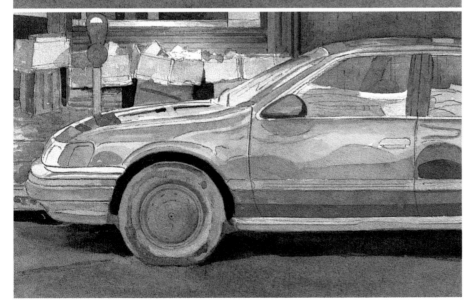

4 | Introduce a few Deeper Darks to Create Contrast

Add more color to the background as indicated in the illustration. Add still more color and refined detail to the car's hood. Use the tire colors to paint the parking meter seen in the reflection on the car's hood. With a mixture of Prussian Blue and Sepia, continue to develop the car's tire and also begin to develop some of the darks underneath the car, here and there in the background and on the car's side mirror. Apply another wash to the street. Darkening the area around the car will make the car appear lighter and brighter.

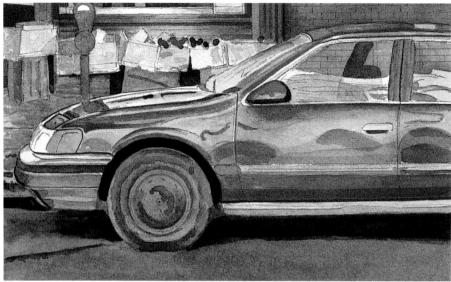

5 | Add More Intermediate Darks to the Car

Continue development of the background. Add more intermediate darks to the car's body, tire and trim. Here and there add Dioxazine Violet to the Perylene Maroon and Quinacridone Burnt Scarlet mixture to make a deeper red on the car. Then focus attention on the hood and the windshield of the car and develop them further. Add still deeper darks to the inside door pillar of the car, to the tire and to the bumper.

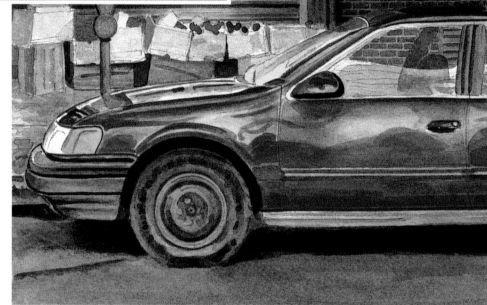

6 | Sharpen Detail With Less Water

From this point on, to assure greater brush control, use only the no. 3 round sable. Begin to sharpen some of the details on the hood of the car and the windshield. Paint the bricks both in the background and the ones visible through the car's window. Continue to develop the tire. Add more darks to the car's bumper and trim. As you continue to develop the car, begin to use less water and glaze the color onto the car's body to make a still deeper red.

Continue to refine the details of the reflection on the hood of the car and the windshield. Finish painting the reflection on the side window. Paint the car's front headlight. Finish painting the car's trim and paint the car's door seams. Add enough color to the white boxes in the background to make all the highlighted areas on the car and elsewhere in the painting look bright by contrast.

TIP · Remember that like mirrors, reflections read backwards. The reflection of the sign on the building across the street reads backwards in the grocery window. The grocery window is reflected on the car and is also upside down.

DEMONSTRATION
A Rainy Evening

As night falls the mood of the city changes. Even more so on a cold, dreary evening like the one depicted in *Toto*. The light, dispersed by the rain, sparkles and glows as it bounces from one wet surface to another. The hard edges of the city appear to dissolve into the mist and its colors seem to melt and run down the sidewalk.

Materials List

COLORS
Burnt Umber · Cadmium Red · Cadmium Yellow · Cerulean Blue · Prussian Blue · Quinacridone Gold · Raw Umber · Sepia · Ultramarine Blue

BRUSHES
Nos. 2, 3 and 5 round sables · No. 9 or larger round sable · No. 4 round synthetic · Old brush

OTHER MATERIALS
Liquid masking solution · Pink Pearl eraser · Rubber cement pickup

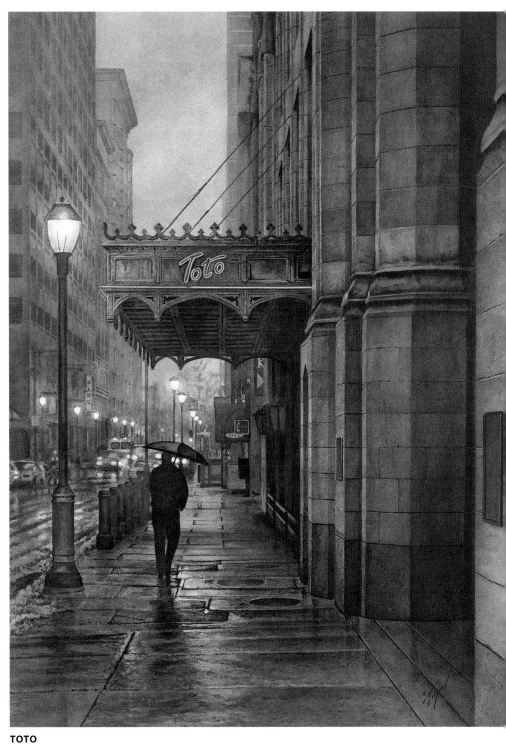

TOTO
20" x 14" (51cm x 36cm) · Private collection

1 | Do Drawing and Establish Underpainting

Except for the angled wall on the right, draw all the primary elements, (the street lights and buildings) to vanish to a single vanishing point on the horizon line. The angled wall vanishes to a separate point to the left but also on the horizon line. After you have completed your drawing, use the largest round brush you have to apply Quinacribone Gold over the entire painting. Apply Cerulean blue to the right of the figure and then mask off the lights with liquid masking solution and begin to establish the underpainting with your no. 5 round sable. Apply a couple of Cerulean Blue washes to the sky, washes of Burnt Umber with a touch of Prussian Blue to the buildings on the left, and washes of Ultramarine Blue with a touch of Sepia on the right.

2 | Work Background Wet-Into-Wet

Apply more Cerulean Blue over the sky and while still wet, apply Burnt Umber mixed with a little Ultramarine Blue to indicate the tree branches in the background. Repeat this if necessary. Dry thoroughly, apply clean water and continue to develop the background using the wet-into-wet technique. Each time you repeat this step remember to dry your paper thoroughly. Continue to block in color as shown in the illustration.

3 | Use Stippling to Further Develop Background

With your no. 5 round sable, apply a rather deep wash of Ultramarine Blue and Sepia to the figure, while still blocking in certain parts of the painting. Further develop the background by gently dripping or stippling paint with a no. 2 round sable. As you continue this technique it will create jewel-like facets of color that replicate the effects of light glinting off of wet surfaces. Begin to paint the aura around the lights, but don't yet remove the masking solution. After the background has been developed, remove the masking solution with a rubber cement pickup. Rub the edges of the lights with clean water and a no. 4 round synthetic to soften them. Begin to develop the sidewalk as shown in the illustration.

4 | Focus on the Sidewalk

After applying a few broad washes to the sidewalk with your no. 5 round sable, begin to develop both the sidewalk's texture and the light bouncing off of it by dripping or stippling another series of drips and dots of color along the sidewalk with a no. 3 round sable. Use Cadmium Yellow for the reflection of the streetlights, Cerulean Blue for the reflection of the sky, Burnt and Raw Umber sometimes mixed with Ultramarine Blue for the reflection of the buildings, and Cadmium Red for the reflection of the *Toto* sign. Continue to develop the rest of the painting as shown in the illustration.

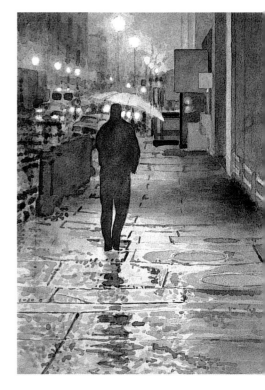

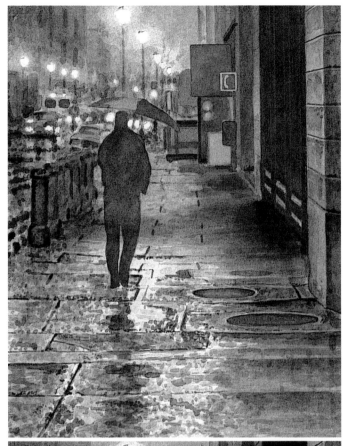

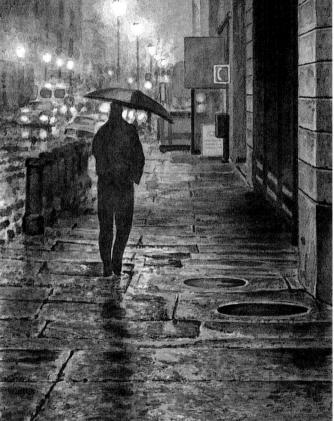

5 Deepen the Color on the Sidewalk and Refine Detail

Paint the umbrella. This will make the lights in the background start to pop. Apply more Cerulean Blue to the sky to deepen its color, but do not apply any near the streetlights. Continue to develop the background. Add more Cadmium Red and Cerulean Blue to the sidewalk. Add more Burnt Umber, Raw Umber and Sepia with a little Ultramarine Blue and Prussian Blue to the dark areas of the sidewalk. Pick out and refine details with a no. 3 round sable. At this point apply the paint with less and less water, as this will allow the colors to become more intense.

6 Finishing Touches

Now begin to pull all the disparate elements of the painting together. Finish painting the details throughout the painting using the no. 3 round sable. Make any necessary adjustments. For example, if any areas appear too dark, first dry the paper and then go over the area with a Pink Pearl eraser. This will likely leave little skips on the paper (from the high spots in the paper) and will not only help adjust the values but will also impart the texture of the rain and mist. Continue to deepen the color of the sidewalk. Because Cadmium Red, Cadmium Yellow and Cerulean blue are all opaque pigments, they can be applied over previously painted colors to make a seamless mosaic of color and texture. That being said, if you choose to apply them over previously painted darks, you will probably have to hit those areas two or three times to get the desired intensity of color sufficient to cover the darks.

Light Pollution

In the city, or any place else with a lot of artificial light, on rainy evenings the sky will frequently appear lighter than it does on a clear night. This is due to the light bouncing from one surface to another. The light bounces not only from building to building, but it also bounces off the mist caused by the falling rain.

Painting Textures of People

Have you ever noticed that a lot of very fine watercolorists never paint portraits or put any people in their paintings? Many think it would be too difficult to paint people properly so they don't even try.

Frequently, though, the inclusion of a figure or figures in a painting is very important to the composition or design of a painting. Painting portraits in watercolor is not only very satisfying, but it's also not that difficult. In fact, watercolor is well-suited to a whole host of different approaches for painting people. You will find the versatility is limitless, from fast, loose and exuberant to very careful and methodical, all well-suited for painting people.

This chapter will discuss several of the issues an artist encounters when painting people. It will discuss the benefit of using people in your composition, what their inclusion does for your painting and when people are not needed in a watercolor. You will learn how to paint the texture of people

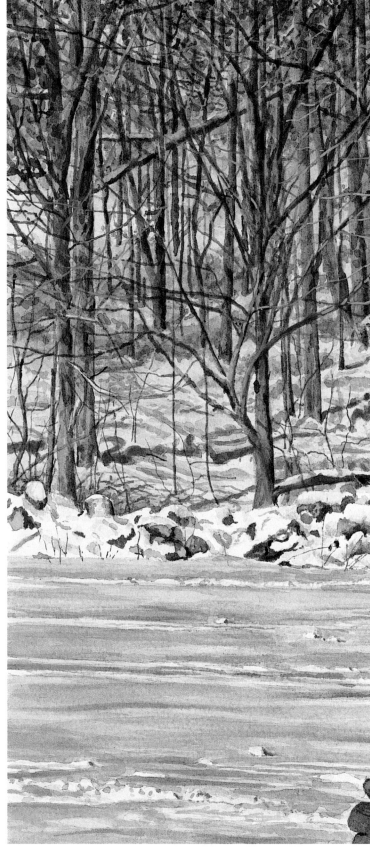

and then learn how to use this information to create stronger paintings. This chapter will also demonstrate techniques specific to painting people in watercolor.

EILEEN IN WINTER

11" x 15" (28cm x 38cm) • Private collection

Why Use People?

Typically when we examine a scene, the process of selecting what to look at first happens quickly and on a subconscious level. Each of us is instinctively drawn to look at those things that provide us with the greatest visual stimulation or interest. Visual interest can come from many sources. Light, texture, color, size and shape can be used to create visual interest in a painting.

What each of us considers visually interesting varies from person to person. However, one thing is universal: Instinctively there is no other shape more interesting for us as humans to look at than another human being. Even when looking at an abstract or non-objective painting, you will often find yourself gravitating to the sensuous, organic, humanistic marks and shapes in the painting.

The inclusion of people can frequently change the texture or indeed the whole meaning of the painting, rendering other elements in the painting secondary in terms of visual impact. It is up to the artist to be conscious of how to use people in a painting—and when to leave them out.

These concepts work not only in the following three examples, but also throughout this book.

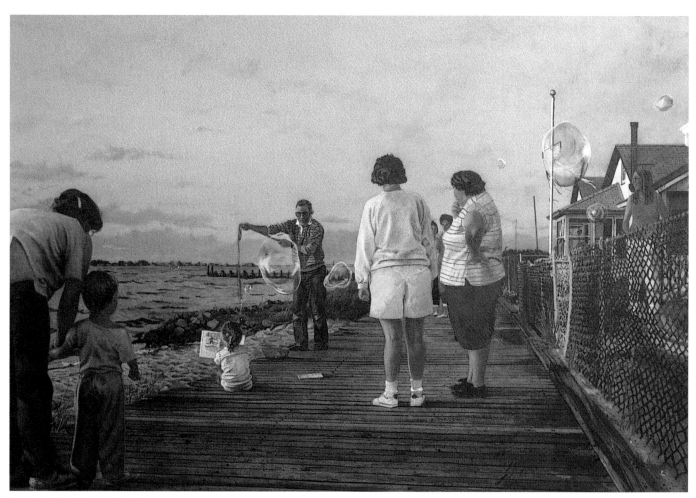

People Dominate the Scene

An impromptu gathering of people stopped to watch a man as he vainly attempted to capture his small child's interest by making these enormous bubbles. As the crowd gathered, his daughter sat reading a book, oblivious to the situation.

The landscape in this painting, even with the lovely light from the setting sun, is secondary to the activity of the people. In fact, you could change the background entirely and the primary content of this painting would remain essentially unchanged.

THE BUBBLE MAN

14" x 20" (36cm x 51cm) • Private collection

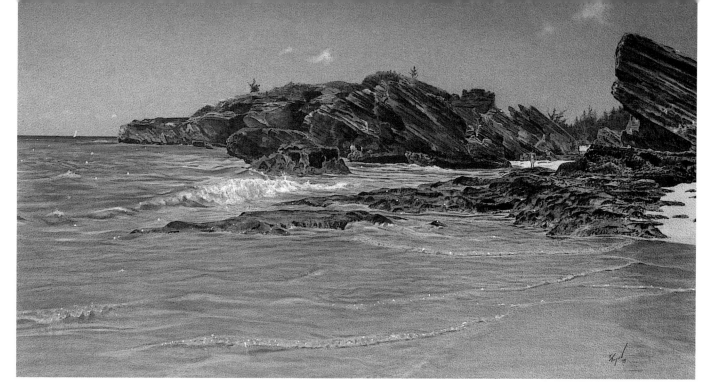

People Can Help Determine Scale

Even when a painting is not specifically about the people in it or the figures are not meant to dominate the composition, people may still play an important role in the painting. The painting *Peel Bay* is really more about the scene itself, and at first glance you might not even see the figure in this painting. (He's on the right, between the rocks.) Once you see him, you realize that the rocks in the painting are larger than you probably first thought. Since we all know the approximate size of an adult male, once you notice him in the painting you determine the relative size of the surroundings without even consciously thinking about it.

PEEL BAY
13" x 21" (33cm x 53cm) • *Private collection*

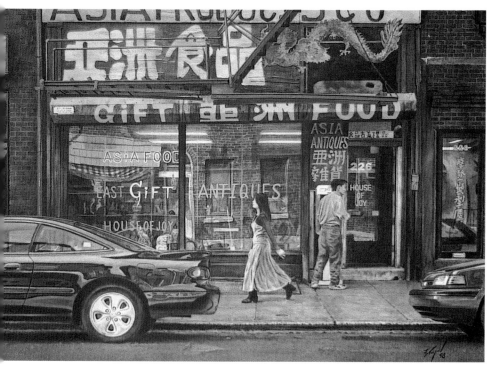

Figures Become a Natural Focal Point

House of Joy is located right around the corner from the Lun Chong Grocery (page 95). They have similar light and textural elements and also a somewhat similar color palette. But there is one very important difference between the two paintings, the inclusion of figures.

Notice how the car and the very interesting reflection on it are barely visible when figures are included. Your eye goes first to the figures, especially the woman. Block out those figures and see what a different painting this would have been without their inclusion.

HOUSE OF JOY
14" x 20" (36cm x 51cm) • *Private collection*

DEMONSTRATION
Human Eye

When painting people there are several textural elements to consider: the pose, the texture of their skin and hair, even their teeth. Let's begin with one of the most basic and important elements to consider—the human eye. Bright sparkling eyes will enliven your model's appearance. One of the first things I noticed about Sophie when I met her were her large, beautiful eyes.

Seeing Eye-To-Eye

Legend has it that English painter Sir Joshua Reynolds, 1723–1792, the leading portrait artist of his time, discovered that if you increased the size of your model's pupil slightly, it made the model more appealing to look at without the viewer actually knowing why. He would do this for his younger models of course, but he could also do the same for an older model. Conversely, since the opposite is also true, he could constrict the pupil of those models with which he had some beef. The viewer of such a painting may very well have said, "I don't know what it is about the person in this painting, but there is something about them I don't like!"

Materials List

COLORS
Cadmium Red · Cerulean Blue · Chromium Oxide Green · Indian Red · Perylene Maroon · Prussian Blue · Raw Umber · Sepia · Yellow Ochre

BRUSHES
No. 5 round red sable

OTHER MATERIALS
Single-edged razor blade

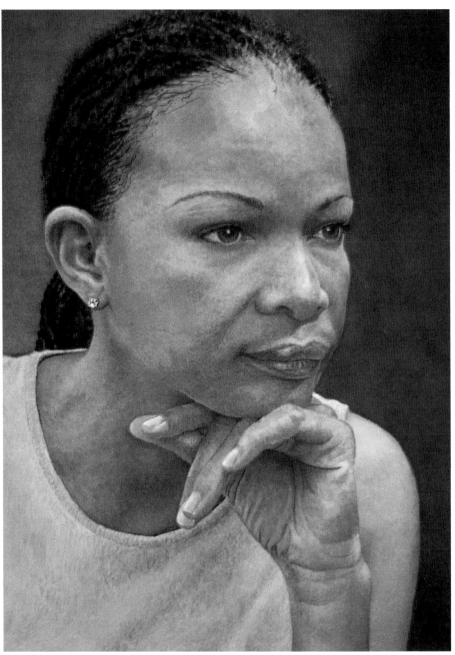

SOPHIE
11" x 8" (28cm x 20cm) · Private Collection

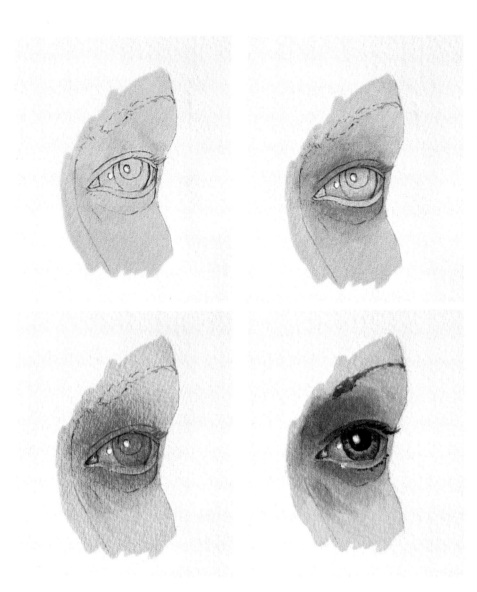

1 | The Whites of the Eyes are Not Really White

When painting the eyes the first thing to note is that the whites of the eyes are not really white. After doing a careful drawing, use the no. 5 round to paint the entire area with a combination of Cadmium Red and Yellow Ochre, reserving white paper only in the highlights of the eyeball.

2 | Add Volume and Dimension to the Eyeball

Apply Cerulean Blue to the top and bottom of the eyeball. This will help the eye begin to look round. Apply the Cadmium Red and Yellow Ochre mixture to the upper and lower eyelids

3 | Add Interest to the Eye

Next apply a mixture of Raw Umber and Sepia to the iris and a mixture of Perylene Maroon and Cadmium Red to the tear duct in the corner of the eye. The whites of the eye will begin to look very light by now, so apply more Cerulean Blue. Remember to reserve the white highlights on the eyeball. Leave a little gap between the inside of the bottom eyelid and the whites of the eye. This will become another reflective spot and help the eye look wet.

4 | Finishing Touches

Apply a mixture of Prussian Blue and Sepia to the pupil. Make the pupil slightly larger than it appears on the model. Apply Chromium Oxide Green to the upper eyelid and Indian Red to the lower eyelid. Darken the edge of the iris and put in small lines for the nerve endings with some Raw Umber. Paint the eyelashes and the eyebrow with Sepia. Last, use a single-edged razor blade to pick out a highlight on the edge of the lower eyelid (beneath the highlight on the white of the eye). The highlight on the lower eyelid should go all the way from the tear duct to the corner of the eye.

TIP · Make sure to put brilliances in the darks and shadows when painting a portrait. Slightly heavy applications of colors like Perylene Maroon, Dioxazine Violet, Indian Red or Burnt Sienna are more satisfying than colors like Indigo, Neutral Tint or Sepia when painting the darks and shadows of the human face.

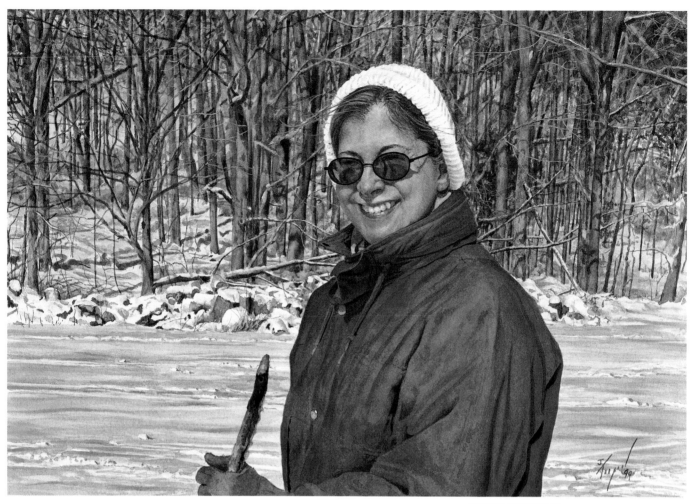

EILEEN IN WINTER
11" x 15" (28cm x 38cm) • Private collection

Mouth and Teeth

When you look at portraits throughout history you don't really see a lot of people smiling. The Mona Lisa is of course a well known exception. I suppose there are many reasons why this is the case but none of the reasons should be that you are afraid to try it. A bright smile is similar to sparkling eyes in that it can make your model look more appealing.

Many artists avoid painting a model smiling, thinking that painting the teeth is too difficult. But what do you do when a smile is so much a part of someone's personality that by omitting it, the the painting would be missing something essential?

This is a painting of my wife Eileen out for a walk on a winter day. Anyone who knows her is also familiar with her bright, beautiful smile. The thing that makes this watercolor work is the fact that I painted her smiling.

Materials List

COLORS
Cadmium Red • Cerulean Blue • Dioxazine Violet • Permanent Rose • Perylene Maroon • Yellow Ochre

BRUSHES
No. 3 or 5 round sable

Highlight on Teeth

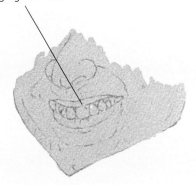

1 White Is Not Really White

Just like the human eye, a person's teeth are also not really white. Paint the whole area including the teeth with a wash consisting of a mixture of Cadmium Red and Yellow Ochre. Leave only the areas of highest highlight on the teeth white.

2 Add Color to the Face to Make the Teeth Appear White

Add a second, somewhat darker mixture of Cadmium Red and Yellow Ochre to the face, lips and gums if visible. This will now start to make the teeth appear white by comparison.

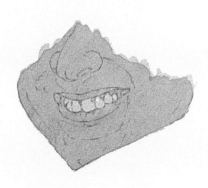

3 Give the Mouth Volume

To give the mouth a sense of volume and roundness, apply a light to medium wash of Cerulean Blue to the corners. Apply a light application of Dioxazine Violet under the nose and the mouth. Apply Permanent Rose to the gums. Apply Perylene Maroon to the nostrils, lips and corners of the mouth. Apply Perylene Maroon a second time to the corners of the mouth and underneath the teeth.

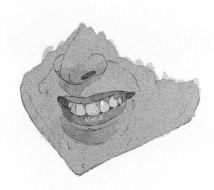

4 Finishing Touches

Continue to develop the facial area around the mouth with a combination of all the aforementioned colors, including Cerulean Blue, which is useful to cool the other colors and helps forms to recede. As you develop the rest of the face, the teeth will actually start to look too white. Add more Cerulean Blue to the corners of the mouth. Here and there add small amounts of Cerulean Blue and small amounts of the other colors to the teeth to give them dimension. Each tooth has its own shape so take care at this point. Try to make the vertical outlines of the teeth less pronounced than they actually appear. This helps keep the focus on the whole mouth and not the individual teeth. Finally, darken the lips with Perylene Maroon and a rich application of the same in the corners of the mouth, under the teeth and wherever else needed.

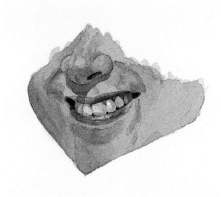

Face, Light Complexion

Alexandra is the daughter of friends. I painted this portrait of her a few years back when she was a young teen. As previously stated, texture is more than the mere surface quality of an object. In this painting the texture is derived from her expression and pose as much as any other aspect of the painting. Her arms are crossed yet she appears relaxed. Texture is further enhanced by her expression and by the fact that as you look at her, she gazes straight back at you. The light in the painting is soft and indirect, softening the contours of her face. The mood of the painting is quiet and gentle.

There are hundreds of excellent ways to paint watercolor portraits. This particular method will produce extremely natural-looking results.

Materials List

COLORS
Burnt Umber • Cadmium Red • Cerulean Blue • Chinese White • Chromium Oxide Green • Cobalt Blue • Dioxazine Violet • Lemon Yellow (Nickel Titanate) • Perylene Maroon • Raw Umber • Sepia • Yellow Ochre • Prussian Blue • Permanent Rose

BRUSHES
Nos. 3 and 5 round sables • No. 20 round • A few older brushes

OTHER MATERIALS
F Grade pencil

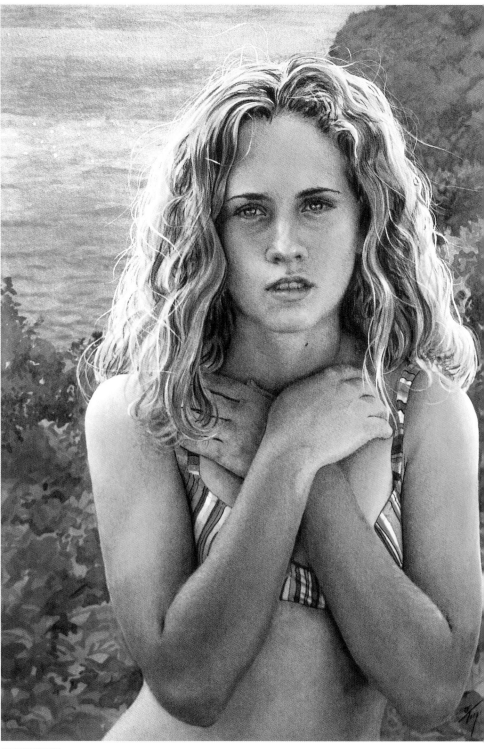

ALEXANDRA
14" x 11" (36cm x 28cm) • Private collection

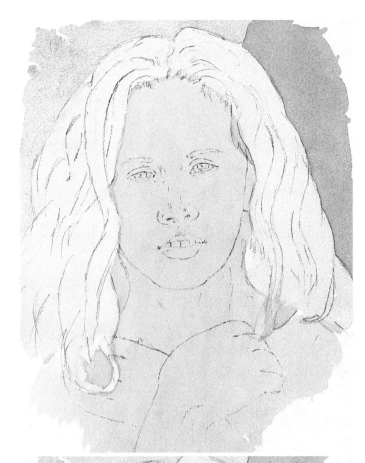

1 | Block in Initial Washes

After completing your drawing, use a no. 20 round brush with a mixture of Cadmium Red and Yellow Ochre to apply a flat wash over all of the skin areas as well as the eyes and teeth. (Remember the whites of the eyes and the teeth are not really white.) Apply a flat wash mixture of Lemon Yellow and Yellow Ochre to the hair. Apply Cerulean Blue and Chromium Oxide Green to the background.

2 | Apply More Washes

Apply a second wash of Cadmium Red and Yellow Ochre to the skin areas except for the eyes, teeth and highlight on the nose. Add Perylene Maroon to the Cadmium Red and Yellow Ochre mixture and paint the side of the face and neck. Then apply Cerulean Blue to the whites of the eyes and mouth as described in the previous two demos. Apply Cerulean Blue to the veins in the hand and wrist. As the painting progresses, subsequent applications of color on these areas will make the veins appear as if they are below the surface of her skin.

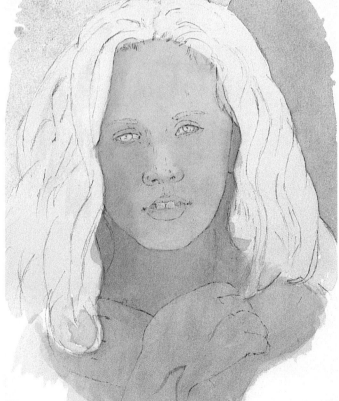

TIPS • What makes this method of watercolor portrait painting work so well is the interplay of many translucent layers of color visible in the finished work (optical mixing). To prevent the colors from mixing both optically and physically—which makes colors become muddy—it is important to thoroughly dry each layer of paint before the next is applied. To further keep your colors clean, change your water reservoir frequently.

• Many inexperienced artists think the human face is one color—flesh color. Some paint manufacturers actually make colors called Flesh Color and Flesh Tint. More experienced artists are usually aware that you can find a variety of colors in the human face. Virtually any color you can think of can be used when painting a portrait, including green and blue. Remember that cool colors recede and warm ones come forward, even on a face.

3 | Use Different Brushwork for Different Areas

Begin to develop the hair by applying Burnt Umber to some of the darks using a no. 5 round. The brushstroke you use to develop the hair is as follows. First, fully load the brush with paint. Begin the brushstroke by applying light pressure on the brush. Increase pressure on the brush in the middle of the stroke then end the stroke with light pressure again. This is similar to the brushstroke used for painting palm fronds (see page 70). Start out with larger brushstrokes. The finer lines describing individual hairs are often not necessary. If they are needed they will be added later in the painting process.

The brushwork for the skin is different. First, apply color to the area to be painted, and then soften the edge of that brushstroke with clean water. Apply the Cadmium-Ochre mixture around the nose and near the hairline to make the hair come forward and then soften it with clear water. You will use these techniques with all other paint applications to the face and hair.

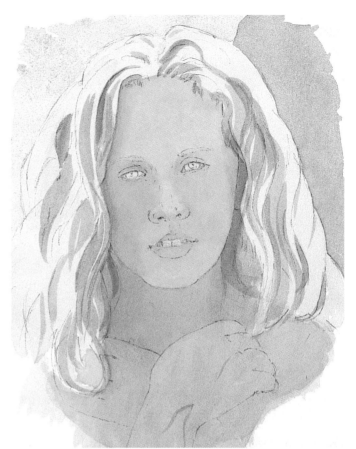

4 | Introduce More Color

Apply Cerulean Blue here and there in the hair, to the left side of the face, under the bottom lip, to the left side of the neck and hand, to the eyelids and both temples. Apply Chromium Oxide Green here and there in the hair, to the right side of the face, along the cheekbone and to the right side of the neck. Apply Dioxazine Violet to the hairline, eyelids and under the neck and hands. Apply the Cadmium-Ochre mixture to both eyelids and across the bridge of the nose. Apply Burnt Umber to more areas of the hair and hairline to integrate the hair and face. Introduce Sepia for the darker areas of Alexandra's hair. Follow the steps in the mouth (see page 109) and eye (see page 107) demos to paint those areas.

Magic Color
- -
When a student is afraid to put green or blue on the face while painting a portrait I ask them to do this simple exercise. Look at your model and imagine that you absolutely have to find a place for both green and blue in the portrait as if your life depends on it! Now pick a place to put both of the colors in the portrait. The moment you do, just like magic, you will begin to see lots of other places where these colors appear on your model. Find at least two more places on the face to put those colors in the portrait to integrate them.

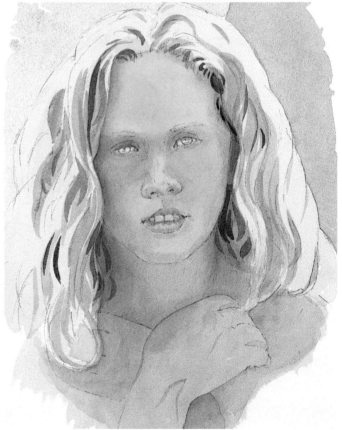

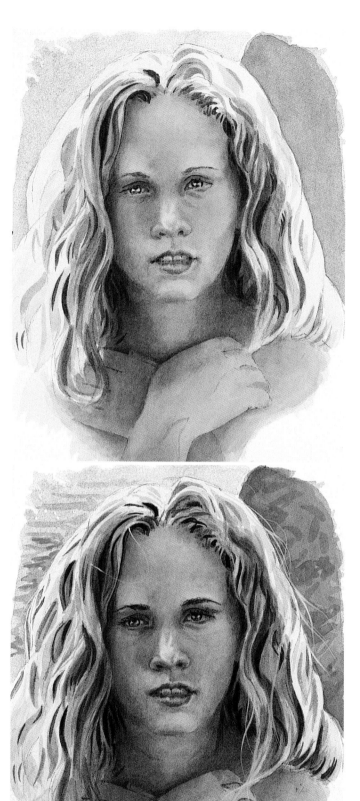

5 | Unifying Wash

Continue to develop the portrait as described in the previous steps. For more color variety, introduce Raw Umber and Yellow Ochre to the hair. You still should be using the no. 5 round for this. As you develop the painting you may notice that the skin tone looks a bit splotchy and perhaps a little disjointed. There is nothing really wrong with this look in a watercolor. In fact, a lot of artists actually prefer the textural quality it provides their work. For those times when you want to avoid this effect in your painting, you may turn to what is called a unifying wash. A unifying wash can blend and soften those splotchy areas. It can be done with clean water (as is the case in this demo), or with an application of color. It can be applied over all or part of the area to be painted. It can be repeated throughout the painting process. A unifying wash should not be applied to areas where you wish to maintain crisp edges, such as the detail areas of the eyes, mouth and hair.

6 | Introduce More Color

Finish painting the background, including the Cerulean Blue and Chromium Oxide Green that are the negative spaces on the outer edges of the hair. Continue to build up the facial features as described earlier. Turn to your older brushes and begin to apply glazes of color that are increasingly dry, but never quite as dry as drybrush. If you see skips of paint over the rough edges of the paper, your paint is too dry, so slightly moisten it with more water. Return to the hair, allowing the pattern to develop naturally. (Notice how the hair on the demo is somewhat different than that of the original painting, but both look right.)

At this point you may wish to apply a body color toptone mix of Lemon Yellow (Nickel Titanate) with a touch of Yellow Ochre and some Chinese White to the hairs that appear to be blowing in the wind, using a well-pointed no. 3 sable. (You may want to practice this brushstroke on scrap paper first.)

Face, Dark Complexion

This is a portrait of my friend and fellow artist, Manuel Palacio. While he and I were trying to figure out the way I wanted to pose him for the painting, he said "How about Basquiat?" Manuel was referring to post-modernist painter Jean-Michel Basquiat (1960-1988), whose work has been an influence on him and who, like Manuel, frequently wore his hair up.

The textures in this painting come from many sources and they are highlighted because of contrasting elements. His smooth dark skin is contrasted with the coarse texture of his hair, jewelry and even his tattoos. His skin color also contrasts with the light background which creates an interesting textural contour—almost a silhouette—between positive and negative space. The illumination is similar to that in the painting of Alexandra (page 110), soft and indirect, lacking pronounced contrast. It is unobtrusive, allowing the viewer to really see Manuel clearly.

You will also notice that in both portraits the subject's arms are crossed, but the feeling, the gesture and indeed the texture of the two paintings is completely different. Alexandra's pose seems to invoke the vulnerability of adolescence, while Manuel's pose suggests that he is a self-assured young man.

Materials List

COLORS
Burnt Umber • Cadmium Red • Cerulean Blue • Chromium Oxide Green • Cobalt Blue • Dioxazine Violet • Lemon Yellow • Permanent Rose • Perylene Maroon • Prussian Blue • Raw Umber • Sepia • Ultramarine Blue • Yellow Ochre • Indian Red

BRUSHES
Nos. 3 and 5 round sables • Nos. 10 and 20 rounds • A couple of older round brushes

OTHER MATERIALS
F-grade pencil • 2 palettes with large paint wells • Single-edged razor • Masking fluid • Rubber cement pick-ups

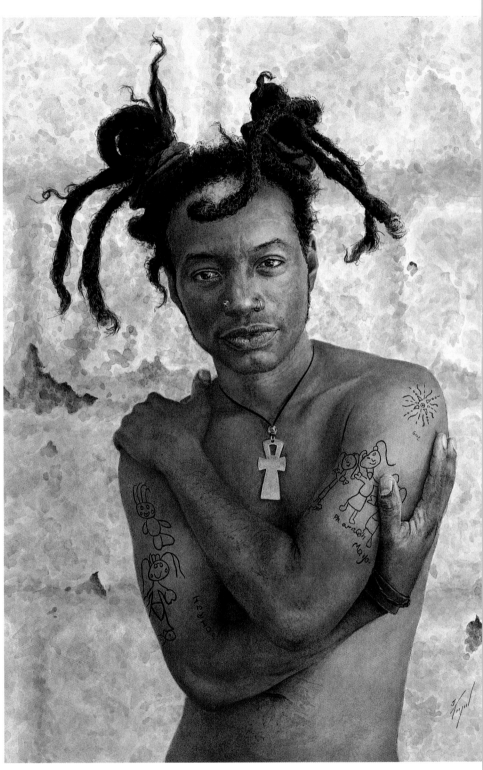

MANUEL
18" x 13" (46cm x 33cm) • Collection of the artist

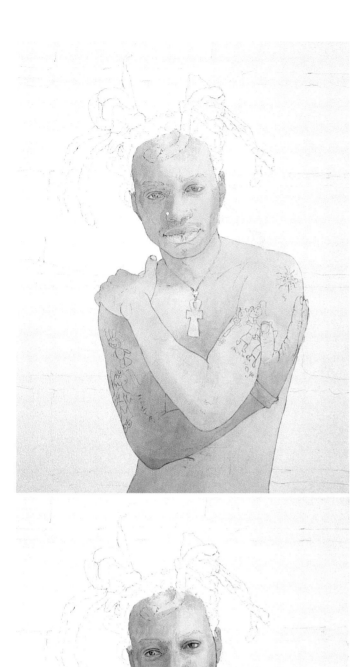

1 Block in the Basic Color

After doing a careful drawing, mix Cerulean Blue, Burnt Umber and a little Dioxazine Violet, and using a no. 5 round, paint the cross on Manuel's chest. Then dilute this mixture and apply a wash to the background with a no. 20 round.

Next mix Cadmium Red, Yellow Ochre and a little Burnt Umber. Load both the no. 10 and no. 5 rounds with this mixture and apply a wash to Manuel. Use the no. 10 for the big broad areas and the no. 5 to manipulate the tight areas around the jewelry. Keep a wet edge at all times to keep the skin texture smooth. After the initial washes are complete, dry everything and apply more color to the shadow side of the face, along the cheekbone and to the neck and arm. Add a little Perylene Maroon to the mix and apply a third wash along the nose and around the mouth. Apply a light wash of Dioxazine Violet to the chin.

2 Continue to Build Color

First using a no. 10 round and later using the no. 5 round sable, add more Dioxazine Violet to the skin colors and begin to build up on the shadow side of the face and around the arms. Begin to paint the eyes as demonstrated in the eye demo (see pages 106-107). To paint the mouth, apply Permanent Rose to the lips and then some Chromium Oxide Green to the upper lip and the bottom part of the lower lip. Apply Chromium Oxide Green around the eyes as well. Look for the area of reflected light on the shadow side of the face. Apply less color there. Apply a mixture of Perylene Maroon and Burnt Umber to the left ear.

TIPS · Frequently older brushes that no longer point can still be very useful tools. This is one such case. Here they are very helpful for blending skin tones.

· Rather than relying on a palette that has lots of little wells, use a couple of palettes with a few large wells so that you can mix subtle variations of the colors to be used in this painting. Place all of the warm colors on one palette and all of the cool ones on the other. The large wells will be used for making the several variations of color needed to paint Manuel.

3 | Begin to Build Intermediate Darks

Continue to build up color around the face and torso, working back and forth with warm and cool varieties of color. Using your no. 10 round for the larger marks and your no. 5 round sable for the smaller marks. Take care to paint around the jewelry on the face and chest. Use Cobalt Blue to darken the bottom arm and the fingers. Continue to build up color around the eyes and mouth. Put a combination of Perylene Maroon and Dioxazine Violet in the dark areas on the corners of the mouth and where the lips part. Introduce Raw Umber around the eyes and on the sunlit side of the temple. Then add touches of the Raw Umber here and there throughout the skin tone to integrate this color with the rest of the skin tone colors.

4 | Unifying Wash

With your no. 3 round sable, carefully develop the detail on the hand and bracelet. For the bracelet, use Perylene Maroon and Ultramarine Blue mixed with the colors used for Manuel's skin. Using your no. 10 round and no. 5 round sable, block in the initial washes for the hair first with Cobalt Blue followed by a mix of Burnt and Raw Umber. Continue to build ever darker color on Manuel's face and torso. At this point put slightly less water into your paint mix. In watercolor this type of application is often referred to as a glaze rather than a wash. Apply a glaze of Ultramarine Blue to the hand on the left shadow side, below that hand and along the darks of the arms. Mix Ultramarine Blue with Burnt Umber and paint the shadow around the finger and thumb on the right. Apply that mixture under the elbows and along the torso. At this point the color on Manuel's arms and torso will probably look a little splotchy. Apply masking solution to the medallion in preparation for a few unifying washes, then apply the unifying washes as needed to even out the skin tone. (Remember that a unifying wash may be applied with either a wash of color or clear water.) Then continue to build color with both the no. 10 and 20 rounds.

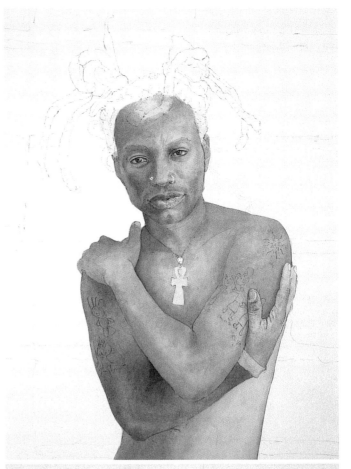

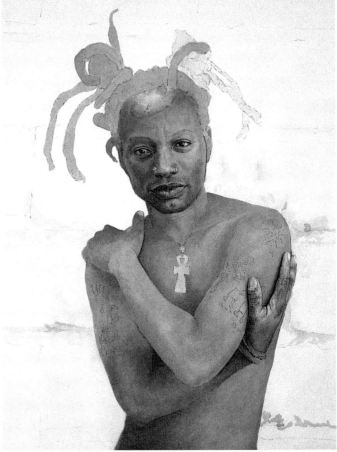

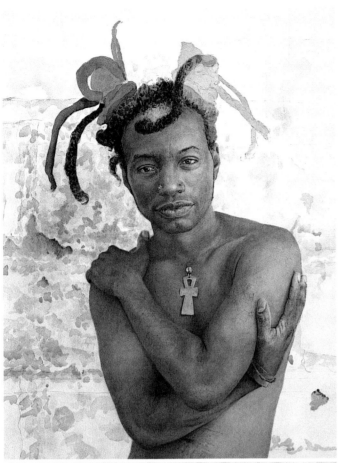

5 | Introduce Background Texture and Begin Hair

After you have finished the unifying washes, remove the masking solution and continue to develop the color. Develop ever deeper darks throughout the face and torso. Begin to indicate the hair on the arm. Continue development of the eyes and mouth. At this point begin to develop the background using the colors mentioned in the first step. Unlike the carefully blended glazes used to paint Manuel's skin tone, the marks used to paint the background should be very wet. When these marks dry, they tend to form slightly darker edges that add to the texture of the stone wall.

To paint the hair, use a no. 3 or 5 round and apply Burnt and Raw Umber. Then dampen the area to be painted and apply Sepia to this area as seen in the dread on the far left. Begin to build up dots of color using random mixtures of Sepia, Prussian and Ultramarine Blue along with Raw and Burnt Umber. These dots are negative spaces. The light spots in between these dots will eventually begin to look like highlights in the hair. Finally make toptone applications of Yellow Ochre and Lemon Yellow (Nickel Titanate) to further develop the highlights on the hair.

6 | Finishing Touches

Using your no. 3 and 5 rounds, continue to paint the wall and the hair as described. Put finishing touches of darks here and there where needed. Finish painting the two nose rings and the leather bracelet. After everything else is complete, paint Manuel's dark necklace and his tattoos. Use Prussian Blue mixed with Sepia for the necklace and Cerulean Blue mixed with Prussian Blue for the tattoos.

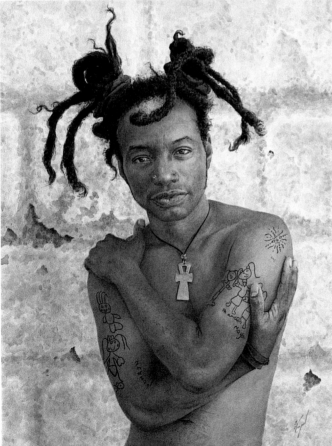

8

Differences and Similarities

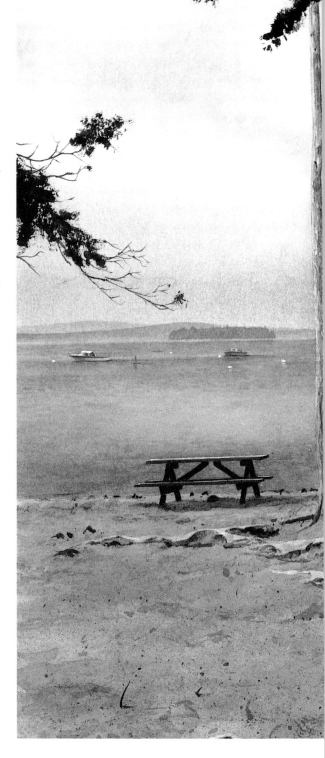

The inspiration for a painting can come from virtually anywhere. Your job as an artist is to take that inspiration and make something interesting, something that engages the viewer. With experience, you will find your own particular way to communicate those things you personally feel are worth saying through the language of painting. Throughout this book I've shown you many of the concepts and techniques that I believe will help you say whatever you wish to say with greater clarity, insight, and authority. I hope it has been as enjoyable for you to read this book as it has been for me to write.

This final chapter will explore how to compare and contrast some of the various elements you may encounter when painting. The more you know about the nature of both the world around you and the nature of your materials, the more you will come across subtle differences and unexpected similarities. This chapter will show you where to look for these differences and similarities and how to use them in your work. It will show you how to create and use contrast to clearly distinguish the various elements in your painting. It will also show you how small changes can make a big difference. Along with the examples shown in this chapter, as you begin to recognize more and more of these things on your own, you will find that you are better able to make nuanced distinctions in your paintings as well as making connections between seemingly dissimilar elements.

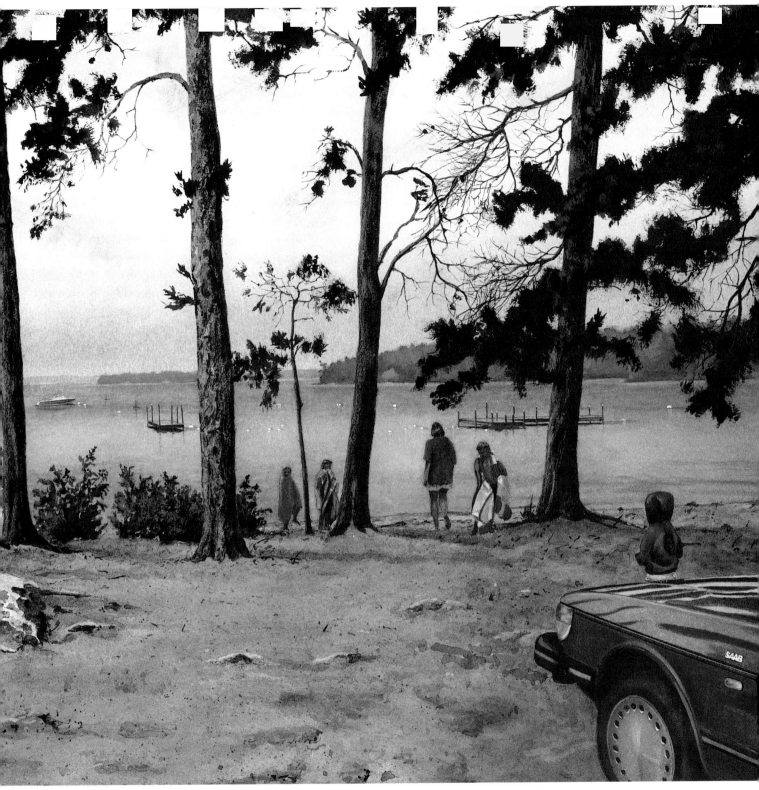

THE LAST MOMENTS OF SUMMER

Lake Winnipesaukee, NH • 14" x 20" (36cm x 51cm) • Collection of the artist

Different Elements Painted Similarly

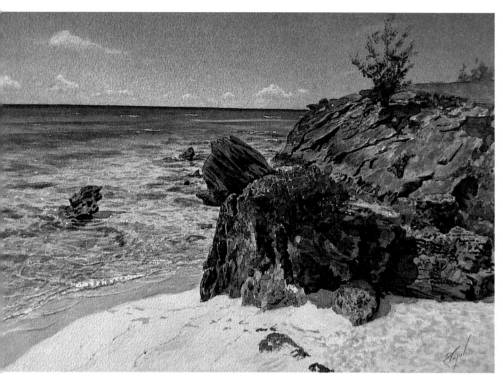

STONEHOLE BAY
7" x 11" (18cm x 28cm) • Private collection

At first you might not think there would be a similarity between the way you paint water and the way you paint the jagged rocks you see in these paintings. I used optical mixing to paint each of their dramatically different textures. To paint the water I applied several layers of thin glazes, making sure each layer was dry before the next was applied. This kept the colors bright and clean and at the same time rich and complex.

The rocks were painted the same way, but with one key difference. This difference creates the strong textural contrast between the water and jagged rocks. This time each layer of color that I applied was much wetter. When these layers dried, a dark jagged edge formed around each brush mark—which helps to convey the rough texture of the rocks.

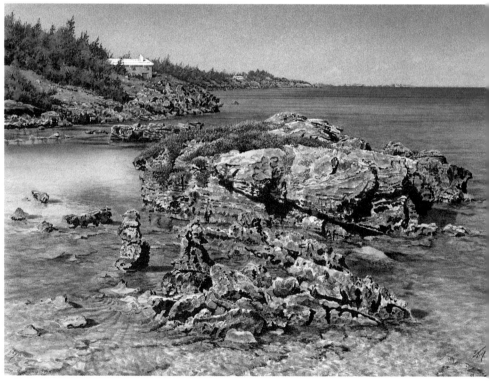

VIEW OF TOBACCO BAY
11" x 14" (28cm x 36cm) • Private collection

Clouds and People Painted Similarly

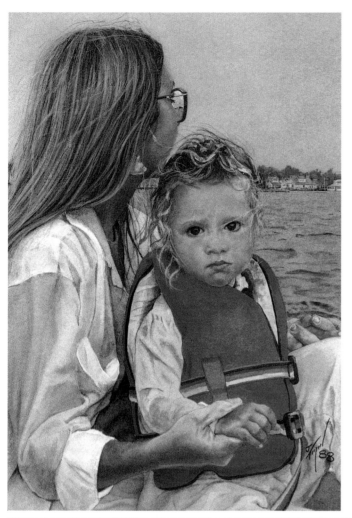

Have you ever spent time staring at a cloud formation, when suddenly you started to see what looked like a face emerging from the clouds? Even so, I'll bet most people wouldn't think that there is actually that much similarity between people and clouds or that the way you approach painting them could be similar, but it is. If you already know how to paint one, you also know how to paint the other. Shapes repeat in nature, and for the artist there are definite similarities between clouds and the face.

It is easy to visualize the three-dimensional structure of simple shapes like a wooden box. If you were to shine a light on the box, its simple structure would be visible and each of its sides would have a different value. A change in plane is a change in value. The human face and clouds, however, besides being more complicated forms than the wooden box, are both curvilinear. For some artists, visualizing the structure of curvilinear forms in three dimensions is a bit more difficult. Not only that, but clouds and people are both soft. Some people equate softness with lacking structure, but this is not so. Hard or soft curvilinear forms like clouds and people still have structure. As mentioned before, a change in plane is a change in value. Once you see and then visualize any curvilinear form in your mind's eye, you have a road map that will enable you to paint it.

For specific tips on how to apply the paint, refer to page 76 (*Dramatic Clouds*) and to the portraits on pages 110-117 and compare the similarities.

KATIE AND ELIZA
11" x 7" (28cm x 18cm) • Private collection

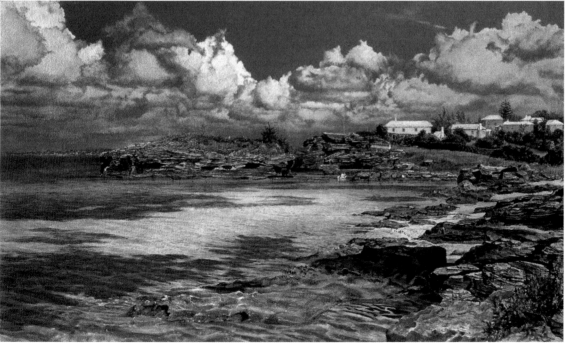

SPANISH POINT
14" x 21" (36cm x 53cm)
Private collection

Contrasting Man-made Textures

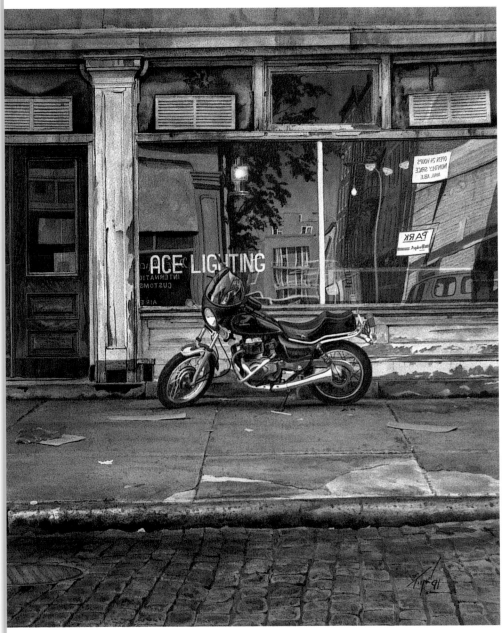

In the painting *Ace Lighting*, several elements are contrasted to create the overall design. Contrast is evident between the smooth, clean and shiny motorcycle and the rough, dirty texture of the street, sidewalk and building. The central thrust of the composition is created by the lines of the sidewalk and the cobblestone street, which point directly at the bike. They are offset and in contrast to the strong vertical shape to the left and the repetition of horizontal lines throughout the building and on the curb. The organized arrangement of these strong horizontal and vertical lines, along with the simple and straightforward lettering of the sign painted on the window, contrast nicely with the curvaceous shape of the bike and the distorted shape of the reflections on the bike and the window. The sidewalk was specifically painted a subtle gray-green, to contrast the russet red found throughout much of the reflection.

ACE LIGHTING
15" x 14" (38cm x 36cm) • Private collection

Contrasting Complementary Colors and Texture

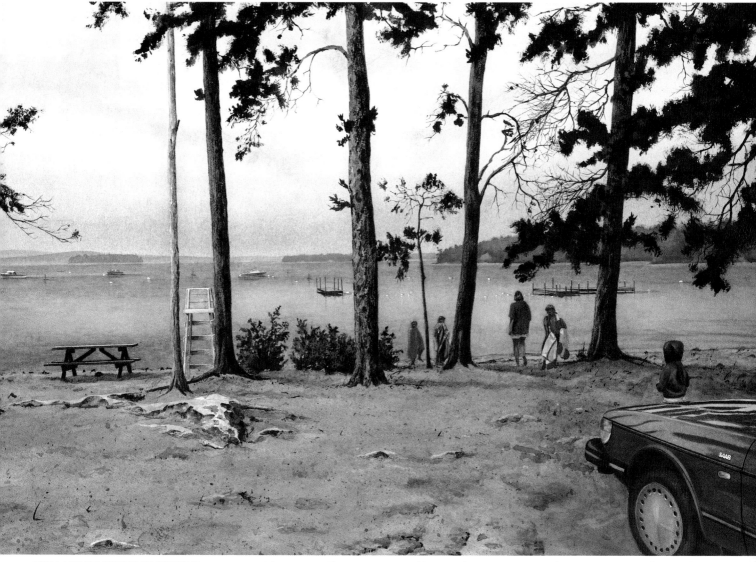

THE LAST MOMENTS OF SUMMER
Lake Winnipesaukee, NH • 14" x 20" (36cm x 51cm) •
Collection of the artist

The painting *The Last Moments of Summer* depicts a woman gathering her children after one final swim of the season. The children, one by one, reluctantly traipse back toward the car. The youngest, already dressed in his hoody, waits patiently for his siblings. He stares back at the lake watching a veil of mist begin to descend upon it like a curtain, bringing yet another summer to a close.

Color and texture, light and dark, and man-made and natural are all contrasted in this painting. The bright red car made up of Permanent Alizarin Crimson is contrasted with the greenish color of the lake made up of Phthalo Green over Lemon Yellow. Other reds are repeated here and there, on the children, boats, markers on the lake and subtly on the trees that are tinged with red by the soft light of the setting sun. Green is repeated by a darker gray-green on the distant shores made by mixing Dioxazine Violet with Hooker's Green. Still darker greens are on the picnic table, bushes and floating islands in the water. Dioxazine Violet is delicately applied throughout the water itself. The needles of the trees, made up of a heavy and directly applied mixture of Hooker's Green and Dioxazine Violet, are such a dark green against the pale gray sky that their texture is reduced to nothing but a spiky silhouette. This, along with the rough texture of the tree's bark, contrasts with the soft texture of the misty background and with the smooth shiny texture on the surface of the car. The choice of the violet throughout the painting, though not obvious, is there to contrast with the complementary Yellow Ochre color of the sand and the yellow underpainting in the water, keeping all the colors in harmony.

Contrast and Similarities: Day and Night

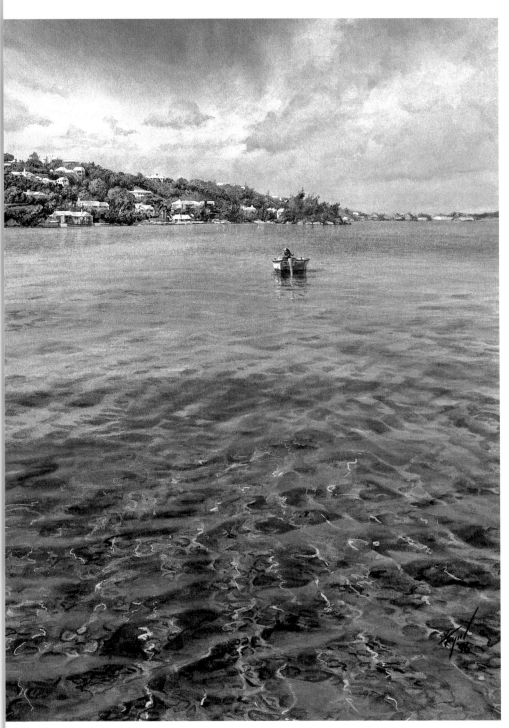

HARRINGTON SOUND
14" x 11" (36cm x 28cm) • Private collection

It is amazing how much the change of light can transform a place. The view in these two paintings is virtually identical. In the first of the two, *Harrington Sound*, the time of day is around 10:00 a.m. The mid-morning light reflects off the water and is dispersed in the moist air. The overall texture appears to be softened by the light, yet shadows are clearly visible on the buildings, trees and the boat. Even in the water you see the areas of both sunlight and shadow. As the ripples move toward you, the areas in direct sunlight act like a mirror reflecting the sky above. The areas in shadow, when viewed at a distance, appear relatively dark. Then as the water gently moves toward you the shadows become more like little windows revealing what is below the surface.

The movement in the painting is not just the obvious implied movement of the water, but comes from various sources. The arrangement of the clouds forms a pattern that subtly points toward the hill across the sound. The pattern of ripples and reflections gently draws your eye forward toward the boat and the foreground. The patterns in the foreground below the surface subtly point back toward the boat and the distant shore.

To paint the surface of the water, Cerulean Blue is used. Remember that Cerulean Blue is an opaque pigment, and as such, changes little in its appearance from its top or mass tone (what it looks like right out of the tube) to its undertone (what it looks like when diluted with water.) This means that when thin washes of Cerulean are applied to the middle ground and distant areas and then later, heavier top-tone applications are applied over the previously painted foreground, the surface of the water blends seamlessly.

Low and High Key Paintings

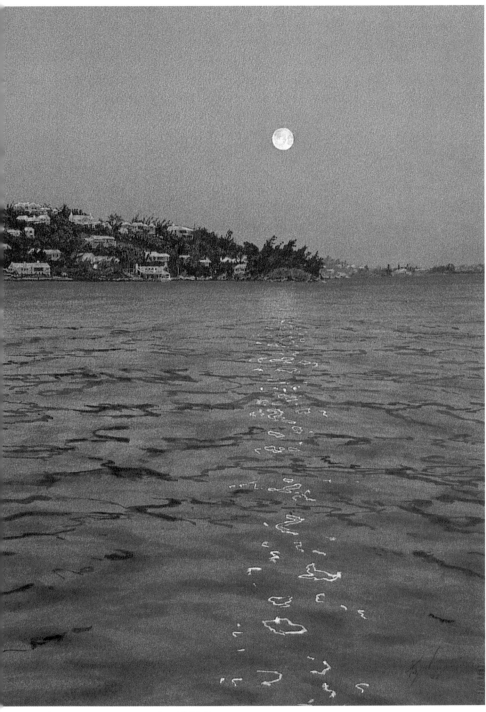

The effects of light and texture are more subtle in *Moon Over Harrington Sound*. The mood is quiet and tranquil. As in the painting *Quiet Night* (page 46), the elements of this painting are unified by a dominant color or tone of Prussian Blue, this time augmented with an underpainting of Quinacridone Gold. The moon and the reflections in the water are also painted with Quinacridone Gold and then masked off. Later, a few more reflections were painted with a combination of Quinacridone Gold and Chinese White. Touches of Cobalt Violet are used throughout the painting, from the hill across the sound to the distant shore, even in the water itself. Although there is diminished illumination, the full moon makes things clear and visible. The view appears less humid and the water appears even more placid than it did during the day—almost silky. The ripples form a series of subtle chevrons pointing back toward the moon, their gentle sound lulling you to sleep.

MOON OVER HARRINGTON SOUND
14" x 11" (36cm x 28cm) • Private collection

Index

The best in watercolor instruction and inspiration is from North Light Books!

Here's all the instruction you need to create beautiful, luminous paintings by layering with watercolor. Linda Stevens Moyer provides straightforward techniques, step-by-step mini-demos and must-have advice on color theory and the basics of painting light and texture-the individual parts that make up the "language of light."

ISBN 1-58180-189-0, hardcover, 128 pages, #31961-K

Accomplished artist Barbara Nuss takes the guesswork out of landscape painting compositions with this indispensable guide. You'll learn how to simplify, arrange and refine what you see in the nature to create a truly great painting. Each of the 14 chapters cover a specific core design format for landscape paintings. Easy-to-follow exercises, thumbnail sketches, complete painting demonstrations, photos and other helpful tools will provide you with the knowledge you need to link real-world nature scenes with these 14 essential compositions.

ISBN 1-58180-385-0, hardcover, 144 pages, #32421-K

Charles Reid is one of watercolor's best-loved teachers, a master painter whose signature style captures bright floral still-lifes with a loose spontaneity. In this book, Reid provides the instruction and advice you need to paint fruits, vegetables and flowers that glow. Special assignments and step-by-step exercises help you master techniques for painting wild daffodils, roses, mums, sunflowers, lilacs, tomatoes, avocados, oranges, strawberries and more!

1-58180-027-4, hardcover, 144 pages, #31671-K

This book is for every painter who has ever wasted hours searching through books and magazines for good reference photos only to find them out of focus, poorly lit or lacking important details. Artist Gary Greene has compiled over 500 gorgeous reference photos of landscapes, all taken with the special needs of the artist in mind. Six demonstrations by a variety of artists show you how to use these reference photos to create gorgeous landscape paintings!

ISBN 1-58180-453-9, paperback, 144 pages, #32705-K

These books and other fine North Light titles are available from your local art & craft retailer, bookstore, online supplier or by calling 1-800-448-0915.